The ROUGH GUIDE to

DIGITAL
PHOTOGRAPHY

CONTENTS

Introduction

Photography has had its fair share of transformative moments, most of which have taken it to a wider audience. Increasingly portable, lightweight cameras, with faster films and shutter speeds, and at ever cheaper prices, have long secured its mass market status. And the advent of digital technology, followed by the rise of camera phones,

social networking and cloud hosting are just the latest milestones on this path. The most distinctive characteristic of these recent developments has been their phenomenal speed. It may have taken sixty-odd years to move from photographic plates to film, and another twenty for colour film to appear, but just a decade after the launch of the first commercially available digital camera in 1990, digital photography had all but wiped out the market for film cameras.

The camera has long been the traditional means of recording our lives from birth to old age, as well as the world around us, but the instant results and relative cheapness of digital technology have led to a sharp increase in the number of people interested in photography. Countless online communities and resources have sprung up in response to this vast outpouring of images, from the online photo-sharing and management provided by popular sites like Flickr to spaces where you can create your own photo books, learn about particular genres or styles, even build a following and sell your work. These days, more than ever, we're all photographers and rarely more than a mouse-click away from a fellow enthusiast, the result being an exponential increase in the sharing of ever-more specialized photo interests – helped along by the ubiquitous, increasingly sophisticated camera phone. At any social gathering, you can count on someone uploading an image to Flickr, Facebook or Twitter before the bar tab has been drunk dry. You can catch your friends behaving badly on your phone, tidy them up (or make them a little more artfully dishevelled) through a quick online edit, and have them tagged and on the web in moments. Our always-on internet connections have helped drive this cultural shift from what the great photographer

Cartier-Bresson called "the decisive moment" to pretty much every moment, and from being in the right place at the right time to being everywhere, all the time.

Meanwhile, "citizen journalism" and user-generated content have burst onto the scene, with images of events as they happen routinely being captured by the people on the ground and then beamed virtually instantaneously around the globe. In the UK, the London bombings in July 2005 were a turning point, with grainy stills and video footage taken on camera phones making the TV news. Worldwide, big news events and natural disasters alike are documented through images and blogs online, and traditional media organizations have responded by absorbing this mass of information into the news flow. Even the weather forecast seems to require its own user-submitted pictures of snow drifts or gambolling lambs. Stock photography agencies, too, have responded to these developments – and to the sheer volume of images coming onstream – with a changed approach to licensing, with the likes of Getty including work from amateur photographers in its library.

At the same time, photography has been welcomed into the art world as never before, even though its status as an art form continues to be debated (as it always has been) by both critics and photographers alike. While many photographers regard themselves as artists, others see themselves as having a purely functional role. And in recent years several artists, such as Wolfgang Tillmans and Andreas Gursky, have started working in photography without identifying themselves as photographers as such. Whatever they call themselves, the work of the most outstanding practitioners – whether contemporary stars like Gursky or "old masters" like Ansel Adams – now fetches huge sums at auction. There is an enormous appetite for a vast range of genres, from candid shots and street photography through to fashion, landscape and eve-rything in between. Interestingly, alongside this surge of enthusiasm, a new generation has emerged who are excited about experimenting with film, as the online platform facilitates knowledge-sharing and the spreading of trends like toy and instant cameras as never before.

About this book

The Rough Guide to Digital Photography is designed to help you get to grips with the technology, to work out what you need to know and the kit you really need (rather than what the manufacturers claim you need). Starting with cameras and other photographic kit, we run through the pros and cons of **different types of camera**, why you might choose to use certain pieces of equipment and what you can get away without. Next, we demystify the **technical** side, looking at how exposure works, how to use depth of field to create striking images, and so on – and, just as important, when you need to take control of the settings and when you can rely on the camera itself to get things right. Photography's about more than buttons, though, and we go on to take you through the rules of **composition**, how to bring whatever's caught your eye to life by thinking through the separate elements – from light and colour to perspective and framing. We then take a look at some of the most popular **genres and styles**, from travel to wildlife, macros to street photography, providing practical tips and techniques and listing some sources of inspiration to get your creative juices flowing. Throughout, the book is packed with images to illustrate and expand on the text and give you more ideas for what you can achieve, using the work of photographers both professional and amateur – and including many of my own photos. Where possible, too, we've included EXIF data so you can clearly see the technical decisions the photographer made for that particular shot.

The second half of the book shifts largely from camera to computer. One of the best things about digital photography is the ease with which you can edit your work, and we run through some of the most widely used **editing software**, from free online packages to high-end programs, before concentrating on some of the ways in which you can enhance your images, along with tips on printing, colour management, resizing and resolution. We then move on to the online environment, taking a look at what's on offer from some of the most popular **photo-sharing sites** and how to get the best out of them. As well as sharing sites, there are plenty of lively **online communities** where you can simply connect with others to discuss kit niggles, swap camera phone app tips, or just hang out and be inspired. We also help you assess some of the options if you want

to take things further: how you might go about building an online **portfolio** or shop, getting into **stock photography** or creating a photo **blog**. And if you're keen to dabble in film for the first time – or, indeed, if your love of all things analogue never went away – we give you some tips for shooting, scanning and storing **film** and take a look at some of the most popular toy cameras and related online resources. We wrap up with a comprehensive **resources** section listing further books and websites, plus a full **index**.

Whether you're a novice or a keen photographer, whether you're investing in a new SLR system or playing with apps on your iPhone, we hope this book will enhance your photographic experience in every way, helping you make the most of your equipment, navigate the vast swathes of the internet related to photography, and leading you to new resources, communities and sources of inspiration.

ACKNOWLEDGEMENTS

This book has benefited from input and images from lots of people, as well as from any number of geeky conversations about photography over the years. My thanks go to Elizabeth Prochaska and Duncan Clark, for believing in the idea in the first place, and to the Rough Guides team for making it happen – to Andrew Lockett for signing it up, Kate Berens for transforming it from rough and ready into Rough Guide, and Diana Jarvis for stylish design work and some beautiful photographs. Other great photographs were kindly provided by Flickr and real-life friends Clare Borg Cook, Anna Brewster, Suzanne Dehne, Natasha Denness, Darrell Godliman, Al Power, Jeff Slade and Mike Stimpson. Thanks, too, to Alison Peel, Phil Goldsworthy, Louise Allen, Kate Jury and Rosamund Snow for being on hand with coffee and cocktails at the relevant moments. And last but not least, thanks go to my lovely family and friends for their interest, engagement and support, and for patiently allowing me to bang on about all the 5am starts.

1 YOUR CAMERA

Buying, upgrading or making do – what you need to know

The technology now exists to help you get the photo you want, wherever you are and whatever you're doing. If you're a keen photographer (or want to become one), or simply enjoy playing around with images, it's easier than ever to make sure you have a camera with you when you're out and about. This chapter will help you get to grips with the bewildering array of features and functions, so you can decide what's important to you and which type of camera will best suit your needs.

Which camera?

The first question to ask yourself is what you want the camera for and what you want to do with the pictures you create. If you want to capture everything as it happens, post pictures on the web or just take holiday snaps, you might want to stick with your camera phone or a basic compact. If you're interested in taking mainly static subjects, such as macro close-ups or landscapes, you might consider a more advanced compact or a bridge camera, which can give you a bit more control over your images and deliver great results – and high-quality prints – without breaking the bank. Finally, if you know you want to take specific types of image that demand more control, such as action shots or pictures in a wide range of lighting conditions, or you want to be able to blow up huge prints of your images, you might consider an SLR.

Price remains a differentiating factor, but less so than ever before. While digital SLRs used to be prohibitively expensive, entry-level models now cost little more than a good bridge or high-end compact, although high-quality lenses haven't come down

in price, meaning the whole bundle can still prove more costly. The gaps between the different camera types have also narrowed, and some high-end compacts or bridge cameras come pretty close to DSLRs in terms of what you can do with them. Other key differences include **size** and **weight**. Even a small SLR is twice the size of a compact, and the addition of a lens means it won't fit in a pocket. You might find you need more than one camera, of course, perhaps a bridge or SLR and a camera phone or compact, making sure that wherever you are you won't miss anything you might want to capture.

Compact digital cameras

For a camera you can slip into a pocket, ready for whenever you come across an interesting photo opportunity, the compact or "**point-and-shoot**" is hard to beat. Designed to be easy to use, compacts tend to prioritize form over function, sacrificing advanced features and a degree of image quality in favour of portability and simplicity. But their picture quality is usually good enough to make standard 6"x4" prints and for sharing online.

The range of compacts is vast and is matched by a wide variation in price, from the cheapest and most basic point-and-shoots to advanced compacts offering as many megapixels as an SLR, and almost as many features. So how do you even begin to pick the one for you?

Some compact cameras lack a viewfinder, but with an LCD screen you can tell exactly what your shot is going to look like.

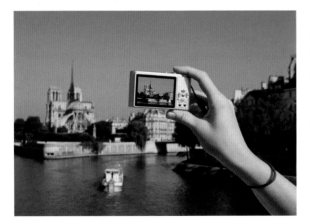

Knowing the sort of image you want to take will help narrow down your options: if you'll be photographing flowers and insects, choose a model with a **macro mode** that will let you get up close; if you fancy taking scenic landscapes you'll want a **landscape setting** that captures a wide panoramic range. So-called "shoot-to-share" technologies are increasingly included, making it easy to upload pictures or videos directly to sites like Facebook or YouTube.

You can spend anything from £50 to £500 ($50–700) on a digital compact, depending on its sophistication and whether or not you're keen to buy into a particular brand, but you'll find a wide array of options in the £70–200 ($80–250) range.

Bridge cameras

Bridge cameras, sometimes also called **super-zooms**, straddle the gap between compacts and digital SLRs, offering more control over the settings than a compact, alongside a high-quality fixed lens with a powerful zoom. High-end bridges can provide similar image quality to low- and mid-range SLRs, while covering a similar zoom range with an SLR would often mean investing in several lenses. Prices mostly fall in the £150–400 ($130–450) range, though there are plenty of advanced models costing considerably more.

The best thing about a bridge camera is the fact that it offers everything in one package. It has a similar learning curve to an SLR on the functions front, but like the SLR still offers the automated settings familiar from using a point-and-shoot; you can experiment and get a feel for whether having more power over the settings appeals to you or not. And you'll never miss a shot while you're changing lenses or when you realize that the lens you left at home is the one you need.

On the other hand, bridge cameras can be almost as heavy and bulky as a small SLR, the **image quality** is generally lower (though still fit for most purposes) and they're slower to operate, with notable **shutter lag** (the time between you pressing the shutter and the camera actually taking the picture). They're also often at the back of the queue for development spend from the camera manufacturers, as they aren't competing directly with the relentless advance of camera phones, nor the envelope-pushing kit at the top of the range. In practice, this means the bridge camera is always running to catch up in technological terms. What's more, with compacts getting better all the time and the price of entry-level SLRs continuing to fall, the bridge camera runs the risk of being squeezed out. But if you're finding your compact a little too limiting, but aren't ready to make the leap to an SLR, a bridge camera might be the solution.

BRIDGE CAMERAS

- ⊕ Portability
- ⊕ Good quality images
- ⊕ Option of manual control as well as full auto
- ⊕ Extensive zoom range
- ⊕ No need to invest in expensive lenses, or change lenses as you go
- ⊖ Can be expensive
- ⊖ Can't use lenses tailored to a particular type of image
- ⊖ May struggle to produce good images in low lighting conditions
- ⊖ Some shutter delay

Single-lens reflex

Single-lens reflex refers to the hinged mirror in an SLR, which reflects the light – which enters the camera through the lens – up to the viewfinder, to allow you to see what you are capturing and to compose your image, but then flips out of the way when you press the shutter, to let the light hit the sensor.

For for a list of review, price comparison and retail websites
▸▸ see p.219

Digital SLRs

They're large, heavy and can be expensive, but for sheer versatility and improved picture quality, you might want to consider a digital SLR, or single-lens reflex. If you've used a film SLR and know how it works (and perhaps have a stash of lenses itching to be used), it's well worth upgrading. The cheapest SLRs are cheaper than a decent bridge, and while a top-end bridge will do more than a similarly priced SLR, you have more flexibility in terms of things you can add on to the SLR later when you need them, such as better quality lenses and other accessories.

The SLR offers full **manual controls** which will give your creativity free rein, plus interchangeable lenses, and a viewfinder which shows you more or less what the lens sees. It will also usually give you most of the automatic controls you get on compacts and bridge cameras, so you can decide whether you want to take control of the settings or not. On the downside, an SLR is bulkier and heavier than a bridge, and you may not want to carry it everywhere with you. The **kit lens** that comes bundled with a new SLR tends to be rather low quality, but good lenses are expensive, and the range can be daunting. Many SLRs don't have live **LCD screens**, meaning you have to use the viewfinder for composing your images, which won't always show you the information you need (see p.14).

The real benefit of an SLR, in image quality terms, isn't the well-lit, every day shot, taken out and about, but all those situations round the edges in which a compact camera will start to creak, when you're faced with poor lighting, a moving subject, or taking someone's portrait in front of a cluttered or unattractive background that you'd like to play down. An SLR can deliver high-quality images in all these

conditions, and its potential to use different lenses and accessories gives you the freedom to push the boundaries with your photos. But even if you never leave auto mode – which many people don't – and stick with a single, all-in-one lens rather than toting around a huge bag of kit, you'll still see improved picture quality.

Prices for new entry-level DSLRs, such as the Canon EOS 1000D or Nikon D3000, usually start at around £300 or $450 for the camera body only, or £350/$550-plus with a kit lens as part of the package. The professional cameras at the top of the range can cost £5000 or more. Canon and Nikon are often seen to dominate the field, filling the bestseller lists and generating much debate between brand aficionados, but many of the other big names, such as Sony, Olympus and Pentax also have a wide range of models, particularly at entry level. One factor worth considering when you look at different brands, which doesn't apply when choosing a compact or bridge, is that a manufacturer's lenses will usually work on most of the cameras in their range, so any investment in lenses won't necessarily be wasted if you later upgrade your camera. For this reason, people often pick a particular DSLR brand and stick with it over time, as changing horses midstream can be a costly exercise.

DIGITAL SLRS

- ➕ Highest quality images
- ➕ Manual control of all settings as well as full auto option
- ➕ Works with external accessories (flashes, filters, specialized lenses)
- ➕ High quality in low light
- ➕ Fast response times
- ➖ Bulky and heavy
- ➖ Higher prices
- ➖ Kit lens often low quality
- ➖ Manual settings can be complicated
- ➖ There isn't always time to change lenses
- ➖ Most don't have live LCD

- ⊕ Convenient, portable, always with you
- ⊕ No need to carry multiple devices
- ⊕ Simple to use
- ⊕ Apps offer a range of creative styles
- ⊕ Immediate upload to web
- ⊖ Lower quality images
- ⊖ Limited control over focus
- ⊖ Slow response times
- ⊖ Models without flash give poor quality in low light

Camera phones

Alongside the three main types of dedicated camera, almost every mobile phone bought in the last couple of years has an integral camera, and these are starting to change the photography landscape. Until recently, camera phones were seen as a bit of a gimmick, good for little more than drunken shots of your mates or blurry holiday snaps, but they have now evolved to a level where they can compete with mid-range digital compacts, as phone manufacturers continue to add better lenses and new functionality to their ranges.

The camera phone of course offers the most flexibility in terms of taking, editing and posting images on the move: you may not always have your camera with you, however neatly pocket-sized it is, but you're likely to always have your phone and often a **web connection** with it, enabling the immediate upload of photos to your own web gallery or a photo-sharing website. Though compact cameras are starting to include this functionality, it's still absent in most models at the moment. You can also simply upload photos to your computer and edit or print them just as you would pictures taken with any digital camera. Meanwhile, developers are coming up with ever more creative **apps** for the various smartphones, offering the sort of in-camera variety a compact can't match – from those which give your pictures a particular style, making them look like film or Polaroid images for example, to apps which let you add speech bubbles or comedy effects to portraits.

Picture quality from most camera phones is good enough for sharing online, and in many cases for making small prints, and they are perfect for capturing the day-to-day, when you don't want to carry several devices around with you. For the time being, at least, they don't offer the combination of camera features needed to make sure you get the best possible picture – understandably, since this is a secondary function and manufacturers are having to juggle optical quality with the compact size demanded by phone consumers – but camera phone specifications are developing all the time, and they are likely to run dedicated compact cameras a very close race in future.

iPhone with onscreen image.

Tips on buying a camera

How deep are your pockets?

With so many manufacturers and a constant stream of new models, it can be daunting to pick a new camera. First off, think about how much you want to spend. Don't forget that you'll need to buy memory cards, maybe a camera case or bag too, plus other accessories such as spare batteries. Sometimes you can find an offer that wraps in one or more of these items, sometimes you can persuade the shop assistant to throw something in with the camera, but more often these will all be extras.

Have a play

The best way to get a feel for what might be the right camera for you is to go into a well-stocked store and ask to handle a few different models. You need to find a camera that feels comfortable, is not too heavy, and – most importantly – that you think you'll use. The best camera in the world won't take good pictures if you leave it in your bag because you feel embarrassed carrying it around. You might also want to ask the sales assistant to talk you through the basic functions, so you get an idea whether the main buttons feel easy and intuitive to use.

Where to buy

While it makes sense to visit a camera shop to get hands-on, there are often better deals to be had online, and plenty of price comparison and review sites showing you where the bargains are to be found (see p.219). As with any other major purchase, double check the small print and customer feedback, and consider walking away if there isn't a manufacturer warranty offered as part of the deal. Regard anything that looks like an alarmingly good deal with suspicion: many suppliers sell "grey goods" – importing items from cheaper territories and selling them below market price. This will probably invalidate the manufacturer's warranty, so if anything goes wrong you're relying on the supplier to fix it.

Buying secondhand

Used cameras and equipment abound on eBay, though buying through a reputable dealer or specialist shop (see p.220) is the safest way of ensuring that what you buy has been properly serviced and reconditioned. If you have a chance to buy in person, look to see if the lens and LCD are scratch-free, and whether the camera body is free of scratches and dents, which is usually an indication that it's been looked after – a scuffed or badly maintained camera may have less visible damage too. Run though the settings and check that all the buttons and dials work. If it's an SLR, remove the lens to check that the lens mounts on both camera and lens aren't worn or damaged, and hold it up to the light to check for any internal marks or scratches on the glass. Check that the focus ring on a detachable lens or bridge camera moves freely through its full range.

If you're buying online or sight unseen, the usual common-sense guidelines apply: check out the seller's feedback, read the descriptions carefully, and ensure any questions you may have are answered to your satisfaction before proceeding. Whether buying online or in person, it's important to get a guarantee, for at least 90 days if possible, as this will give you time to put the camera thoroughly through its paces and get it fixed or replaced – or get a refund – if you find any faults. As camera equipment can be expensive, it's sensible to pay by some method that will offer you buyer protection, too.

Features and functions

On any modern camera, the seemingly endless list of features and functions can be somewhat daunting. How do you know what size sensor you need? Is 13 megapixels really that much better than 12? Separating the marketing from the facts, this section aims to help you figure out what you need in a new camera – or how much you can do with the one you've already got.

How many megapixels is enough?

A digital camera uses a sensor array composed of millions of **pixels** to produce a picture, which you can usually see in the final image if you zoom right in on your computer monitor: the image will seem to be composed of tiny squares, like a mosaic. They are the smallest controllable elements of an image. A megapixel (MP) is made up of a million pixels and the number of megapixels a camera can produce in an image is the most common way to express its resolution. In the absence of other uniform elements in a camera spec, it's become a kind of visible yardstick for choosing a camera, on the assumption that more megapixels has to mean better, which is why camera manufacturers continue to stuff newer models with ever more megapixels, far beyond the needs of the average user. As a measure of potential picture quality, though, number of megapixels is a bit of a red herring, not least because pixels vary in size from camera to camera, but also because a huge number of factors influence image quality, including lens quality, image sensor, shutter speed and available light, all explored elsewhere in this book. A point-and-shoot with 12MP will produce lower quality images than a bridge camera with 10, and an SLR equipped with a high-quality lens will do better still.

MP	Pixels*	Max print (in) at 200ppi	Max print (in) at 300ppi	Max print (mm) at 300ppi
2	1725 x 1150	9 x 6	6 x 4	152 x 102
5	2750 x 1833	13.5 x 9	9 x 6	229 x 152
10	3900 x 2600	19.5 x 13	13 x 8.5	330 x 216
15	4752 x 3168	24 x 16	15 x 10	381 x 254
25	6150 x 4100	30 x 20	21 x 14	533 x 356

* Precise pixel counts will vary from camera to camera, as will pixel size.

How many megapixels you need is determined by what you're going to use the images for. Most editing packages let you save files at different resolutions, usually measured in pixels per inch (ppi). An image with, say, 72 pixels to every inch is going to look much more blocky and pixelated than one with 300 pixels to each inch. If you just want to post pictures online, you can get away with low resolutions and as little as 2 or 3 megapixels, but if you want to create large prints you may need a camera with 10, 12 or more.

A standard rule of thumb when **making prints** is that 300ppi offers a high-quality image, but prints made at 200ppi can look perfectly good in most cases. The table opposite gives you a rough idea of the kind of print sizes you can get from different megapixel counts for both resolutions without starting to see print quality reduce. You can work this out for your own camera by checking the specifications for the maximum file size, and then dividing the pixels by 200 or 300 (though remember if you crop into your photos at all you will be throwing pixels away). What all of this shows is that while megapixels were a useful measure of photo quality in the early days of digital photography, most modern compacts will now give you more than enough megapixels to make reasonably sized prints of acceptable quality.

The top image is saved at 300ppi; the bottom image shows what it looks like when zoomed in to the pixel level. A lower resolution image will start to look this blocky if you print it too large. **1/100, f/2.8, ISO 100, 24mm**

The top image is a high-res TIFF file saved at 300ppi, while the bottom image is a JPEG saved for the web at 72ppi, showing how much more fuzzy a low-resolution image will look when printed.
1/320, f/4.0, ISO 250, 92mm

File formats

When you take a photograph, your camera compresses the data captured in order to store it on a memory card. There are several ways in which it can do this, but by far the most common are to save the data as either **JPEGs** or **RAW** files.

As well as file format, you may also be able to select **image resolution** (pixel size) and quality (type of **compression**) from your camera's menus, though basic compacts might only offer one fixed setting. If you know you only want to share your photos on the web, you can get away with selecting lower quality and higher compression, which will take up less space on your memory card (and computer) and allow you to take and store more photos. But if you have the space, and want some flexibility later on when it comes to making decisions about what to do with your photographs, it makes sense to select a higher-quality file option with lower compression, even if you stick with JPEGs rather than moving to RAW.

• **JPEGs** The format most photographers start out shooting. It is often described as a "lossy" format, which means that the compression process will result in the loss of detail in your images, as the camera selectively discards image data. When you select high or low quality and large or small image size from the settings menu, you are making decisions about the compression options, and about how much data will be kept or lost.

• **RAW files** These are stored without any in-camera processing, relaying everything the sensor has captured. They are good at capturing a wide range of brightness and colour, and keeping detail in shadows and highlights that a JPEG would fail to record. You'll need special software to process RAW files: this should be covered by

the proprietary software which comes with your camera, though you need to check it will work on your computer. Many cameras have an option of taking "RAW plus JPEG", storing a small-sized JPEG alongside the RAW file, which allows you to review the images on your computer without having to convert the RAW files, though it does use up a little more space. Most in-camera editing functions won't work with RAW files.

- **TIFF** Some cameras also offer the option of capturing images in TIFF format, and if your camera doesn't shoot RAW, TIFF is the highest quality alternative, retaining more of the original information than a JPEG. The files are either uncompressed or undergo lossless compression, but they take up a lot more space than even a RAW file due to the way in which they record data.

DNG format

Because RAW file formats vary from manufacturer to manufacturer, and demand that other software manufacturers support a range of files, Adobe have proposed the Digital Negative file format (DNG) as a way of creating an open standard RAW file format that would be supported by all camera and software manufacturers, whether instead of or alongside their proprietary RAW file formats.

To date, users are conflicted about DNG, reflecting the lack of universal take-up by camera manufacturers. A few have rolled out camera models that produce DNG files as their RAW file format, including Samsung, Ricoh, Leica and Hasselblad, but this represents a gentle testing of the water and is the exception rather than the rule. Many people use their camera's proprietary software for editing, and programs such as Canon's Digital Photo Professional or Nikon's Capture NX don't output in DNG. Set against that are the many people processing their RAW files with Adobe products, and happily outputting DNG files.

The tipping point will no doubt come when the major manufacturers get on board, either adopting DNG as the native RAW form for their cameras or as an alternative RAW format within the camera firmware, or simply bundling their cameras with DNG conversion software as part of their proprietary package. For the time being, making an active choice to switch to DNG and delete original RAW files seems like a decision too far for many people, when it isn't what their camera manufacturers recommend.

THE SHOOTING GALLERY: JPEG VS RAW

JPEG

✚ Files are smaller, but lower quality

✚ Immediately suitable for printing or posting on the web

✚ Small files are easier to share by email or online

✚ No need to spend time processing files

RAW

✚ Highest quality images

✚ Large files make it easier to create large prints or publish your images

✚ The camera records and stores everything it sees, giving you more control over the final image

>> QUICK TIP

If you're undecided about switching to RAW, try shooting a few images in both RAW and JPEG. Process the RAW images then compare the two. It helps to choose images with extremes of light and shade, so you can compare the degree to which the RAW file allows you to recover detail in those areas.

Optical and digital zoom

Your camera's zoom range indicates how much flexibility you will have in magnifying a scene. Compact and bridge camera specs usually mention two types of zoom, optical and digital, sometimes combining them to suggest a more extreme range. **Optical zoom** is the one you really want to pay attention to, as it expresses the camera's facility to change physical focal length to magnify or minimize a scene, and thus fit more or less of it into the frame. **Digital zoom**, on the other hand, sometimes marketed as "intelligent" or "smart" zoom, is the facility to blow up a portion of the image, discarding the extraneous pixels. And in the same way as when you zoom right into an image on your computer, excessive digital zoom results in a blocky, pixelated image, with irreversible loss of quality. So while it can extend your zoom range, it's no use if you want to print your images larger than around 5"x3" or 6"x4". If you're buying a camera, don't be swayed by figures for digital zoom in the manufacturer's marketing. You might even want to pick a camera that allows you to disable it altogether, or which alerts you to the fact that you are about to move into digital zoom.

With higher ISOs, images have more grain and colour noise, though different camera makes and models produce varied results at different ISOs. **1/40, f/1.4, ISO 400, 50mm**

ISO sensitivity and noise

ISO is a setting that has been carried over from film photography. You may remember buying rolls of film marked 100, 200 or 400 on the ISO (International Organization for Standardization) scale, used to indicate how sensitive a film is to light. The higher the number, the more sensitive the film, and the better suited to taking pictures in **low-light situations**. For bright, daylit conditions you could pick a film with a lower rating.

With a digital camera, it's not the film negative but the sensitivity of the digital sensor that's measured by the ISO setting. In auto mode, the camera will select the most appropriate ISO for the lighting conditions, in conjunction with

aperture and shutter speed (see Chapter 3); 100 or 200 are good standard levels, if there is plenty of available light. Many cameras will allow you to increase the ISO to 3200 or higher (some high-spec models go as far as 12800), but there is a trade-off.

Just as using high ISO film would produce grainy images, so increasing the ISO produces **digital noise**, which can reduce the quality of the final picture. This is because in making the sensor more sensitive to light you also make it more sensitive to background electrical noise. Noise is particularly visible in areas of a single colour, which may look mottled or speckled. The amount of noise created will depend on the size and quality of the sensor, and different cameras are often reviewed on how well they work at higher ISO speeds.

The grain often found in film images can add to the overall feel, and some image-editing programs have the option to "add noise", which helps give a digital image the look of film. But digital noise itself tends to be visually unappealing. Noise reduction software allows you to clean up an image to a degree, but it's preferable to keep the noise to a minimum in capture if possible, which means working at the lowest possible ISO speed the lighting conditions allow.

Sensor size

The size and quality of your camera's sensor are significant factors in image quality. Bigger is best in this case, because a **larger sensor** usually features larger pixels, each of which has a larger surface for light gathering and thus receives a stronger light signal. This tends to mean a reduction in digital noise, and results in sharper, smoother pictures with a wider dynamic range (better detail captured in the shadows and highlights).

In size terms, a standard 35mm sensor is 36mm x 24mm, and is known as "full frame". Most consumer-level DSLRs have sensors rather smaller than this, at around 23mm x 15mm, and bridge cameras tend to come in just below this. There is then a big jump to compact camera sensor sizes, usually nearer to 7mm x 5mm, and camera phone sensors are further reduced in size, rather smaller than a fingernail. The diagram overleaf shows just how much difference this makes in terms of the relative surface area available to capture data in some of the popular models of each type.

Aspect ratio

The aspect ratio of an image is the relationship between its width and its height. The most common ratios in digital photography are 4:3 (most compact cameras) and 3:2 (many SLRs). Some cameras offer the choice as a menu option. These translate into standard print sizes in the same ratios, for example an 8"x6" print is in ratio 4:3, and a 6"x4" print in the ratio 3:2. If you're planning to make prints of your images it's worth thinking about the standard print size you prefer, as unless the ratio is the same you'll end up cropping away significant chunks of your photos.

CMOS and CCD

You may come across the terms CMOS and CCD used to describe the sensor. CMOS (complementary metal oxide semiconductor) and CCD (charge coupled device) sensor chips differ in the way they convert light into electronic signals, CMOS allowing every pixel on the sensor to be read individually, CCD transporting the charge across the chip and reading it through sometimes just a single output node. Neither is absolutely superior to the other, despite manufacturer claims, and both can offer excellent image quality.

The relative proportions of different types of sensor vary greatly from camera phone to bridge or SLR

Standard: 35mm, "full frame": 36mm x 24mm

SLR: Nikon D3000: 23.6mm x 15.8mm

Bridge: Sigma DP1: 20.7mm x 13.8mm

Compact: Sony CyberShot DSC-W350: 6.16mm x 4.62mm

Camera phone: Average camera phone: 2.40mm x 1.80mm

Cameras with larger sensors tend to be more expensive, heavier and bulkier, so there's a clear trade-off at the compact and camera phone end of the scale between sensor size and image quality, and device size and portability.

LCD screen

A digital camera's LCD screen is used for **reviewing images**, navigating the control **menus**, and in-camera editing – and on compacts can be used instead of the view-finder for **composing images**. This last feature is also now available in an increasing number of DSLR models, where it's known as "Live View". Helpfully, the LCD displays the same view as the lens; the viewfinders of most compacts and SLRs don't show the whole field of view captured in the final image. Only top-of-the-range pro models, with price tags to match, have 100% viewfinders.

>> QUICK TIP

To preserve battery power you might want to turn the LCD off while out and about, or at least turn down its brightness, as it uses a lot of juice.

The LCD can be an invaluable tool, letting you zoom into small areas of the image to ensure crisp focus – particularly useful in macro photography – whereas the viewfinder doesn't show what is and isn't in focus. The screen is also handy when scrolling through your images, deciding what to keep and delete, though you can't always be certain about sharpness, so if in doubt wait until you can review an image on the computer. Larger screens obviously make the image review and in-camera editing process easier, so it's worth factoring that in if you're choosing a camera. It can be hard to see the LCD in bright sunlight, though, so you might want to choose a model where you can tilt the screen or adjust its brightness.

EXIF metadata

One useful feature, common to almost all digital cameras, is EXIF (exchangeable image file) data. This is the information the camera records about each image as it is captured and then stores with the image file, which ranges from basics such as date and time to shutter speed, aperture, focal length, whether the flash fired, and so on. The data is usually visible on the LCD screen and in most photo-editing software, and it's not only a good record of the settings you used for a particular image, but also a great learning tool, and one of the real advantages digital has over film.

Face detection

Many cameras now sport technology that claims to identify faces in an image and ensure they are in focus and correctly exposed. This can be useful in fast-moving situations where you are trying to capture people, though it's no substitute for properly composing your image and setting the exposure that works best for the scene you're trying to capture. Face detection can be slow to focus, and may struggle when there are a lot of faces in the frame, though you can tell it manually which face to focus on by using the LCD. An interesting extra, perhaps, and worth experimenting with. You can always turn it off if you don't like it.

>> QUICK TIP

Flickr and other photo-sharing sites often import and display EXIF data, where users have made it available. You can then see which settings were used for pictures you like – a great way to think through what went into their capture.

REC

Moving images

Many SLRs also now include video capabilities, and this is a common feature in most compacts and camera phones. This movie mode capability is an add-on, and as such often doesn't match the quality of the photographic functions. However, it can be fun to experiment with, and if video is something that interests you, your camera can be a good place to start. The best models are those which shoot at least 30 frames per second (fps), and it's worth knowing that the audio capabilities of stills cameras tend to lag some way behind camcorders, and that they sometimes struggle in anything less than bright lighting conditions. Shooting video will also rapidly eat up space on your memory card. You may also want to investigate the video-editing software possibilities, if you want to do anything to your videos after recording them.

There isn't space in this book to do videos justice, but if you want to find out more, check out some of the articles and video tutorials on the following sites.

eHow www.ehow.com/ how_4895117_make-movie-digital-camera.html

www.ehow.com/how_5828437_ shoot-movie-digital-camera. html

www.ehow.com/way_5161585_ quality-making-using-digital-camera.html

reelSEO www.reelseo.com/hd-video-dslr-camera

Digital Photography Review www.dpreview.com/learn/?/ Guides/hd_beginners_ guide_01.htm

A Nikon D7000 in video mode.

2 THE REST OF THE KIT

Lenses, tripods, printers and bags – what's essential and what's not

The more you get into photography, the more you'll become aware of just how much kit is out there, tempting you to part with your money. Some of it is must-have stuff – memory cards, a back-up system, spare battery power, perhaps additional lenses, a solid tripod – but really it all depends on what you're planning to photograph and how much you want to spend. It's worth remembering that good photography isn't all about high-end SLRs with fancy lenses, though. If you have a good eye, and a rough idea of what you're doing, you can capture beautiful and evocative images with the most basic kit – as many people are doing with the cameras built into their phones. This chapter evaluates some of the options and debunks a few myths along the way.

>> QUICK TIP

Most kit lenses (the lenses packaged with a new DSLR camera body) are wide-angle zooms, often with a rather limited range of around 18–55mm. They tend to be of fairly low optical quality, too, so if you know you'll quickly upgrade to something better, look out for a "body only" SLR deal, which will be cheaper than buying it with the kit lens.

Lenses

When it comes to image quality, the lens is perhaps the most important part of the package. The better the optical quality of the lens, the clearer and more crisp your image will be. One of the main benefits of an SLR is having the flexibility to **change lenses**, and being able to use specialist lenses that are perfectly tailored to a particular task. Conversely, if you ignore the quality of the lens you may as well forget about the quality of the camera too. If the choice is between an entry-level SLR with a high-quality lens and a higher-spec SLR with a kit lens, go for

Compact adaptor lenses

Lens flexibility isn't strictly limited to SLRs: you can buy adaptor lenses for some compacts, which fix over the existing lens and allow you to expand the focal range at the wide-angle or telephoto end of the scale. You're simply building on what's already there, though, and since the lenses in compacts tend to be lower quality to start with, any extension of its range will come at the further expense of quality.

the former. A low-quality lens can at worst give you an inaccurate autofocus, blurry images, poor perspective and distorted colours.

Lenses are likely to be the most expensive thing you'll buy, with the most commonly used running from around £60/$90 right up to pro versions – with better quality glass and mechanisms and a sturdier build – costing thousands apiece. Even if you start out with a single lens with a wide zoom range such as 18–200mm, in the hope that it will cover all eventualities, as your photography develops you're likely to want to use a variety of different lenses. If you choose carefully, though, your lenses can outlive your camera: a manufacturer's lenses will usually work on most of the cameras in its range (though you can't swap lenses between, say, a Canon and a Nikon, as the camera bodies have different lens mounts), so any investment won't necessarily be wasted if you later upgrade the camera itself. Look for a lens with **image stabilization**, as this will help compensate for any camera shake and help you produce crisper images (see p.26).

Which lens when?

Focal length	Category	Used for
24mm or less	Ultra wide angle	Architecture, interiors, confined spaces
28–35mm	Wide angle	Landscape, images needing wide field of view
35–70mm	Standard	Street, documentary, walkabout; replicates field of view of human eye
70–135mm	Telephoto	Portraits; good perspective effect on faces
135mm+	Super telephoto	Sports, wildlife

Aperture and focal length

The aperture of a lens is the size of its opening, which determines how much light can enter the camera. This is covered in much more detail in Chapter 3, but when buying lenses what you need to know is that a lens with a large maximum aperture is generally considered to be better than a lens with a smaller maximum aperture, because by allowing more light to enter the camera it gives the photographer more flexibility with the exposure and composition of an image. But hand in hand with that, a larger aperture also means more glass, and such lenses are also therefore more expensive.

Whatever your camera or lens, if you zoom in and out you will become aware that both the magnification of the scene and the angle of view, or the width of the scene visible through the lens, change. As you zoom into a scene, what you see becomes larger but you see less of it, and as you zoom back out you see more of the scene. At its most zoomed out, you are at the widest angle end of the range, and when zoomed in you are at the telephoto end.

This range is the focal length of the lens. In technical terms, the focal length, expressed in millimetres, is the distance between the centre of the lens and the place where the light rays converge to a single point. It is a measure of how strongly the lens focuses light, determining both the magnification of the image and the field or angle of view, as the illustration here shows: a lens with a short focal length will have a very wide angle of view compared with a telephoto lens with a longer focal length.

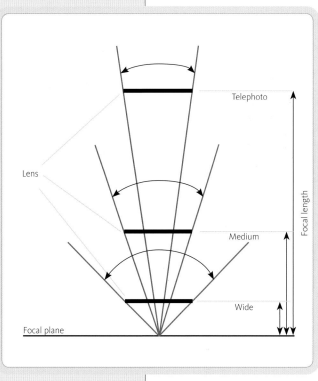

Lenses basically fall into two camps, fixed or "prime" lenses and zooms. **Fixed** lenses give you a single focal length, for example 50mm, while **zoom** lenses offer the ability to move over a range of different focal lengths, to suit the requirements of the scene and the framing of the image: a zoom might range from 35mm to 105mm, for example. Fixed lenses are usually sharper than zooms, but zooms offer greater versatility: as usual, there's a trade-off between convenience and quality, but how much of one will depend on the lenses in question, and you may decide that the freedom of carrying a single lens and not having to change it outweighs any other factors. Otherwise, the two key characteristics of a lens are **focal length** and **maximum aperture**, also known as lens "speed" – see the box on p.19.

Buying lenses

Once you've decided which lens you need, in terms of focal length, maximum aperture, fixed or zoom, you'll still be faced with a vast amount of choice. The most straightforward option is to stick with the **brand-name lenses** made by your camera manufacturer – they often make the best lenses in terms of image quality, and tend to offer more than one range, differentiating higher-quality (and more expensive) "pro" lenses from cheaper "consumer" versions. High-quality lenses are also made by dedicated lens manufacturers, such as Sigma and Tamron, for various brands of camera. Before investing, read plenty of lens reviews and user feedback online: there are often oddities peculiar to a particular lens or model. Several sites will let you compare the features of different manufacturers' versions of the same lens side-by-side, and those listed in the Resources section (see p.219) all have extensive lens reviews sections.

Look, too, at the secondhand dealers and equipment rental companies mentioned on pp.220–221, as it's possible to find some good deals on used lenses (with the usual caveats about buying secondhand). Alternatively if you're considering investing in a particular lens, renting it can be a good way of getting a feel for whether or not it's right for you.

Special-purpose lenses

- **Macro lenses** Designed to provide high-quality images when working up close, macro lenses provide beautifully detailed shots of the tiniest of objects. The definition of a macro used to be that the image as projected onto the camera sensor would be magnified up to the same size as the subject, i.e. in a ratio of 1:1, but the minimum focusing distance is now considered more important, describing as it does how close you can get to your subject and still focus. Macro lenses come in a wide range of focal lengths, and which you need will depend on your subject: if you're photographing insects, for example, you may want a macro with a longer focal length, to keep a little more distance between you and the insect than you would need when photographing a flower, say.

For more on shooting macro
▶▶ see p.116

Looking up using a 15mm fisheye lens.
1/50, f/5.0, ISO 400, 15mm

- **Tilt-shift or perspective correction lenses** Often used by professional architectural photographers, these lenses compensate for the perspective distortion and converging parallels that result from tilting the camera upwards to take a photograph of a building. They are usually very expensive, and as you can correct perspective distortion in most editing programs – or may anyway find the effects pleasing – they are really a specialist-interest lens.

- **Fisheye lenses** These lenses have an extreme wide-angle (e.g. 4.5mm to 15mm) and produce very striking images, exaggerating the central subject. They can be useful when trying to capture a very wide field of view, and can give some interesting effects when shooting architectural images, or humorous effects when shooting a portrait. But unless you're after this particular look – which, in any case, you can often play around with in the edit – you're likely to find a straightforward wide-angle lens more useful.

Memory cards

While not the most glamorous of accessories, the reusable flash memory cards that record all your images and associated data are one thing you can't avoid spending money on. The main types are **CompactFlash** (CF) and **SecureDigital** (SD), but the camera you buy will determine which you can use. Their storage capacity is measured in megabytes or gigabytes, and the number of photos a card will hold depends not only on your camera's megapixels, but also the image quality and resolution at which you're shooting: you might be able to save as many as 2000 images to a 2GB card if you're using a 2MP camera, but just 400 or so on a 10MP model. For more on file types and sizes, see p.10.

Cards have come down massively in price over the last few years, giving all the more reason to be wary of buying ultracheap versions on online auction sites – there's every chance they're fakes. In general, buying one card with lots of memory can be cheaper than buying several smaller-capacity cards, and means you won't have to change cards when out and about, but if it becomes corrupted (or if you mislay it) you risk losing all those photos in one go. It's safer to work with a handful of smaller cards, though some of the largest cards, at 64GB and higher, come in handy if you're shooting video.

Photos can be transferred from cards to your computer direct from the camera, by using a card reader or camera-connection kit, or via card slots in the computer or laptop itself. Lots of printers will also let you insert your memory card and print the images you select direct; you may even be able to plug the card straight into your television to review images before transferring or printing them.

Looking after memory cards

Memory cards are pretty hardy, though a bit of common sense will help prolong their life: keep them as cool, dry and dust-free as possible, and away from anything that might have an electromagnetic field, to avoid inadvertently wiping or corrupting data.

Data can also be **corrupted** if the battery dies midway through taking a picture, or if you remove the card while data is still being written to it, so do keep an eye on your battery levels and wait until the camera has finished writing data and turned off before removing the card. Cards do eventually stop working, but will usually last several years before giving up the ghost. They perform better if you **reformat** them periodically, after uploading your photos. This will wipe everything on the card, clearing out digital debris and fragmented files, and is usually best done within the camera itself rather than on your computer.

In the event of some kind of card corruption, all may not be lost: there are a number of file recovery programs out there to help you try and restore your data, and many memory cards come with a data recovery package on disk. Likewise, if you've deleted an image in-camera by mistake, there's a chance of getting it back, as long as you don't go on and take more photos with the same card, as they may overwrite it and make it unrecoverable. Don't reformat the card either, as this will wipe any remaining data.

>> QUICK TIP

If your camera or computer are simply not recognizing a memory card, try a dedicated card reader – sometimes these can register a card and its contents when your computer won't, which gives you a chance of retrieving any images.

Wi-Fi transfer cards

It was perhaps inevitable that card, as well as camera, manufacturers would start to build on Wi-Fi and Bluetooth technologies in an attempt to hang onto some of the market share being eroded by camera phones. First to market and still fairly expensive, ranging from £50/$50 for a standard 4GB card to £120/$150 for an 8GB Pro version, are Wi-Fi memory cards launched by Eye-Fi (www.eye.fi), which let you upload over a specified wireless network to your computer, and to select images or videos for sharing online and send them straight to sites including Facebook, Flickr and YouTube. Some of the higher-spec cards also allow you to take advantage of open networks and free Wi-Fi hotspots for a year, though you have to pay for this service after twelve months. They come in Secure Digital (SD) format, and the standard cards let you transfer JPEGs, while the pricier Pro versions will also let you transfer RAW images. Most of the cards also support geotagging of JPEG images – for more on this, see p.142.

Batteries and chargers

Digital cameras come with a rechargeable battery, which will usually last a long time before it needs replacing. It's a good idea to invest in one or two extras, charge them and keep them with you as spares when out and about: there's nothing more infuriating than missing a great shot because you've run out of power. Reviewing and deleting images in-camera, using the flash, brightening the LCD, using live view and so on all consume a lot of power and can quickly run your battery down. Batteries also run low swiftly in very low temperatures, when it's a good idea to keep the camera protected in a bag – or, better still, inside your coat, with spare batteries inside your pocket to keep them warm.

>> QUICK TIP

Be wary about buying cheap batteries online: they may be duds, or simply drop their charge fast.

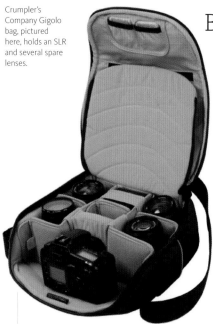

Crumpler's Company Gigolo bag, pictured here, holds an SLR and several spare lenses.

Bags and cases

There's a camera bag out there to suit most purposes, from the most arduous hike to gadding about town, or simply wanting to look like you aren't carrying a camera at all. And they come with a similarly varied range of price tags, from just a few pounds or dollars for a small compact pouch to several hundred for an adjustable bag that will safely store any combination of camera bodies and lenses. You want to find one that will hold all your regular kit and is easy to get into quickly. Wide and/or padded straps are most comfortable when you're out and about, and specially designed bags often have padded section dividers to keep your kit in place. Some have a built-in rainsleeve that you can pull over the whole thing in damp conditions.

 If you're visiting a store, it can be a good idea to try the bag out with all the gear you'll be carrying, to make sure it will fit and is comfortable to carry, but if time doesn't permit or you're shopping online you could simply check out the type of bags that other people with your camera and kit have recommended – see the websites listed on pp.219–220.

- **Holster or pouch** Usually designed for a compact or single camera and lens, these sometimes come with belt loops. Quick to get to, they are also fairly secure.

- **Day packs or rucksacks** Good if you're doing a lot of walking or need your hands for climbing but not great for speedy access, as you have to take the bag off to get at your camera. This is probably the best option if you're carrying a lot of heavy kit, and doesn't necessarily advertise the fact that you're carrying a camera, unless you go for one of the well-known camera bag brands. A related option is a **sling bag**, something of a cross between the rucksack and a shoulder bag, which is carried on one shoulder and rotates round the body for quicker access to your gear.

- **Shoulder bags** Good for getting to your gear swiftly, particularly the top-loading variety, but offer less protection for your camera. On the plus side, like the rucksack, a shoulder bag doesn't necessarily scream "camera bag", which can be useful when you're travelling.

- **Hard cases** The most secure of all, these are more of an effort to carry around and to get into quickly. Perhaps the most secure option because they tend to get left at home.

Perennially popular brands of bags and cases include:
Lowepro www.lowepro.com
Kata www.kata-bags.com
Tamrac www.tamrac.com
Crumpler www.crumpler.com

Lowepro's Inverse "beltpack" carries an SLR plus spare lens and has a handy waterproof cover concealed inside.

Tripods

You can get by shooting hand-held much of the time, but if you're interested in taking long exposures for any reason – night shots, landscapes with moving water, and so on – or if you're using a telephoto lens with its increased risk of movement, a tripod will help eliminate camera shake and ensure your photos are pin-sharp. You'll also need a tripod if you plan on bracketing exposures or experimenting with high dynamic range (HDR) images (see p.55), or to take a series of panned images to stitch together into a panorama.

» QUICK TIP

If you have a lot of equipment, invest in a smaller bag as well as one that holds everything, so you're not tempted to take the whole lot out with you when you don't need to.

>> QUICK TIP

If you want to develop a sense for when you can personally shoot hand-held, and when you might need to use a tripod to avoid blurry images, try slowing the shutter speed down a few times and looking at the resulting images blown up on your computer. Lenses with image stabilization will allow you to shoot at slower shutter speeds than you would otherwise be able to manage, but everyone has a different cut-off point after which their images start to look blurred. For more information on shutter speed, see p.45.

Choosing a tripod

Established photographers tend to regard cheap tripods as a false economy; in many cases they've learnt the hard way, buying and discarding a succession of basic models over the years. Using a tripod is all about stability, and the cheaper the tripod the flimsier it will be. If the weight of your camera plus lens makes it unstable, or it sways in every gust of wind, it isn't going to deliver the results you need. As long as you're going to actually use it, this is one area where buying the best you can afford will pay off over time. That said, if you're only going to use a tripod occasionally and aren't too fussed about image quality, you can find one for as little as £20/$20. At the other end of the scale, you can easily pay several hundreds of pounds or dollars for a high-spec carbon fibre model.

If you have access to a good camera store, this is another time when it makes sense to get hands-on if you can, taking your camera and lens along and asking to try it out on a range of models. You'll soon get a feel for the sort of set-up you prefer, and if you decide the full tripod isn't for you, there are several alternatives:

- **Monopod** A single pole providing a degree of support, useful when working in limited space or when you need to set up and move around quickly – often used by professional sports photographers for just those reasons. Not so good for long exposure work, when you really need the stability of a tripod.

- **Table-top tripods** Smaller and more portable than a full tripod, these come in handy for low-level shots or can be set up on any sturdy flat surface.

- **Joby Gorillapod** These bendy miniature tripods for both compacts and SLRs can be twisted around posts or bars to create interesting, stable viewpoints.

> Popular tripod manufacturers include:
>
> **Manfrotto** www.manfrotto.com
> **Gitzo** www.gitzo.com
> **Giottos** www.giottos.com
> **Joby** www.joby.com/gorillapod

TRIPOD CHECKLIST

⊕ Sturdiness vs portability Stability is important, but it doesn't matter how good your tripod is if it's too heavy to carry.

⊕ Tripod head Pan-and-tilt heads allow you to rotate the camera and tilt it up for vertical shots; ball heads, which are more versatile (and more expensive), allow quick adjustment to very precise positions.

⊕ Quick-release plate Attaches to the bottom of your camera and clips into the tripod head, allowing you to attach and remove the camera quickly.

⊕ Height If possible, choose a tripod that is tall enough for you, with legs extended, to avoid having to raise the centre column, as this reduces stability.

⊕ Leg sections More sections can make a tripod slower to set up and reduce stability; on the other hand, it can be folded to a smaller size.

Cleaning equipment

Inevitably, when you're out and about, your camera will be exposed to dust, dirt, water spray and countless other technology-unfriendly elements. You can protect against these to some degree, by using waterproof covers and avoiding changing lenses or opening the case in particularly dusty situations, but at some point you're inevitably going to risk getting dirt inside your valuable camera.

Though risks are minimal, when it's not in use for a while keep your camera somewhere cool and dry, with a couple of packets of silica gel to prevent condensation, and remove the batteries to avoid the risk of corrosion. The manual will probably tell you to ensure you turn the camera off before changing a lens, removing the battery or memory cards, and connecting or removing cables, in part because there may be a risk of dust being attracted to the sensor during a lens change or of functions being interrupted and creating a problem. Of course, it's a good idea to do all this if you remember, but you're unlikely to cause lasting damage if you forget.

- **Air blower** Useful for removing loose dust, these usually have a nozzle plus rubber bulb which you squeeze to puff air into the camera and blow particles away. It's important not to touch the sensor itself with the blower, as scratching it will cause permanent damage, though your sensor will always be protected by either a filter or an optical glass cover. Store your air blower somewhere clean, ideally in its case if it comes with one, as if you let it get dirty you may well make the situation worse by blowing dust into your camera. You can also get cans of compressed CO_2 gas, which sometimes come with a sensor cleaning kit, but they can leave a residue which will make matters worse, and can also blow dust further into the camera body.

Cleaning the sensor of your DSLR

However careful you are when changing lenses, you may eventually notice small particles of dirt or dust showing up as specks on your images in bright areas such as the sky, and realize the sensor needs cleaning. There's no rule of thumb about how often this must be done – it depends what your camera has been exposed to and how well you've been able to protect it during use. Some models have in-built sensor cleaning systems, which vibrate to shake dust off at start-up and again on turning the camera off, combined with anti-static technologies to avoid attracting particles to the sensor, but these won't necessarily keep all dust at bay.

You can send the camera away to have the sensor cleaned, a service offered by most of the major manufacturers as well as some camera stores, though this can be expensive. If you're within the warranty period, it's important to be aware that cleaning the sensor yourself can invalidate the warranty: most manufacturers have disclaimers all over their websites warning that you work on your own camera at your own risk.

If you still feel confident about giving it a go yourself – and this is not something we recommend – at least check out the pair of videos at the link below which show you how to do it. Make sure you're working somewhere that is both dust-free and relatively bright so that you can see what you're doing, and work with the camera pointing down, to minimize the risk of more dust entering the body once you've removed the lens.

www.mahalo.com/how-to-clean-your-digital-slr-camera

- **Lens cleaning fluid** Comes in a bottle or in pre-impregnated pens or cloths, and is useful for cutting through grease and getting rid of persistent marks that the lens cloth alone won't shift, on either the lens or the LCD screen. The pens can be particularly useful for getting into corners, or you can use cotton swabs to the same end.

- **Lens cloth** Invaluable for cleaning dirt and smears carefully from the end of the lens or the LCD, rather than polishing them with your clothing, which might scratch the glass.

- **Sensor brush** A brush with very soft, fine bristles that's passed gently across the sensor to remove dust and then cleaned with compressed air after every pass. Again, store this in its case to keep it clean between uses.

- **Sensor cleaning fluid and swabs** For more persistent dirt which won't be moved by either an air blower or a brush, moisten swabs with the fluid and pass gently across the sensor from one edge to the other, only lifting the swab when you get to the far side. If you use too much fluid and leave a residue, you'll need to pass gently across it again with another swab.

Camera sensor from a Nikon D7000.

Filters

Filters are invaluable for making the light you're capturing appear exactly as it does to the human eye – or for making it look significantly different. They attach to the front of the lens and come in either circular or square varieties. **Circular** filters screw onto the filter thread of your lens and are less bulky to carry around, but you will need different sizes for different sized lenses, while **square** filters slide into a filter holder fixed to your lens with an **adaptor ring** – you need just one filter and filter holder, and only have to buy additional adaptor rings to use it on lenses with differently sized threads (these are cheaper than the filters themselves).

Many of the effects filters create can now be replicated in the photo-editing suite – see Chapter 6 – but there are some images that could simply not be captured without a filter, and these are covered below, along with some of the most commonly used filters.

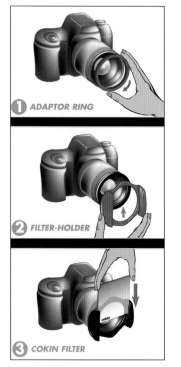

Cokin's square filters slide into a filter holder attached to an adaptor ring that screws onto your lens – easier than it sounds, as this Cokin P Series brochure illustrates.

Choosing filters

The best-known filter systems come from manufacturers Cokin and Lee, with many of Cokin's filters in the £10–25 ($13–25) range, and Lee's from £10 to £60 ($15–75) apiece. You'll often see Lee filters recommended by professional photographers, as they are generally regarded as being of better optical quality. B+W also makes a range of high-quality circular filters, ranging from around £15 to £60 ($18–75), while Tiffen and Hoya both make extensive and reasonably priced ranges of UV and polarizing filters. Cokin also make a series of magnetic filters compatible with most compacts, and some bridge cameras have a filter thread or can be used with an adaptor – it depends on the model in question.

- **UV and skylight filters** UV filters are designed to limit UV light entering the lens and creating a slight haze or blue cast in images, though most modern lenses already have a UV coating themselves. So-called skylight filters have a very faint magenta cast and are also designed to correct a slight blue cast coming from the sky or being reflected from shadows. Because both look clear and neutral to the human eye, and

don't have a noticeable effect on the image, many photographers leave a circular filter screwed onto each of their lenses all the time, as they are a lot cheaper to replace if they get scratched than the lens itself. At around £10/$10 and upwards apiece, it's well worth investing in one for every lens in your collection.

- **Polarizing filter** Polarizers are used to minimize reflected glare from water or glass, and can also boost the contrast in a bland-looking sky and make the image seem more saturated. These circular filters are screwed onto your lens, and then rotated to increase or reduce their effect, something that can't easily be replicated in the editing suite. They are a very handy tool to have in the field, though they can easily result in oversaturated and false-looking skies if you're not careful.

- **Neutral density filter** ND filters reduce the light entering the lens, without affecting its colour, and are often used so that you can slow the shutter speed right down even in bright conditions, to enable the creative use of movement in an image, or to allow the use of a wider aperture for selective focus (see p.59 for more on this). They come in a range of strengths, depending on the degree to which you want the light to be reduced, and you'll often see them used in landscape photography to create a soft, blurred feel to flowing water or the movement of clouds, though they can be used for any kind of movement.

- **Graduated filters** Grad filters allow you to adjust exposure at different levels across the frame to compensate for dif-

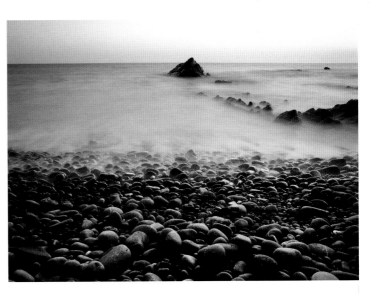

Image taken with an ND filter to reduce the light entering the lens and allow the use of a slower shutter speed, which gives the water this smooth effect. **15 sec, f/22.0, ISO 100, 24mm**

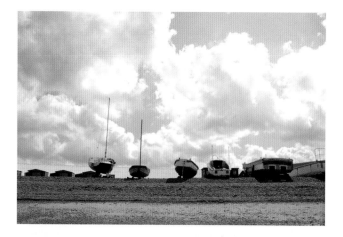

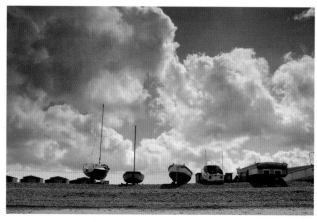

Both images: **1/320, f/11, ISO 200, 20mm**
The bottom image was shot using a 4-stop ND graduated filter to retain some detail in the brighter sky while exposing for the darker foreground.

ferent light levels, such as an imbalance between bright sky and dark foreground. They allow you to capture the most dramatic light, and to enhance the dynamic range of a scene. So-called hard grads have a sudden transition from colour to clear, whereas soft grads have a more subtle, graduated shift. Both can be moved up and down in the filter holder to ensure the transitions match the needs of the scene. Their effect can be replicated to a degree in the digital darkroom, but there are some images you simply wouldn't be able to capture without grad filters (except by taking and merging multiple exposures), because the contrast between the lighting in the foreground and the sky are too stark.

- **Effects filters** Countless filters are available that allow you to create particular effects, such as warming and cooling filters used to change the light in a scene; infrared filters to give your images an Ansel Adams look; filters specifically designed to enhance sunrise or sunset, to add a touch of mist to a scene or turn the points of light in an image into stars; or red filters to enhance the colours lost in underwater photography, and so on.

Lighting gear

In a perfect world, you'd always have the natural light you need, but once you've struggled to take pictures indoors or to shoot a portrait on an overcast day, you'll soon discover that the flash on your camera, whether compact or SLR, is pretty limited in its strength and reach. Fortunately, there are a range of accessories that can step up to fill the gap, outlined below.

Flash units

Flash units have more power and versatility than on-camera flashes. Generally attached to the top of an SLR or bridge camera via the hot shoe mount (a bracket on the top of the camera), they have swivelling heads to enable you to bounce light off nearby reflective surfaces rather than firing the flash directly at your subject. You can also take them off the camera altogether and trigger them either with a connecting flash cord or wirelessly, or use a flashgun with "master" capabilities on your camera to trigger a "slave" unit somewhere else, if you need more light than can be provided by one unit alone. One or two models can also be used with compact cameras, as slaves triggered by the compact's in-camera flash. A flashgun may be anything from £40 to £400 ($50–500), depending on whether you go for a big brand or not, and for one with master and slave functionality or one that will simply work on its own on the hot shoe.

Ring flashes are circular units that fit around the end of the lens and project an even, flat light. These are often used in macro or close-up photography, when you want to eliminate shadows and show as much detail as possible. Prices start at around £120/$150, and rise steeply.

For practical information on flash units and working with lighting in general ▶▶ see p.62

Flash! Aaaa-aaaah, saviour of the universe.

Reflectors and diffusers

These come in handy when you've got enough natural light, or have set up a flashgun, but need to change the quality or direction of the light. Both usually come in the form of square or circular sheets of fabric on a frame, which you position close to your subject (or get your subject to hold it, if you're shooting a portrait). Prices start at £10–50 ($10–75), but you can pay a lot more depending on the size and the brand. You can also often find all-in-one reflectors/diffusers, with different sheets that zip on or off to create the desired effect.

Reflectors work by bouncing reflected light into areas of shadow falling on your subject. You position them on the side of your subject that's in shadow, angled in such a way as to catch the light and reflect it into the shaded area. They usually come in white, silver and gold, and the reflected light will pick up on any colour, adding a cool or warm tone. If you don't want to shell out on something you might not use often, reflectors are easy to improvise using sheets of paper, card or tinfoil.

Diffusers are held between your subject and the prevailing light source, reducing the intensity of the light falling on them, so are particularly useful in high contrast conditions. The same principle works with any light source, natural or not, and there are diffusers available in all shapes and sizes to fit over a flash or studio light. You can make your own diffuser too, out of a sheet of gauze or muslin, though you'll need to attach it to some kind of frame or stand unless you have people on hand to hold it up between your subject and the light source. If this is something you think you'll use a lot, you might be better off buying one.

Different coloured reflectors are here used to bounce warm and cool light onto the two sides of the subject.

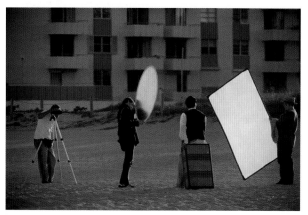

Light meters

If you're using any kind of lighting equipment, or even if you're just working in difficult lighting conditions, a light meter can help take the guesswork out of getting the exposure exactly right, by measuring the light burst of the flash or the available light in the scene, and calcu-

lating the required aperture, shutter speed and ISO (for more on how both exposure and metering work, see Chapter 3). However, it's true that a light meter is by no means the essential piece of kit it was when working with film, when getting the exposure wrong could result in your pictures simply not coming out. With digital, you already have a powerful meter in the camera which measures all the light reflected from the scene, and can manually adjust your settings between shots until you have the exposure you're after. What a light meter can do is reduce the time you'll spend playing around with settings.

Basic models start at around £120/$200, though you can pay hundreds more for a high-end meter with colour temperature gauge and other features. But if you're starting out, and want to try using a meter, the main thing to look for is one that is easy to use, with straightforward controls, and which seems relatively well-built and durable.

Other accessories

Some of the following bits of kit are fun to play around with; others you might find essential for a particular kind of trip or shoot.

- **Lens cap straps** Lens caps with straps attached that you can connect to the strap holder of your camera and avoid ever losing a lens cap again.

- **Lens hoods** Provided with many lenses, lens hoods can also be bought separately from around £10/$10, and are designed to stop light hitting the front element of the lens from the sides, which creates flare and reduces contrast in your images. This means that they can aid with colour and saturation in your pictures as well as protecting the front of the lens. You can also buy folding rubber lens hoods, which take up less space in your bag.

- **Rainsleeves and waterproof covers** Invaluable for keeping your camera clean and dry when out and about. The budget version is to use a plastic bag with a hole cut in the end for the lens, secured with an elastic band.

» QUICK TIP

At a pinch, it's possible to make a DIY lens hood from a piece of black cardboard: check out **www.lenshoods. co.uk** for a range of patterns to fit different lenses.

- **Padded straps** If you've got a compact you've nothing to worry about, but if you're carting an SLR and large zoom around all day it can become quite uncomfortable, and a padded strap will make the load a little easier to bear. Some of these come with pockets for additional memory cards, which can be useful.

Bottle cap tripods from www.photojojo.com.

- **Remote cable release** Available for all types of camera, the remote release connects via a cable or wirelessly to ensure that when you trigger the shutter button you don't introduce camera shake to your long exposure shots.

- **Sun position compass** A nice bit of kit that will tell you in which direction the sun will rise and set, wherever you are in the world, and allow you to plan your position accordingly; check it out at www.suncompass.info. The Golden Hour Calculator website at www.golden-hour.com works in a complementary way, giving you the exact timing of the golden hour, or the first and last hour of sunlight during the day, and is also available as an app for the iPhone and iPad. For Android phones, check out Golden hour, an app available from the Android Market.

- **Bean bags** Useful for cushioning or propping up your camera if there's a surface to rest your camera on. They are often filled with poly beads, to make them portable, but if you're travelling overseas and space in your luggage is at a real premium you can take an empty bag and fill it with rice or beans once you reach your destination.

- **Bottle cap tripods** If you don't want to carry even a table-top tripod, you might like this rubber cap which fits the top of most bottles, and has a standard-issue tripod screw on the other end. Works best if the bottle is at least half-full, for stability, and probably won't support anything bigger than a point-and-shoot. They cost around $10 from www.dynomighty.com or www.photojojo.com and are also available from Amazon for around £7.

- **Underwater photography** Many manufacturers and third-party specialists such as Ikelite make underwater camera casings, allowing you to take your camera with you on diving expeditions down to depths of 30m or more. There are also dedicated underwater cameras, if you're reluctant to trust your pride and joy to a piece of plastic casing. You can even buy diving masks with a digital camera built in, which works down to about 5m. If all this is too expensive, check out Aquapac's series of underwater pouches for any type of camera, which will float if you let go of the strap.

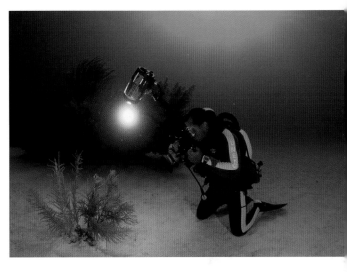

- **Right-angle viewfinders** Available to fit most SLRs – and useful if you don't have a live view LCD screen that can tilt outwards – these attachments fit onto the eye-piece and can be rotated through 360° to allow you to use the viewfinder more easily when using the camera at an awkward angle; when you're holding it low to the ground, say, or if it's mounted on a tripod at a tricky angle. They sometimes also offer magnification of the scene and also cut out light, making it easier to see the image you're composing.

Underwater equipment specialists include:
Ikelite www.ikelite.com
Liquid Image www.liquidimageco.com/products/water/
Aquapac www.aquapac.net

- **LCD hoods** www.hoodmanusa.com The Hoodman HoodLoupe fits over your LCD screen and enables glare-free viewing of images, histograms and so on through an eye-piece. Fits any camera up to a 3" LCD screen. Useful for brightly lit situations, though at around $80 it isn't a cheap solution; you may prefer to keep shading the screen with your hands and squinting.

For more on underwater photography ▶▶ *see p.124*

- **Panorama adaptors** www.lenspen.com/403/381 This device, the LensPen Panamatic, helps you take perfect panoramas, up to 360°. You mount it on your tripod, attach the camera, level it, and then take a series of pictures by clicking around the index wheel, which will join up seamlessly when stitched together into a panorama on your computer.

- **Handheld tripods** www.quikpod.com The extendable Quik Pod allows you to take your own picture with your camera held out in front of you – you'll never have to ask a stranger to take a photo of you again. You can also use it to get a better shot over the heads of the crowd at gigs or parades. There's also a mobile model, pictured here, that works with your iPhone.

Computers, software and storage

You don't have to have a computer to enjoy digital photography – you can print direct from the camera or take your memory card into a shop and get your pictures printed as they are – but you'll miss out on some of the best things about using digital. The software that's available, some of it for free, will help bring out the best in your pictures, so that they reflect what you saw in the first place. And then of course, you can share images quickly and easily with family and friends – and the rest of the world, if you want to – online.

Computers and storage devices

It's wise to back up memory cards when you're on the road, so your data is always held in at least two forms.

Whether you use a PC or Mac, laptop or desktop, there are certain minimum specs you'll need to make the most of your digital photography. For more detailed information, check out the *Rough Guides* to Windows or Macs. Any computer bought in the last year or so is likely to have enough RAM, though if you're working with RAW files and using memory-hungry programs such as Photoshop you might find you start to run out of hard-drive space fairly swiftly. But every bit as important is having a solid back-up system to ensure that you don't lose everything if your hard drive gets corrupted, and an alternative to upgrading is to use a network of external hard drives to store your images.

- **External hard drives** These are essentially the same as your computer's hard drive, but supplied as a peripheral device, connected via USB or FireWire. From multi-drive RAID storage products, such as popular models from Data Robotics Inc (www.drobo.com) which can be tied to a single machine or set up to allow sharing across a network, to one or more individual hard drives updated manually on a regular basis, you can tailor your back-up precisely to your needs. A lot of photographers will back up on at least two systems, and keep one offsite, in case of fire or theft. Having your photos on an external hard drive also makes it easier to transfer them to another computer if you later upgrade.

- **Portable drives** External drives are useful for back-up on the road, and there are many portable versions, some with screens allowing you to check through or play back your images, others just providing storage until you can connect them to your computer and review your images in the normal way.

- **Online** Numerous companies offer secure online or cloud storage, where data is backed up over an internet connection and held on servers that you can then access via the web. This offers a solution to the question of holding one back-up permanently offsite, and you can set the system up to scan a particular set of folders and files for updates on as regular a basis as you like. These work for photos as well as any other type of data. See Chapter 7 for more on the options.

- **CDs and DVDs** Backing up onto discs, though very handy, shouldn't be your only form of back-up, since discs can become corrupted over time and there's some question about their long-term durability. However, the portable CD/DVD burner is a good alternative to the external hard drive when you're on the road, though remember to take discs with you, as they may not be readily available.

LaCie's Rugged portable hard drive.

Software: the basics

While there are plenty of purists who prefer their photos unedited, or "SOOC" (straight out of camera), photo-editing software can be invaluable in terms of saving precious images from the trash or turning a so-so capture into a strong picture. With film, a large part of the creative process happened amongst the chemicals and trays of the darkroom, and with the advent of digital the darkroom has simply shifted onto your computer.

There are numerous set-ups available, ranging from applications that come with your computer to free online services and highly priced software packages aimed at professionals. Chapter 6 covers a number of popular programs in more detail. Most of the major packages are offered on a thirty-day free trial, and it makes sense to download a couple to see which you prefer before you buy – and to make sure you aren't paying for functions you don't need or that you already have on your system.

Printers

Though printed photos are more of an exception than a rule these days, there's still something to be said for **making prints**, whether for framing, filling an album, or just to show friends. There are huge numbers of print shops, both online and on the high street, that can do the job for you; or you can buy a printer and do it yourself. This allows you more control over how your images will look, as you can adjust colour and brightness as you go, and may seem like an appealing option as the price of printers has come down, with the most basic models starting at around £40/$40. However, once you factor in the cost of photo paper and the full range of coloured inks, not to mention the cost of the time you might spend, it can really start to add up. Printers with a higher specification can cost a few hundred pounds or dollars, and if high-quality prints are important to you but you won't be printing often, it might make more economic sense to get your images printed by someone else.

Once you know you want to buy a printer, deciding which will do your images justice involves filtering several different criteria and more choice than you could ever need. Some stores will let you print on a demonstration model before you buy, which is a useful way of assessing quality, but otherwise it's worth reading the most up-to-date product reviews online before you finally choose a model.

Choosing a printer

Most printers used for photography are **inkjet** models, which can produce good quality and lasting photographs, if you pick the right type of papers and archival inks. They are also sufficiently versatile to work as all-round home printers. Look for a "photo-quality" model, specifically designed to support the dynamic range of photographs, or an inkjet as part of an all-in-one or multifunction printer, which will also offer copying and scanning options (see box overleaf).

There are still a few **dye-sublimation** models around, which use thermal dye-transfer technology to fix the printed image, but they're usually just available as dedicated photo-printers, producing postcard-sized pictures. Domestic **laser printers** don't often deliver sufficiently good image quality when it comes to printing photographs, with a few, very pricey exceptions.

When checking out reviews and actual print samples, look for information on the accuracy of **colour reproduction** from original to print, and the **sharpness** and **dynamic range** (the range of brightness from dark to light) of the copy. Is colour faithfully reproduced in areas of shadow and highlight? Does the image lack contrast and look flat? Is there any kind of overall tonal shift; for example, is the copy more yellow than the original? Are colour and light transitions smooth rather than mottled or patchy? Then there's the technical specifications:

- **Resolution** The maximum number of dots per inch (dpi) the printer can produce is regularly used in marketing, much as megapixels are in cameras: the majority of printers now offer 1200 x 4800, which is more than enough for most purposes.

Colour printer cartridges: the more colours your printer needs, the more expensive it will be to run.

For printer reviews, check out the following sites; see also the general kit review sites listed in Chapter 10, many of which cover printers too:

Imaging Resource
www.imaging-resource.com

PrinterComparison.com www.printercomparison.com

BobAtkins.com
www.bobatkins.com/
photography/reviews/index.
html#printers

Photography Blog
www.photographyblog.com/
reviews/#printers

For information on how colours work onscreen
and in print ▶▶ see p.145

Scanners

Your all-in-one printer may include a flat-bed scanner, useful for transferring old film work onto your computer. Some come with attachments for negatives and slides, and they often include colour restoration and dust/scratch removal technology. If this is one of your reasons for buying the printer, do check that it can handle the film format you want to work with and whether you'll need a separate transparency adaptor. Scanners are basically cameras with an exceptionally shallow depth of field, and there's also an increasing vogue for "scanner art", with many websites and Flickr groups devoted to using scanners in creative ways that were anything but their manufacturers' intentions.

- **Number of colours** Most printers use four colours (cyan, magenta, yellow, "key" black – CMYK), but some use six (adding light cyan and magenta – CcMmYK), and the best may have seven or eight, including red and green or blue. Additional colours do sometimes make it easier to capture the finer gradations, but don't necessarily guarantee a higher-quality final image – this will depend on the printer itself – and the more cartridges you need the more expensive it will be to print.

- **Black and white printing** Some printers use coloured inks to produce black and white images (creating what manufacturers call "'composite black"), but if you're likely to do a lot of black and white work you should choose one that uses black inks, or at least gives you the option, in order to avoid colour casts.

- **Upload options** If you're keen to make prints of your images quickly, or don't want to run them through an edit, you can find a printer that allows you to connect your camera or simply insert the memory card directly, rather than via a computer. It's fast and straightforward, but does limit the control you have over exactly how your pictures will appear.

- **Paper handling** Check that the paper handling specs can manage the full range of different sizes and thicknesses of paper that you're likely to want to use.

GETTING TECHNICAL

Exposure, focus, depth of field, white balance and flash – the essential facts

Why bother with the more technical side of photography? You've got a digital camera with a huge amount of processing power and whether it's a point-and-shoot or a high-end SLR it can handle most subjects and situations in auto mode. But being able to understand and make use of some key functions gives you a lot more control and, despite being a technical exercise at heart, allows you to harness powerful tools that can greatly influence the look and creative impact of your photos. This chapter will help you decide when you need to get technical and how to do it.

Exposure: the basics

Exposure is all about how much light reaches the camera's sensor. Overexposing your image will give you bleached-out areas where the detail has been lost, whereas an underexposed image will have areas of shadow where the detail has been lost. Three main elements are involved in achieving good exposure: **aperture**, **shutter speed** and **ISO**. Various combinations of the three will correctly expose an image, though each combination will have a different impact on the final picture – see p.48 for more on this. SLRs and bridge cameras both give you the opportunity to control all three elements, though most compacts limit control to the selection of a particular preset mode (see pp.46–47), and will only let you manually control ISO.

A well-exposed shot will show detail in both the dark and light areas of the image.
1 sec, f/5.6, ISO 400, 32mm

Aperture...

The aperture, or opening, of a lens dilates and constricts to allow more or less light to enter, in much the same way as the pupil of an eye. As well as having an impact on exposure, the aperture size also determines the amount of an image that appears to be in focus (see depth of field, pp.58–59).

Aperture size is measured by what's known as the **f/stop** or f/value. This doesn't express the actual size of the opening directly, but the ratio of the focal length of the lens to the aperture size, and thus the larger the aperture, the smaller its f/number, and vice versa. Moving a complete f/stop in either direction will double or halve the amount of light reaching the sensor by either doubling or halving the surface area of the aperture.

A so-called **"fast" lens** is one with a large maximum aperture, for example in the range f/1.2 to f/2.8. This allows more light into the camera in low-light situations and thus helps create better quality and better lit images. Fast lenses tend to be more expensive – and a lot heavier – than lenses with smaller apertures, at least in part because of the larger diameter of the glass.

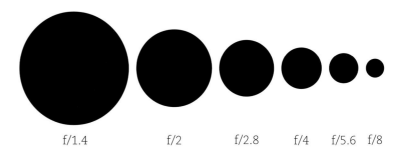

f/1.4 f/2 f/2.8 f/4 f/5.6 f/8

Relative aperture sizes (not to scale).

Shutter speed...

A photograph freezes a moment in time, capturing it for posterity; just how long that moment lasts is controlled by the camera's shutter. The shutter is always closed, keeping light off the sensor, until you press the shutter button, when it opens to allow a burst of light to enter the camera. **Shutter speed** controls how long it's open, with most SLRs and bridge cameras offering a range from the extraordinarily fast 1/8000 of a second to as long as 30 seconds. Like aperture, the shutter speed is moved up and down in "stops" to achieve the desired result, and a stop in either direction will double or halve the shutter speed, and thus double or halve the amount of light hitting the sensor. You can't usually set shutter speed in a compact, though you can select a preset mode such as action or night, which will use a fast or a slow shutter speed, respectively. See overleaf for more on preset modes.

As well as exposure, shutter speed also affects the way movement is portrayed in an image. Imagine photographing a jogger as they run across the frame. A shutter speed of a second might allow them to cross most of the frame (depending on how close they are to you), giving you a blurry, half-there figure – or even just the colours of their clothes – right across the image. Conversely, a shutter speed of 1/250 sec would freeze them in action at a particular moment. For more on capturing motion, see p.79.

A shutter speed of 1/30 sec allows these runners to move some way across the frame during the time the shutter is open, capturing their movement in the form of blur.
1/30, f/8.0, ISO 100, 42mm

>> QUICK TIP
Try your camera out at different settings, and see what ISO number you can get to before your images start to look noisy or grainy, so that you'll know exactly how much flexibility you have to push the settings when you need to.

ISO...

ISO speed (see p.12) controls the degree to which the image sensor is sensitive to light. The lower the ISO number, the lower the sensitivity and the finer the grain or "noise" in the image, while increasing the ISO makes the sensor more sensitive to light, but also to noise. The ability to shift ISO levels between images is one of the many benefits digital has over film.

ISO ratings again usually increase or decrease in stops (100, 200, 400 and so on, to 6400 or even higher), and – as with aperture and shutter speed – moving up or down a stop will double or halve the sensor's sensitivity to light. If there's plenty of available

Using presets

Most digital cameras offer a selection of preset modes so that in any particular situation you can simply turn a dial and be confident that the camera is set up correctly. These usually include "scene" modes geared to both shooting conditions and type of photography. In each case, whether the mode is governed by shutter speed or aperture requirements, the camera will automatically match up the other settings to create a correctly exposed image. Having said that, in difficult lighting conditions you might find several of the preset modes come up short. Still, knowing what your camera is trying to do when you select one of the presets or scene modes can help you understand why it doesn't always quite work – why that landscape or night portrait came out blurry, or why the key element of your macro shot seems to be out of focus. Different camera brands and models offer a wide range of presets, but the following are the most common.

Some cameras also offer a couple of spots on the dial for you to set up your own presets. It makes sense to do this if you use one or two settings on a regular basis.

- **Auto** Point and shoot – the camera controls all the settings.

- **Program** Depending on your camera, this can be the same as full auto; or it's a separate mode that gives you some control over basic functions such as ISO, flash and white balance.

- **Portrait** For pictures of people or animals, or any other discrete subject, where the camera will use a wide aperture to ensure the background is out of focus and doesn't distract from the subject. This is known as minimizing depth of field (see p.59).

- **Landscape** Great for capturing a wide expanse of scenery as the camera does almost the opposite to portrait mode, using a smaller aperture to make sure the scenery is all in focus from near to far (maximizing depth of field – see p.59). The small aperture may let in so little light that the camera compensates with a very slow shutter speed, so you may need to use a tripod if you don't want your images to come out blurred.

- **Macro** For taking close-ups or photos of a small subject, such as a flower or insect. The camera will select a larger aperture and a short focusing distance, to ensure that the camera can focus even though you are working very close to your subject, and that only the subject is in focus. The narrow amount which is in focus can make it difficult to get everything you want acceptably sharp.

- **Night portrait** For taking pictures of people at night and in low-light conditions. The camera will combine a slow shutter speed – to let more light reach the sensor – with the built-in flash and red-eye reduction function to ensure that your subject is properly exposed. You may find you need to use a tripod because of the slow shutter speed, which will show any camera movement as blur.

- **Sports or action** Used for capturing a moving subject. This mode is also governed by the shutter speed, in this case a fast shutter that will freeze the action. It works best in bright light, because the fast shutter speed will reduce the light entering the camera and your images may otherwise look too dark. Increasing the ISO a bit will help. You'll also need to think about whether you will focus on the subject and pan slightly with it to ensure you get the composition you're after, or whether you want to anticipate a point it will pass and focus on that. For tips on photographing motion, see p.79.

- **Other modes** Some cameras offer preset modes to cover a number of scenes: a sunset, fireworks, beach or snow, underwater, a party, foliage, even an aquarium. In each case, these are pre-programmed settings designed to help you capture the best photo you can in a certain situation, and should mean you don't have to play around with the function menus before getting your shot.

"f/8 and be there"

There's an old photography saying, "f/8 and be there", which means that just turning up with your camera is more important than worrying about the technical details. You could quite easily miss a good shot while playing around with various settings. F/8 is a good standard aperture that gives a reasonable depth of field, though it's pretty meaningless without shutter speed and ISO. But that's because the important part of the phrase is "be there".

"Sunny 16"

Traditionally, on a sunny day a good starting point for your exposure is to set the aperture to f/16 and the shutter speed to the reciprocal of the ISO setting (1 over the ISO, or 1/ISO). For example, at ISO 100, you'd select a shutter speed of 1/100, or at ISO 200 a shutter of 1/200. This is another pretty basic, easy-to-remember rule, and a useful way of working out how to expose for bright daylight without the complicated calculations; though it won't be much help if you need a wide aperture to minimize depth of field.

light, it's best to keep ISO at a standard level of 100 or 200. In fact, a lower ISO is almost always desirable, though you'll often need to increase it to compensate for low lighting conditions. Higher-spec cameras with better quality sensors tend to offer higher ISO settings and deliver better results at those higher levels.

...and bringing them all together

Your camera is a sophisticated device, and shooting on auto or program mode will usually result in a correctly exposed image. So why wouldn't you just shoot in auto all the time?

A useful analogy to explain the **relationship** of aperture, shutter speed and ISO is that of **filling a bucket with water**, where the water represents the light and a full bucket represents correct exposure. Whether the water is allowed to rush or trickle slowly into the bucket is equivalent to how much light you allow into the camera at once, determined by the width of aperture. How long you allow the water to pour into the bucket equates to how long you leave the shutter open for light to enter the camera. And the size of the bucket represents the sensitivity of the sensor, controlled by the ISO: a large bucket will need more water to fill it, just as a lower ISO setting will need more light to expose the image correctly.

As you can imagine, there are many different combinations of these three factors that result in a full bucket – or a correctly exposed image. Letting a lot of light reach the sensor with a wide aperture (small number) for a short time, or a fast shutter speed, can have the same result as allowing only a little light to reach the sensor through a narrow aperture (large number) for a longer period of time, or slower shutter speed. If you also vary the size of the bucket, or the sensor's sensitivity to light, you can adjust the other two factors and get the same result in a number of different ways.

Moving any of the three variables up or down a stop results in a doubling or halving of the light that reaches the sensor. Assuming then, that the third factor, the ISO, remains constant, any of the following pairings of shutter speed and aperture would give the same exposure:

At the same time, they can have dramatically **different effects** on your image, since the shutter speed and aperture don't just determine exposure. The combinations at the top (1/1000 to 1/250 shutter speed) will do a very good job of freezing motion, while the ones at the bottom have the potential to show motion blur if there's something moving in the frame. Similarly, the large apertures at the top (f/2.8 and f/4) will reduce the depth of field, limiting how much of the picture is in focus, and the smaller apertures increase it, which means that the combinations at the top of the chart will result in an image with less in focus than the ones at the bottom.

APERTURE		SHUTTER SPEED	
f/2.8	Larger	Faster	1/1000
f/4			1/500
f/5.6			1/250
f/8			1/125
f/11			1/60
f/16			1/30
f/22	Smaller	Slower	1/15

Using the histogram

The histogram – a graph that tracks levels of brightness in an image – is a useful tool both in camera while shooting and afterwards when editing (see Chapter 6). It records the different levels of brightness along an axis from shadows on the left, through the midtones, to highlights on the right, with the height at each point illustrating how many pixels are at that level of brightness. If you can look at the histogram for each image on your LCD screen, this can be a useful way of checking exposure as you go, particularly on a bright day when it's hard to review the detail of the image itself.

If the pixels are all bunched at the left-hand end, your image is underexposed. If they're all at the right-hand end, it's overexposed. The image shown here is slightly underexposed. The convention is to try and expose for the highlights, rather than the shadows, because you can't do both, and areas of burnt-out white tend to look more unpleasant in an image than areas of blacked-out shadow. You don't always want to be governed by the histogram, though, as what you're after will depend on the scene you're taking and the look you want to convey. Sometimes you might be happy to completely blow out the background as long as your subject is nicely exposed, or to live with the moodiness of a dark, shadowy image. Technically perfect exposure can lead to a conventional, dull image, while turning the rulebook on its head and pushing things to the extremes can give compelling results. But understanding the histogram is a logical first step on either path.

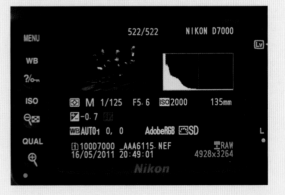

If all this seems bewildering, rest assured that you don't have to work it all out your-self. **Exposure value**, or EV, is a system that denotes all the combinations of aperture and shutter speed that give the same exposure, but allow the photographer a choice about how they represent the movement and focal depth. Using the **chart below**, if your image is correctly exposed at, for example, f/11 and 1/250 sec, or EV15, you can choose to slow the shutter down to show motion, or increase the size of the aperture to increase background blur without affecting exposure, by moving to one of the other settings on the EV15 diagonal.

Exposure value		Aperture												
		1.0	1.4	2.0	2.8	4.0	5.6	8.0	11.0	16.0	22.0	32.0	45.0	64.0
	1	0	1	2	3	4	5	6	7	8	9	10	11	12
	1/2	1	2	3	4	5	6	7	8	9	10	11	12	13
	1/4	2	3	4	5	6	7	8	9	10	11	12	13	14
	1/8	3	4	5	6	7	8	9	10	11	12	13	14	15
	1/15	4	5	6	7	8	9	10	11	12	13	14	15	16
	1/30	5	6	7	8	9	10	11	12	13	14	15	16	17
Shutter speed (sec.)	1/60	6	7	8	9	10	11	12	13	14	15	16	17	18
	1/125	7	8	9	10	11	12	13	14	15	16	17	18	19
	1/250	8	9	10	11	12	13	14	15	16	17	18	19	20
	1/500	9	10	11	12	13	14	15	16	17	18	19	20	21
	1/1000	10	11	12	13	14	15	16	17	18	19	20	21	22
	1/2000	11	12	13	14	15	16	17	18	19	20	21	22	23
	1/4000	12	13	14	15	16	17	18	19	20	21	22	23	24

Exposure modes and controls

SLRs and bridge cameras tend to have a selection of different **exposure modes**, ranging from full automatic to fully manual. If you're up for more of a challenge, you can take advantage of a number of other **in-built features** that give you additional flexibility in arriving at a perfect exposure, without necessarily having to take full manual control of the settings. Compacts, on the other hand, are usually limited to auto mode when it comes to exposure, though do offer manual control of the ISO setting.

Your camera will probably also have a range of other preset modes such as macro, landscape or portrait, pre-programmed to deliver well-exposed images in a range of different situations; these are covered in the box on pp.46–47.

Basic exposure modes

- **Auto or program mode** A fully automatic setting, where the camera makes all the decisions about shutter speed and aperture. It will take a meter reading to evaluate the available or ambient light in the scene and come up with settings to deliver the correct exposure.

- **Aperture priority** You select the aperture and the camera decides what shutter speed is required to expose the image correctly. Unless you're trying to capture motion, this is probably the best mode to use if you want to experiment outside of auto, as it allows you control over the amount of the image that will be in focus (see p.59), without having to work out the exposure.

- **Shutter priority** You select the shutter speed and the camera decides on the necessary aperture for correct exposure. The best choice if you want to capture motion in your shot, be it sports action, your children running about, or the ebb and flow of the tide, as you can control whether you freeze the movement or introduce a motion blur, again without worrying about the exposure.

For more on capturing motion
▶▶ *see p.79*

- **Manual** Full control of both aperture and shutter speed allows you to adjust exposure very precisely for any scene.

Measuring light

One of the most powerful features of your camera is its built-in **light meter**, which – in the split second after you press the shutter – can calculate the average brightness of a scene and set shutter speed and aperture accordingly to expose the image correctly.

In order to deal with different exposure conditions, most cameras offer a selection of **metering modes**, which change the way in which the light levels are read by the camera. It's a good idea to play around with these to get a feel for how your own camera works, as different models vary. They come under different names, but the options most cameras offer are:

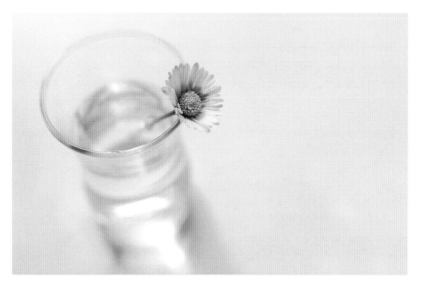

The histogram for the image above shows pixels bunched at the right-hand end of the graph, indicating that the image contains more pixels at the brighter end of the scale.
1/500, f/2.8, ISO 100, 24mm

- **Evaluative or multizone metering** The camera divides the scene into zones and takes a reading from each to come up with an average across the whole frame. This is a fairly safe mode to stick with if you don't want to worry about exposure and the lighting conditions don't vary too radically across the scene.

- **Centre-weighted metering** The camera takes a reading from the whole of the scene but gives weight to the lighting in the middle of the viewfinder; useful if your subject is in the centre of the frame and if the lighting is again fairly even.

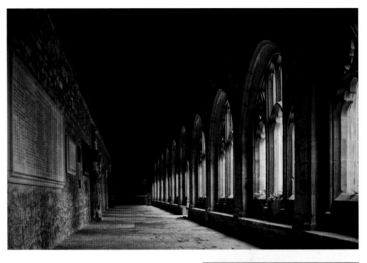

- **Partial or spot metering** The camera takes a reading from a small area of the scene, sometimes as little as 1–5% of the whole. This is handy if the scene is unevenly lit and gives you fine control over the exposure of your subject. In many cameras the spot is at the centre of the frame, though unlike centre-weighted metering it isn't simultaneously taking a reading from the rest of the scene. In some cameras you can ensure the meter reading is taken from the part of the scene that you need to be correctly exposed.

The histogram for the image above shows bunching at the left-hand end of the graph, indicating that there are more darker pixels in the image.
1/80, f/4.0, ISO 500, 24mm

Exposure compensation

Most meters are calibrated to give you the correct exposure for something in the region of 13–18% grey, a number that sounds random but is based on the range of brightness in a statistically average scene. This usually delivers good results but it does mean that when you're shooting extremes of dark or light in a scene you may need to use exposure compensation. What's more, because the meter in the camera is a **reflected-light meter**, meaning it measures all the light reflected from the scene, it can't distinguish between incident light (the light falling on the subject) and a scene which is simply full

>> QUICK TIP

Remember to re-set exposure compensation to zero once you've taken the shot, or your subsequent photos could all turn out disastrously over- or underexposed.

of **light tones** – a snowy mountain, say, or a sandy beach. The camera reads all of this as reflected light and – in order to compensate for what it sees as an extremely bright scene – will underexpose the image. For the same reason, a scene that's full of **dark tones** will simply be read by the meter as having very low lighting, and the camera will overexpose it. In either case, the quickest and most straightforward way to adjust the exposure is to use the exposure compensation dial.

This feature, common to all SLRs and bridge cameras, and most compacts too, allows you to override the camera's automatic exposure settings without getting into the detail of shifting individual settings, simply lightening or darkening the image by up to a couple of stops, which you can usually do in precise increments of half or one-third of a stop. It means you can stick with auto mode if you like but still retain some control over exposure, getting better results in tricky exposure conditions.

Because of the many bright tones in this snowy shot, the camera read the scene as very light and underexposed the image, so the photographer needed to stop up from the auto-metering in order to expose it correctly. **1/250, f/4.0, ISO 200, 32mm**

It's most useful in situations where the background light conditions are significantly darker or lighter than your subject, and thus where the camera's meter reading would naturally settle on over- or underexposure of the subject. Imagine you've composed a close-up portrait of your friend, who is standing indoors in a beam of light from the window. Your camera will do a pretty good job, but if you then pull back and take a photo which includes the darker room, the exposure meter will calculate the average brightness of the scene and compensate for all that darkness by making the image a lot lighter, meaning your friend's face will be overexposed. Underexposing the image by a couple of stops using exposure compensation should ensure their face is correctly exposed.

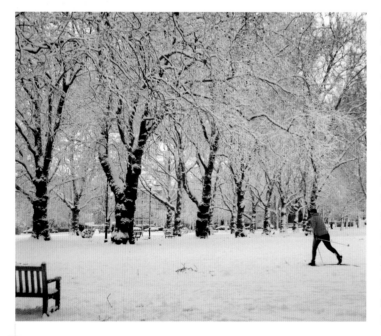

Bracketing exposures

Another way to work around your camera's metering system in difficult exposure conditions is to bracket exposures. This means taking one shot at your camera's automatic setting, a second which is taken down a stop or two, and a third one or two stops up from the original exposure. This gives you three differently exposed versions of the same image. Many photographers will bracket any and all important shots, just to ensure they end up with a well-exposed image and most cameras offer an **auto exposure bracketing** (AEB) feature, where the camera will take three differently exposed shots on a single shutter release, often allowing you to specify the number of stops by which the shots vary. Don't forget, though, that by taking three exposures for every shot, you will be using up space on your memory card three times as fast.

Multiple exposures and HDR

High dynamic range imaging (HDR) is a technique that involves taking and then merging (on your computer) a series of bracketed exposures to produce a single image that captures a wider range of brightness or luminance than a single exposure could ever show. By capturing more of the detail in the shadows and highlights, it can represent a scene more accurately. You can work with the three exposures taken with AEB, but taking five to seven different exposures, or even more, will enable you to capture the full range of brightness: the more extreme the lighting conditions, the more exposures you need to take.

Using a tripod to ensure precise alignment of the images, you need to work in manual and focus manually, keeping both aperture and focus precisely the same to avoid changing depth of field and focus points between exposures. You then simply adjust the shutter speed to stop up and down. The exposures can later be merged in Photoshop (using the File > Automate > Merge to HDR function) or in a dedicated software package or plug-in, such as Photomatix (for more on this, see Chapter 6).

Three separate exposures taken using the bracketed exposure mode.
Top: **1/10, f/11, ISO 250, 18mm** Middle: **1/30, f/11, ISO 250, 18mm**
Bottom: **1/250, f/11, ISO 250, 18mm**

Focus

>> QUICK TIP

When using a compact, you can't in most cases specifically control aperture, but using the portrait or macro presets will give you a shallow DOF, and the landscape preset a wider DOF.

>> QUICK TIP

The best way to ensure the first shot you take with continuous focus is sharp is to lock onto and track the subject for a few seconds before releasing the shutter.

For more on shooting portraits
▶▶ *see p.109*

When you look at a photograph, your eyes will naturally be drawn to the sharpest section of the image, the part which is absolutely clear, or in focus. But **focus** is about more than sharpness or clarity for its own sake: it can be used to make your subject stand out from its surroundings, to convey a sense of depth in a scene, make details leap out of the frame, or to create an emotional connection between subject and viewer. Which is why, when taking a picture, it's important to actively focus on the main point of interest, wherever it is in the frame.

Focus works as a **flat plane**, parallel to the front of the lens, and drops off sharply beyond the exact point of focus, though the human eye perceives this as a more gradual falling away, and thus sees a portion of the image as in focus, not just a single point. This is known as its **depth of field** (DOF), and controlling it gives you a great deal of creative power over your images – see p.58.

Choosing focus points

If you're taking a **close-up** portrait of a person or a pet, say, you want to lock the focus onto the eyes, or – if your subject is at an angle to you – to the nearest eye. This helps create an immediate emotional connection for the viewer. If you're photographing someone in a **wider setting**, simply focusing on the person is usually enough. If you're shooting a **landscape**, and want most of the image to be in focus, so there's no obvious focal point, the viewer's eye is more likely to be drawn by strong elements in the composition, such as leading lines or shapes, or bold blocks of colour, so you might focus on something striking in the foreground to help lead the viewer's eye into the frame but go for a wide depth of field (see below) so that as much of the image as possible is also in focus.

Your camera will offer anything from 3 to 45 **focus points**, with the autofocus sensor, basically the camera's default focus point, usually in the centre of the frame. You can choose to leave it on auto and let the camera select what to focus on, although that won't always result in the best shot. Alternatively, you can manually select a particular focus point when composing your photo, which will help you avoid simply putting eve-

rything in the centre of the frame. (For more on shifting your subject to create dynamic compositions, see Chapter 4.)

Selecting **multipoint focus** will use all of the available focus points, though since only one part of the image can ever be pin-sharp, there's some debate about the merits of doing this. It can be useful occasionally, though. For example, if you were shooting a number of moving subjects, multifocus would allow the camera to select the one that was closest to the camera at the moment the shutter was pressed.

If you want to **shift your focus** to a spot that isn't covered by the camera's focus points, simply place the nearest focal point on the subject, half-press the shutter, locking the focus onto it, and then – without releasing the shutter button – move the camera to recompose your image and press the shutter fully to take the picture. Remember, focus works as a flat plane, equidistant from the camera, so when switching the focus you need to ensure you aren't moving the camera nearer to or further from the subject. If you do, then just focus on the subject again and recompose.

In the image above, wide DOF, an aperture of f/11.0 and a focus point some way into the scene in the wall on the right has left a lot of the scene in focus. Conversely, for another shot taken in the same location, below, an aperture of f/2.8 and a close focus on the candles nearest the camera has resulted in a narrow DOF and the groups of candles behind being progressively more out of focus.

Focus modes

Most SLRs and bridge cameras, and some advanced compacts, have more than one focus mode, and because focus is so critical to the success or failure of an image, it can be useful to get to grips with what each one does.

- **One-shot or single focus mode** Focus on the subject, press the shutter halfway, recompose the image if necessary, and take the shot. If the subject moves, you start over.

- **Continuous or predictive mode** When shooting a moving subject, your camera's focus-tracking mode – which goes by various names, such as AI Servo in Canon, and Continuous Focus in Nikon – allows you to lock onto the subject. It then uses algorithms to predict the movement of the subject and to maintain constant focus as it shifts around the frame and moves nearer or further away. It isn't completely foolproof, but it is easier and, more importantly, a lot faster than predicting the movement yourself.

You can create a similar effect to using a shallow DOF by applying background blur to your images in the edit (see p.164).

QUICK TIP

- **Manual focus** An option in all SLR and bridge cameras, manual focus gives you very precise control over the focus of an image but can take quite a lot of practice to get right. You might want to switch to manual if you're taking an image carefully composed around a very **off-centre subject**, so that you can ensure autofocus doesn't move the focus from your desired focal plane, or simply in order to avoid having to refocus and recompose. Another time you might want to go manual is in **macro** photography, where you're working with a very narrow depth of field, sometimes as small as a couple of millimetres, and need your focus to be absolutely precise.

Depth of field

Once you've mastered the principles of focus, you can use it to dramatically change the appearance of an image by controlling the **depth of field**, the focused section of the image, from near to far. Using a deep or shallow depth of field can highlight or isolate your subject within the frame, or convey the relative importance of different elements within an image.

At one extreme, if you're taking a **portrait**, a shallow depth of field will keep in focus your subject – or even just their eyes, if it's an extreme close-up – while blurring objects in the foreground or background so that they don't distract from your subject. In **sports** photography, you might well want to freeze the action in the foreground but blur the rest of the scene. And if you're shooting **macros**, you might choose just a tiny detail – the stamen of a flower, for example – to be pin sharp, and the rest to be creatively blurred. At the other end of the scale, you might want a scenic **landscape** to be as crisp as possible from near to far, to show the details in their entirety and convey a sense of depth. Of course, there's also every conceivable example in between.

The top image has a narrow DOF: just the centre of the flower is in focus and the petals progressively lose focus moving outwards. The lower image has a wider DOF: the focal point is still in the centre, but you can see the outline of most of the petals clearly, and the background is clearer too.
Top: **1/100, f/2.8, ISO 160, 24mm** Bottom: **1/60, f/8.0, ISO 800, 24mm**

Controlling depth of field

There are three main factors involved in controlling depth of field: aperture, focal length and the distance between the camera and your subject. Which ones you can use will depend on your type of camera. Once you have mastered them, though, you can control depth of field with a great deal of precision.

Although everything in front of or behind the focal plane immediately begins to lose sharpness, the human eye can't tell the difference between something exactly in focus and something slightly less sharp: we perceive a more gradual transition. Depth of field is thus perceived to extend slightly before and after the focal plane, so you can experiment with precisely where you focus in the shot to ensure that you get the effect you're after.

- **Aperture** DOF decreases as aperture size increases, and vice versa, assuming the two other factors remain the same. So, the wider the aperture, the more **shallow** the DOF; the smaller the aperture, the **wider** the DOF.

- **Focal length** DOF decreases as focal length increases, and increases as focal length shortens, assuming aperture and distance from the subject remains the same. So zooming in on your subject will help you achieve a more **shallow** DOF, while zooming out will give you a **wider** DOF.

- **Distance between the camera and the subject** DOF decreases as the distance between subject and camera (known as the object distance) decreases, and increases as the camera moves further away, again assuming the other two factors stay the same. In macro photography, where you're working close up, you will have only a narrow DOF to play with, but shooting a landscape from further away will help maximize DOF.

Getting depth of field right is often a case of trial and error, adjusting your settings and moving your position until you're happy with the shot. Those SLRs that feature **live view**, where you can preview the image you're about to take on the LCD screen,

DOF rules

To maximize DOF...
- small aperture
- short focal length
- further away from subject

To minimize DOF...
- large aperture
- long focal length
- closer to subject

>> QUICK TIP

Experiment with DOF by varying just one of aperture, focal length or distance from subject at a time, and keeping the other two constant, to see what effect each has. Then try using all three at once, and see how precisely you can control what remains in focus.

usually also have a depth of field preview setting, which lets you see how much of the image will be in focus before you press the shutter. The viewfinder can't show this, because the lens only stops down to your selected aperture when you actually take the picture. The preview button, however, stops the lens down to the right aperture, which means that if you're using a small aperture the LCD screen will look a lot darker (when you actually take the picture, the shutter speed will allow more light in to compensate), but once you get used to this, it's a great way to check how much of the image is sharp.

White balance

Adjusting white balance is a means of correcting the colours in an image to take account of the light they are being shot in. Different light sources can produce light that tends towards one end of the spectrum, either **bluish** (**cool**) tones or **reddish** (**warm**) ones. Even natural light can vary hugely over the course of the day because of the angle of the sun, or whether it's cloudy or bright; sunlight at midday comes the closest to producing light across the whole of the visible spectrum. By ensuring that anything which appears white in reality is shown as white in your photograph, you're also making sure that the rest of the colours in your picture are faithful to the original scene.

Compensating for colour temperature

>> QUICK TIP

Remember to turn any white balance settings off afterwards or to reset it for your new environment, or you may get some very strange results in later images.

Our eyes are naturally very good at compensating for changes in colour temperature (the warm or cool tones of the light), but the camera isn't. Most digital cameras offer a way of working around this though, most straightforwardly by means of an **auto white balance** (AWB) setting. This will analyse the type of light falling on a subject – in terms of the relative amounts of red, green and blue light reflected onto the camera's sensor – and attempt to adjust the colour to give a neutral result. The AWB setting can sometimes give strange results though, particularly if the scene you're shooting is naturally warm- or cool-looking, as the camera will try and compensate for what it sees as an imbalance.

In this case, you'll want to change the white balance yourself, and most cameras offer a range of **settings**, including tungsten, fluorescent, cloudy, shade and flash, as well as a daylight or "neutral" setting, which will allow you to capture the natural colours in an external scene without the camera trying to alter the colour temperature. If you're going to be shooting JPEGs, then you'll need to use the daylight/neutral setting if you want to avoid images with a distorted colour cast. AWB is less problematic if you're shooting RAW, as you can correct the images once you've uploaded them into your RAW conversion or editing software.

Setting white balance manually

Many cameras also have a **custom white balance** setting, which gives you the most accurate setting for the exact conditions in which you're actually shooting. To set it up, you'll need to select the appropriate function, then hold or position a white card or piece of fabric – any object that's uniformly white, in fact – so that it's illuminated by the light in your scene, and take a photo of it, filling the frame completely.

By telling the camera that this is supposed to be white under these lighting conditions, you enable it to calculate the difference in colour temperature required, and shift the colour temperature of subsequent images by the same amount. For this to work, you'll need to take these photos at the same exposure settings, without adjusting the ISO or flash.

These two versions of the same image show the difference a warm or cool colour temperature can make to the overall feel of a picture.
1/800, f/11.0, ISO 100, 105mm

›› QUICK TIP

Slip a small white card into your camera bag for this purpose, as you can't always find something white when you're out and about.

Using flash

>> QUICK TIP

Flash units can be used on a bridge camera if your model has what's known as a hot shoe mount – a bracket located on the top of the camera which allows an external flash to be attached.

For a rundown of flash guns and other lighting accessories
▶▶ see p.33

Photography is all about capturing light, but there are plenty of cases in which the available, or ambient, light is far from ideal, and you may need to consider using an additional light source to get the image you want.

Your camera's built-in flash is a fairly blunt but useful tool as long as your subject is within range, though its size means it won't always give you the light you need. Convenient it may be, but it isn't very subtle or particularly flexible. And because it provides quite a harsh, unflattering light, aimed directly at your subject, it can be hard to avoid that startled rabbit-in-the-headlights look. One of the problems in working with flash is that because it fires so fast, you can't preview how the scene will look once you've illuminated it, and thus there's a great deal of trial and error involved. You'll develop a sense for how your flash works and the effect it has the more you use it.

It's worth checking the **flash range** in your camera's manual: your subject will often need to be within 1–6m to benefit from its light. All those flashes you see going off at gigs in stadiums will only ever light the backs of a few heads in the rows in front; if you get a nicely lit shot of the main attraction on stage, it's because of their lighting rig, nothing to do with your camera.

There are some straightforward alternatives to the built-in flash, with most camera manufacturers making **flash units** or "speedlights" that can be used with your SLR. More powerful than built-in flashes, they usually sport adjustable heads that allow you to direct the light away from your subject and bounce it at them off nearby reflective surfaces, such as the walls or ceilings, or a strategically positioned reflector. Reflected light is softer and more diffuse than direct flash light, making shadows less harsh and giving a more flattering effect. You can also take these units off the camera altogether, triggering them wirelessly, by remote control or through a cable between camera and flash, which means you can be more creative about the angle from which you're lighting your subject.

Front- and rear-curtain sync

Any photograph taken with flash actually consists of two simultaneous exposures, one in which the available light illuminates the scene for the whole time the shutter is open, and an additional exposure which lasts for the brief duration of the flash firing. On most SLRs and bridges, as well as some advanced compacts, you can select whether you synchronize the flash to fire just after the shutter opens or just before it closes. This is known as front-curtain and rear-curtain sync (or sometimes first- and second-curtain sync). If you are working with a fast shutter speed, the difference may be negligible, but if you're working with a slow shutter, to get as much of the ambient light as possible out of the scene, you can use this to good creative effect.

In order to understand how this works, imagine, for example, you are shooting in low light and trying to capture the trails of light made by moving vehicles. You set your camera up on a tripod, and work with a low shutter speed, so that the shutter will stay open for the period of time that allows it to capture the lights as they move from one side of your frame to the other. If you set the flash up on front-curtain sync, the flash exposure will capture the scene as the shutter opens, and freeze the motion of the car as it enters your frame. The slow shutter will then capture the light trails as they move across your frame, and you're left with a photo in which the light trails appear to be in front of the car. If you use rear-curtain sync, the car enters the frame and the slow shutter captures the light trails across the frame, then the flash is fired just before the shutter closes, freezing the motion of the car just before it exits the frame on the other side. Thus you've captured the car with light trails behind it, nicely conveying the sense of motion.

This picture was taken using a slow shutter, hence the slight blur in the background, and the scene was then illuminated and frozen in position by using rear-curtain sync flash at the end of the exposure.
0.4sec, f/3.5, ISO 250, 18mm

>> QUICK TIP

Ensure you know how to turn your flash off if you usually work in auto mode, as otherwise it will always fire in low-light situations, and you may not want it to if you're aiming to just use the available light in your image.

Flash synchronization

Because the flash fires so quickly, and because you want to make sure you get every bit of light out of it, it's important to select a **shutter speed** that synchronizes with the flash, so that the shutter is fully open when it fires. If you're shooting in auto mode and using the built-in flash, you don't need to worry about this – the camera will synchronize the two automatically. But if you're working with an off-camera unit or adjusting your settings manually, you should check the manual for the maximum shutter speed at which the camera can synchronize with the flash. This is sometimes called "**x-sync**", and is usually somewhere between 1/60 and 1/250 second, though some models can synchronize at faster shutter speeds. If you were to use a shutter faster than this, it will have started to close again by the time the flash fires, and you'll lose some of the benefit of the flash.

Red-eye

We're all familiar with those family photos where the subject beams obliviously into the lens as their eyes glow an evil, demonic red. This effect is caused by the light from the flash reflecting off the red blood vessels lining the retina of the subject's eye and bouncing back into the camera, creating a red glow. You'll notice it most when using the flash to light a scene with low available light, because your subject's pupils will be dilated to let in more light, and because of the relative brightness of the flash compared to the ambient light. If you're using flash in daylight, your subject's pupils will be contracted and reflect less light, and the relative brightness of the flash will also be lower.

You can reduce the risk of red-eye if you have an off-camera flash, either by moving it further away from the lens, or by pointing the flash away from your subject and letting the light bounce off another surface. If you're using the built-in flash, turn on your camera's red-eye reduction function, if it has one. This works by letting off a series of pre-flash bursts of light or turning a secondary light on for a couple of seconds, which are designed to make your subjects' pupils contract before the flash fires. Do warn your subjects first though; otherwise they'll smile for the first burst of light, and by the time the flash actually fires they may all have dropped their poses.

Some more recent cameras can analyse the picture just taken and use face detection algorithms to identify faces and then eyes, and automatically fix any red in the eyes before writing the data to the memory card. There are also techniques you can use for fixing red-eye when editing photos on your computer, such as cloning or desaturating – see pp.162 and 157–158.

Fill flash

It may only occur to you to use flash in low light (or when your camera decides it needs it), but using flash can be invaluable in brightly lit situations too. Fill flash is a technique used to light – or fill – areas of shadow in your image, and if handled right it should be invisible, as if you haven't used the flash at all. It can be particularly useful if your subject is backlit (meaning the light in the scene is coming from behind them and their face is in shadow), or if you're working in harsh sunlight, which is creating hard shadows on your subject. Again, you can only work within the range of your flash, but if you're doing close-up macro work or taking someone's portrait, fill flash can help to even out the light across the image.

Because of the brightness of the scene, the flash won't go off automatically, so you'll either have to force the flash to fire or select your camera's fill flash feature, if it has one. The fill flash setting gives you a less intense burst of light, specially designed for the purpose.

If you don't have a fill flash option, you may find that your flash is too bright and makes the scene look unnatural, as it thinks it's providing the main light source rather than supplementing it. In this case, you need to set the camera's overall exposure for the brightest part of the scene. Then override the flash and make it think less light is necessary to illuminate the scene, either by taking the flash exposure compensation down a stop or two more than the overall setting (flash exposure compensation controls the brightness of the flash in the same way as the standard exposure compensation setting works, as described on p.53), or by increasing the ISO on the flash unit (again found in the flash menu). Most compacts lack this functionality, leaving you to decide whether the shadows are sufficiently deep to use full flash as a fill device, or whether you're better off without it.

Although there was plenty of natural light available in this scene to ensure an even exposure, the image at the bottom was taken with a little fill flash in order to further illuminate the subject.
Top: **1/250, f/4.5, ISO 200, 29mm**
Bottom: **1/160, f/4.5, ISO 200, 32mm**

COMPOSITION

Colour, perspective, framing and more – how to create dynamic images

Often you'll be taking a quick snap on the run, but whenever you've got more time, or simply want to ensure a better end result, it pays to think through the composition of your image – how you'll draw the separate elements together into one satisfying whole. You can't always rely on instinct, as the camera and the human eye perceive the world very differently. You've experienced this first-hand if you've ever been disappointed that an image you've just uploaded to your computer looks nothing like the dramatic scene you thought you'd shot. But if you can develop a sense for how the relationship between eye and camera lens works, you can use the difference to your advantage. This chapter looks at the ways you can bring your compositions to life – through use of colour, texture, light, perspective and framing, to name just a few – resulting in dynamic, resonant photographs.

Translating between eye and camera lens

The eye and brain are a powerful combination, unmatched by any camera. For a start, you're generally seeing the world with two eyes, which gives you the advantage of **depth perception** – the sense of distance between different objects in the frame – which is something the camera can't easily convey in a two-dimensional image. What's more, your eyes are continually moving and adjusting, roaming around the detail of a scene,

Look and learn

If you want to learn how to take images that move you, and that might move others too, the best place to start is by looking at other people's photographs – and working out what it is about their composition that speaks to you. Consider the subject of the picture and its location in the frame, and think about where the photographer must have been positioned and at what height and distance relative to the subject. Does the image feel intrusive, or does it feel as though the photographer is part of the scene? Are there other objects competing for your attention? How does your eye move around the frame, and can you see why it's following a particular path: are there lines or shapes, whether visible or relational, pulling you in a particular direction? Are strong colours or textures being used to draw your eye? Look, too, at how the light and shadows fall, and try to work out where the light is coming from, whether it's natural or artificial, whether there's more than one source. What about where the photo stops? Why do you think the photographer has chosen to frame or crop it as it is? What decisions might they have made about what to include and leave out? Answering these questions will give you the clues you need in order to create similar effects in your own images.

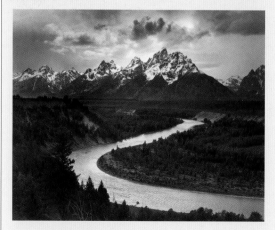

Tetons and Snake River by Ansel Adams, 1942.

making instantaneous changes to points of focus and focal length, while the camera is limited to a single focal plane.

In terms of **light and dark**, the human eye can perceive a greater dynamic range than a camera can, and adapts quickly to contrasting light conditions. It also has a wider field of view than most camera lenses (around 160°), though our peripheral vision is less sharp and colourful, and what we actually see with relative clarity covers a far smaller range. Street photographers traditionally used 50mm lenses in order to create images that came as close as possible to the natural field of view of the human eye.

The camera will also record everything in front of the lens, while we have a tendency to **see selectively**, focusing on the main subject in the frame. This gives rise to those classic photos where trees and lampposts seemingly sprout from people's heads. You can compensate for the brain's selective vision by ensuring you look carefully at everything in the frame, from foreground to background, checking all around your subject.

These differences between what we see and what the camera records are exacerbated by the fact that it only captures one of our five senses, stripping away everything else that may have struck you about a scene and leaving you with a two-dimensional representation which can't hope to convey the same emotional impact. There are, however, many ways in which you can try to replace some of this lost information. Get into the habit of **reviewing** how your planned images actually come out, and you'll naturally start to view the world around you with an eye to the subsequent photograph: how the framing would work, how the camera would handle the dynamic range, where the viewer's eye will be drawn, and so on.

ignificance of an event as well as the precise organization of forms which gives that event its proper expression."

Henri Cartier-Bresson

o much of what makes a great image comes from the photographer simply being alert to the world around them, having an eye for detail and being in tune with how the camera sees. It's about being in the moment but outside it at the same time, and capturing those resonant but fleeting points of time unobtrusively. Sometimes you'll be aware of a potential photographic opportunity and can plan for it, thinking through the composition in advance; sometimes you'll just stumble upon it and everything will come together in the moment of capture. Many photographers also talk of happy accidents, those moments when something unanticipated happens as you press the shutter, giving you a knock-out image.

One of the most influential figures in twentieth-century photography and an early proponent of the reportage style, Henri Cartier-Bresson (1908–2004) placed great faith in the decisive moment, when everything comes together in an instant of perfect confluence. He was instrumental in transforming photography, which had until then been dominated by enormous, stationary cameras, taking his pocket-sized Leica out onto the streets, capturing what he found there with a click of the shutter, and thus giving new expression to the day-to-day reality of people's lives. Rather than waiting behind the camera for the right moment, HCB (as he was known) went looking for it, anticipating something significant in order to capture it forever in a photograph. In many ways, the work of HCB and the street photographers who followed him heralded today's candid portrayals of everyday life, as well as the occasional sense of voyeurism, of stumbling into someone's private world, generated by the

Henri Cartier-Bresson at work, outside a cold storage warehouse in Brooklyn, 1946.

Using the space

The images that really grab your attention usually have a clear **point of interest**: something that immediately draws your eye and helps you make sense of the rest of the picture. Without this, you'll find the image lacks impact and the viewer's gaze will wander aimlessly around the frame. The point of interest might be a single object or a group of things in a particular part of the frame – a person, a bunch of people or a landmark – whatever you've decided is the main subject of your picture.

When you start taking photos, it's common to place your **subject** bang in the middle of the frame. But once you start looking critically at images you find striking, you'll notice that the space has often been used more creatively. Perhaps the subject is all the way over at one edge, or the photographer has used a pattern that leads your eye into the frame in an interesting way.

Including other, less important, objects along with your subject can help to give your image balance, as long as they don't distract; your subject should be the **right size**, not dwarfed by other elements within the frame. You can also use focus as a tool, making sure that your subject is absolutely pin-sharp and perhaps blurring the background with a shallow depth of field to make your subject really stand out (see pp.58–60). Using lines, shapes, colour and texture to direct the viewer's eye within the frame are covered later in the chapter, but probably the most helpful rule in terms of using the space in your frame is the centuries-old rule of thirds.

Key areas of this scene have been placed on the thirds lines to create a harmonious composition.
1/80, f/11.0, ISO 100, 70mm

Positioning and the rule of thirds

The **rule of thirds** is a basic but powerful compositional tool that governs subject placement within the frame. Think of your picture as divided into thirds both horizontally and vertically and try to place your subject on the lines between these sections, or – better still – on one of the four points where two lines intersect (sometimes called "power points"). These lines and their conjunctions are the strongest focal points in the image, and using them leads the viewer's eye into the frame. A centred subject, on the other hand, draws the viewer's eye straight to it and leaves nowhere for the eye to travel, wasting the area around the subject.

This is a widely known and followed rule. Use it often enough and it will eventually become second nature. And like all rules, once you've fully understood it, it's crying out to be broken in order to create some deliberate effects. You might want to push your subject right to the corner of the frame, or have the barest sliver of horizon at the foot of the image and dedicate the rest to a dramatic sky – or, in fact, you might decide that after all your subject does need to be bang in the middle of the frame. Don't feel you have to be governed by the rules, if you think your composition works.

The rule of thirds

The rule of thirds has its origins in the geometric principles of an ancient Greek compositional formula called the Golden Ratio or Golden Mean, which suggested geometric lines that the eye could follow around an image, and that a composition following these principles would be harmonious. These principles were widely adopted by artists during the Renaissance to give their compositions balance and structure – wander through any major art gallery for a host of examples.

>> QUICK TIP

Your camera may let you switch on a grid in the viewfinder to help you compose your image along thirds lines. You can also create a thirds grid in most photo-editing software to use as a guide when cropping into your image.

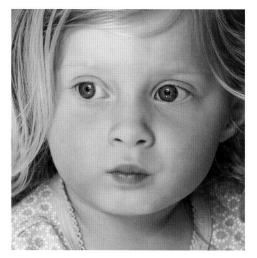

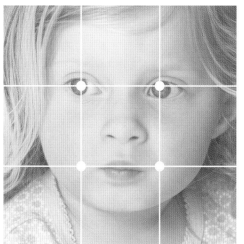

In a portrait, or any other image where you're effectively filling the frame with your subject, you can use the thirds lines to place the elements that comprise the subject, for example someone's eyes or the centre of a flower in a macro shot.
1/160, f/4.0, ISO 200, 65mm

Some of the lines and points have more power than others, depending on what you are trying to achieve with the image, and also on factors such as whether yours is a culture which reads from left to right or right to left. In Western cultures, the **left-hand line** is thought to be the strongest.

In addition to the rule of thirds, here are some further guidelines on choosing your subject's position in the frame. Though, as ever, these rules can be turned on their head to striking effect.

- If you're shooting a moving subject, leave some **open space** in the frame for it to move into, locating the subject on the line nearest the side where it would have entered the frame.

- When there's a person or creature looking into the frame, give them some **space to look into**. Having a subject looking or moving out of the frame leads the viewer's eye out of the image too.

- Objects with leading lines, or which seem to be **pointing** in a particular direction, for example the branches of a tree, should be used to lead into the frame rather than out of it.

- **Horizontal lines** that seem to be passing through your subject are almost as distracting as the objects that appear sprouting out of people's heads. Scan around the frame to make sure there are no unfortunately placed horizons or window frames, for instance; if there are, either alter the angle or height at which you're taking the picture, or take it from a different position altogether.

A subject looking out of the frame has the tendency to lead your eye out of the picture too. **1/60, f/11.0, ISO 200, 24mm**

Framing

Using the space is defined as much by what you leave out of the image as what you choose to include. "Framing" is the term used to cover these decisions as well as any framing of the subject itself within the overall picture. Where you choose to place the frame, or the edges of the picture, works with the elements within the image to create lines and geometric shapes which draw in the viewer.

Using a **frame within a frame** device can add depth to an image, and help lead the viewer's eye towards whatever you want them to look at. Framing can also be used to give context, by placing your subject in a particular environment, whether outdoors in nature, inside a building looking out, and so on. If your subject is at a distance, consider frames closer to your position than theirs: for example, a long range landscape could be framed by nearby trees, or you might shoot through a door or window and use that as your frame. But try to avoid using as a frame anything that will overpower the subject and make it difficult to determine the point of the photo.

Think, too, about image **orientation**. It often seems easier and more natural to

>> QUICK TIP

Look for natural framing devices when composing your shot: architectural elements such as gateways and arches, or natural elements such as trees and foliage all make good frames.

>> QUICK TIP

Before you next go out shooting, experiment with space and framing by playing around with different crops of an image, to see how giving the subject more or less space changes the feel of the overall picture.

>> QUICK TIP

Avoid cutting off small parts of a person or object with the frame – half objects and strange chopped-off points can be jarring, breaking the continuity of the frame and distracting from the main subject.

Different framing techniques: on the left a frame within a frame, and on the right foliage is used to frame the subject.
Left: **1/15, f/8.0, ISO 320, 28mm** Right: **1/250, f/11, ISO 200, 20mm**

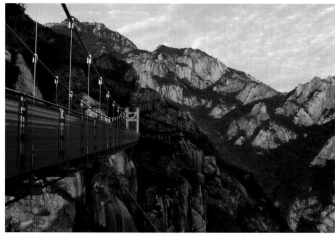

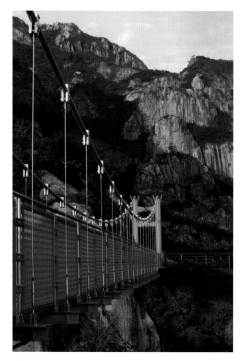

The vertical image gives the bridge more emphasis, echoing its vertical lines, while the horizontal image allows the surroundings more space, making the bridge seem smaller and more incidental to the image.
Left: **1/5, f/22, ISO 100, 28mm**
Right: **1/8, f/32, ISO 400, 70mm**

shoot with your camera on the horizontal (known as **landscape**), but when you're thinking about how to frame your subject, consider whether it would better suit a vertical (or **portrait**) image. Subjects with strong horizontal lines, like landscapes, usually work better on the horizontal, but if you're seeking to emphasize the height of something, or it's a subject with strong vertical lines –buildings, trees or people, perhaps – you might find that turning the camera onto its side and taking the subject vertically does it more justice.

Filling the entire frame by getting in really close to your subject can eliminate distracting backgrounds and help create a more satisfying picture. For example, if you're shooting a building, instead of trying to fit the whole thing in, get in close to a particularly interesting architectural detail.

If you're taking a picture of a person, you don't need to get them in the frame from top to toe, or even necessarily to give them lots of headroom. Try taking some really close portraits of people or animals, focusing on their **eyes** (or the eye nearest you, if you are *really* close) and filling the frame with their face. This often results in a much more intimate and emotional portrait than a shot that's pulled back to include the head and shoulders. The same goes for any object or scene you're trying to capture: think about what it is you're trying to show, get in there and focus tightly on the point of interest.

Leaving lots of negative space emphasizes the empty, open stretches of sky and sea. **1/800, f/7.1, ISO 250, 48mm**

Negative space

The **empty space** you choose to leave around your subject, within the frame, helps define it, and can be as important a part of the image as the subject itself, either emphasizing the subject's relationship to the rest of the picture or simply giving the viewer's eye somewhere to rest.

A composition may work well when there's a balance between positive space (the subject) and negative space, but pushing the relationship to extremes can result in a very striking image. You can use the space to emphasize the outlines and contours of your subject, or to change the way you look at it: consider the classic **optical illusion** where a silhouetted image can be seen either as a vase or as the outline of two faces, and what that says about the relationship between subject and space.

It's natural to instinctively move your eyes past the space to the subject, but if you spend some time actively looking at the way space is used in an image you'll see the difference it can make.

The classic Rubin's vase optical illusion: is it a vase or two profile faces in a stand off?

>> QUICK TIP

If you want to go for a more abstract effect, ignore the guidelines on scale, making sure there's nothing in your picture to give a sense of context.

Playing with perspective

Because of the way the camera sees, its solitary lens stripping away the depth perception our eyes give us, even the most dramatic setting – the Grand Canyon, say – can look flat and lifeless in your photos. If you want your pictures to show scale and depth, you're going to have to create them yourself in your composition. Perspective in photography is all about the spatial relationship between the objects in a scene, the way they look smaller when further away, or larger close up, and how viewpoint affects what you can see of a scene – all visual cues that help convey three-dimensional depth on the two-dimensional plane of a photograph.

Giving a sense of scale

One crucial technique, particularly in landscape photography, is the ability to convey a sense of scale. Without some familiar pointers, the viewer simply can't grasp the spatial context of the scene and your dramatic shot of a mountain range looks like nothing so much as a pile of rocks, with no way to communicate its breathtaking immensity. The most common way to indicate scale is to include something of a **recognizable size**, which is partly why so many travel photographers shoot landscapes that feature people, but you can use anything familiar: trees, a car or a house. If you want to convey the vastness of a landscape, you'll want to capture them in the middle distance, closer to the object being photographed than to the camera, otherwise the variations in perspective mean that they will seem disproportionately large in relation to the surrounding scene, and the sense of scale will be lost.

Including a person or other recognizable feature in the shot gives a sense of scale.
Top: **1/100, f/7, ISO 100, 55mm** Bottom: **1/90, f/11, ISO 100, 70mm**

Experiment with scale by including an object in the foreground, positioned not only to give the photograph a sense of depth by its apparent closeness relative to the rest of the scene, but also to distort the scale of the scene, for example having some flowers loom large in the front of the frame and allowing them to tower over the mountain in the distance. Or you can use something large in the foreground – perhaps only showing part of it – to make your subject in the middle distance seem smaller.

Distance and zoom

Whatever type of camera you're using, **zooming** in or out can also influence the perspective in the shot, as can the **position** from which you shoot. You can focus more closely when working at the wide-angle end of the range, making objects in the foreground seem much closer and larger than those further away; while zooming in or using a telephoto lens has the effect of flattening or compressing the perspective, making distant objects seem nearer to those in the foreground.

Once you understand these principles, you can use your position and focal length – or lens, if you're using an SLR – to change the perspective within a scene, moving closer and zooming in or out to create more or less distance between different elements, thus giving the image a different feel. For example, you could use a wide angle to emphasize the isolation of an object in the distance, or a telephoto lens to make the bustling crowd in a market scene appear even more packed and chaotic.

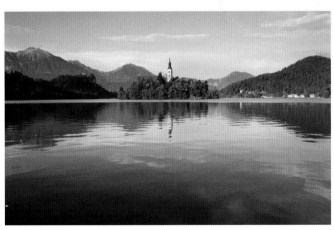

Here the zoomed-in top image makes the church seem closer to the camera and further from the hills behind it, while the bottom image shows more of the surroundings and makes the church appear isolated amid the hills across the lake.
Top: **1/8, f/32, ISO 100, 94mm**
Bottom: **1/15, f/22, ISO 100, 30mm**

Choosing a viewpoint

Where you shoot from can have a radical effect upon your image. Typical tourist shots often all look the same because they're taken at eye-level, by a photographer picking a single vantage point and using their zoom rather than their feet to shoot a number of pictures all around a scene.

Consider different **angles** and **vantage points** that will allow you to be more creative. Get in close, crouch down, climb on a bench or up steps, even lie on the ground and shoot up. If you're shooting children or pets, try getting on their level. If you're shooting a building, ask yourself whether there are more interesting views than that head-on shot you've seen on a million postcards. Shoot architectural details, find unusual angles, walk away and see if you can frame the building creatively using surrounding buildings, or find its reflection in a window or a puddle.

The same applies when taking photos of people. Altering your point of view can give your photos a real energy, and make them far more compelling than images taken on the same level as your subject. The closer you can get, the more you can make the viewer part of the action. On the other hand, shooting from a distance or pointing the camera down at someone can convey a sense of being remote and uninvolved, even a feeling of superiority.

Another practical reason to change viewpoint is to mask or lose a distracting background, choosing an angle that will instead allow you to fill the frame with the sky or ground, and to pick how you want the light to be striking your subject. If you're shooting a person you may want to move them out of bright sunlight, positioning them where they are neither squinting into the sun nor obscured by deep shadow. For more on this, see p.92.

Using different viewpoints creatively: at the top, the cattle and trailer loom over the low viewpoint of the photographer, while shooting from above gives a dizzying perspective to the spiral staircase in the second picture.
Top: **1/320, f/9, ISO 200, 46mm** Bottom: **1/160, f/4, ISO 1600, 17mm**

Capturing motion

You may have the hang of capturing a perfectly focused, static subject, but what about when what you're taking isn't absolutely still? Working creatively with shutter speed can allow you to develop mesmerizing images, where the world seems to hang suspended for an endless moment in time, or where movement whirls and flows through the frame.

The main thing to do when capturing motion, whatever technique you're using, is **work fast** – and be prepared to take a lot of shots. Many variables are involved, and you might have a low hit-rate at first, but if you persevere you'll find you can produce some effective photos.

Handheld or tripod?

If you're trying to use motion creatively, the last kind of movement you want to show in the picture is **camera shake**. When shooting at slow shutter speeds, any movement made while holding the camera will show as a blurring of the image. A good general guideline for choosing the slowest shutter speeds you can safely use when shooting hand-held is that the shutter needs to be at least as fast as **1 over the focal length** in seconds, so if you are shooting at 200mm, your shutter speed needs to be 1/200 or faster, while if you're shooting at 50mm you can probably work at 1/50 (although many people can't handhold steadily at 1/50). Imagine directing a laser pointer at a wall, and moving it a tiny distance from left to right. The point of light

You can also create the effect of motion blur in the edit.
▶▶ *see p.63*

›› QUICK TIP

If you are able to adjust shutter speed on your camera, experiment with motion capture of different subjects, such as the light trails behind cars at night, flowing water or even the movement of clouds, to see what effect different speeds have on your image. If you can't change the shutter speed itself, experiment with different modes such as sports/action, which will speed the shutter up, or landscape, which will often slow it down, to see what difference they make.

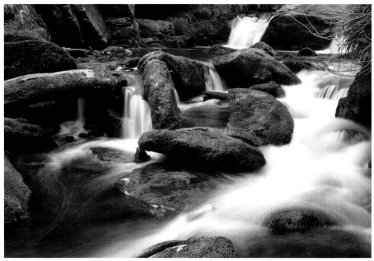

A long exposure taken from a tripod makes the water appear blurry and mystical.
2 sec, f/16.0, ISO 50, 47mm

on the wall will move more the further away you are from the wall, and in the same way a longer lens will magnify relatively small movements of the camera and lead to blurring in your images. If your camera or lens has image stabilization, you can usually slow the shutter down a couple of stops more, but once you get down to speeds of 1/60 or slower you'll almost certainly start to see unwanted movement in your images. You also need to consider the effective focal length of your lens when making this calculation.

If you want to use a shutter speed **slower** than the 1 over the focal length guideline, or if you know your images start to show camera shake before these cut-off points, consider using a tripod. Even the action of pressing the shutter will move the camera slightly, and while this may not be visible at faster shutter speeds, it can show up as blur in your photos when using a slower speed. Using a tripod is the best way to avoid this; you may also have an option to set the shutter release on the timer (or use a remote shutter release), so that the camera can settle back into stillness after the shutter is pressed but before the picture is taken.

Panning and blur

Deliberate blur creates a strong sense of movement, capturing the shift of elements within the frame and encouraging your eye to follow, and can enhance the most everyday image: use a slow shutter to capture a bustling street and the resulting blur will highlight the activity of the scene. An effective technique is to focus on something that isn't moving, in order to anchor the image and increase the sense of activity all around. Slow shutter speeds can also be used to create beautiful images of rushing water or cloud movement, though in all these instances you'll need to use a tripod to avoid introducing camera shake and blurring those elements of the scene that should be crisp.

Panning, where motion is emphasized by the background rather than the subject becoming blurred, involves moving the camera to

Lens conversion factor and effective focal length

Most consumer (as opposed to pro) SLRs have a sensor that's smaller than than "full frame" or 24mm x 36mm, the equivalent of a 35mm film camera (the system that most digital SLRs are still based on). This means that the circle of light projected by the lens is usually larger than the rectangular sensor, and a shorter lens with a wider angle (see p.19) is therefore needed to give the same field of view as a camera with a full frame sensor.

Because most lenses are also designed and calibrated for the equivalent of a 35mm film camera, what this means, in practice, is that you have to apply your camera's conversion factor to calculate the **effective focal length** (EFL) of any lens you use. Your camera manual will list the conversion factor in the form of a multiplier, usually in the range 1.3x to 1.6x. If your camera has a conversion factor of 1.6x, and you are using a 24–105mm lens, the effective focal length becomes 38–168mm (24mm x 1.6 at the wide-angle end and 105mm x 1.6 at the telephoto end). At the zoom end of the scale, you can see that this can be a benefit, as it extends the magnifying reach of the lens, but at the other end of the scale it reduces the effective width of a wide angle quite considerably.

When trying to calculate the minimum shutter speed you can use for a particular lens without incurring camera shake, it's this effective focal length that you need to use. So, for instance, if you're shooting at 200mm, rather than assuming a minimum shutter speed of 1/200, you need to multiply the focal length by its conversion factor, which at 1.6x would give you a shutter speed of 1/320 or faster to avoid camera shake.

keep pace with the subject, following it either in the view-finder or the LCD, and then pressing the shutter at the point at which you want to capture the image. It helps if you can anchor yourself fairly firmly and move the camera smoothly in the direction of movement. You can also pan on a tripod, which helps reduce camera movement in any direction other than the one in which you're panning, but it's quite possible to achieve good panning shots without one. Combine this with your camera's focus-tracking mode to ensure that you maintain focus on the subject (see p.57). There's a great deal of trial and error involved, playing with different shutter speeds and getting the pace at which you are panning absolutely right, but when everything comes together you'll end up with your subject crisp and sharp in front of a blurred background, enhancing the impression of movement.

Freezing the action

By freezing the briefest instant in time, a photograph can show us things we might never otherwise see – the moment a balloon bursts, for example, or the motion of a humming-bird's wings. How fast a shutter you need to use will depend on the speed at which your subject is moving and whether it's moving towards you, across the frame, or diagonally somewhere between the two, as well as how close it is to the camera. Someone jogging across the frame fairly close at hand will demand a faster shutter speed than a car speeding across it in the distance, even though they're moving more slowly than the car in real terms. It's important to get the speed just right in your final image: a subject that's slightly blurry but neither pin sharp nor properly blurred will just look like a mistake.

Your choice of shutter speed also needs to take into account the speed at which you can handhold the camera as well as the lens you're using (see p.80) – unless you use a tripod, that is.

The difference between panning and blur: in the top image, the camera has been kept still as the cyclist whizzes through the frame, while in the bottom image the photographer has followed the cyclist as he moves and has captured him fairly sharply while the background blurs. Both images give a sense of movement but each with a different dynamic.

You can also use flash to freeze the action ▸▸ see p.63

Using colour

Using minimal colour variation can also have a strong impact; the photographer could have chosen to shoot these pomegranates on a white background but using a near-match cerise makes the colour punchier and emphasizes the texture of the fruit.
1/125, f/1.8, ISO 400, 24mm

Colour is one of the most important components of a photograph, and developing an eye for how it works is something that can really set your shots apart. Think about it as a separate element within the image, rather than something incidentally attached to the objects in the frame. You can adjust colour as part of the editing process, but it's something that really repays being given some thought when you capture your image as well.

When you think of contrast, you might naturally think of black and white, but **colour contrast** is every bit as important in compositional terms, determining how the image hangs together, as each colour is perceived in relation to the other colours around it. The colour wheel (see box, opposite) can be a useful tool in understanding how colours work together. You could, for example, use complementary colours to make a picture more striking, or capture a range of shades from a similar colour palette

Using complementary colours, which lie opposite each other on the colour wheel, makes for a striking image.
1/160, f/4.0, ISO 100, 24mm

Colour theory: the basics

Complementary colours are any two colours that lie exactly opposite each other on the wheel. They are contrasting colours, which form striking combinations, make each other seem brighter, and can often help create a very dramatic image. They tend to work best if one is more dominant in an image, and the other supplementary, as they can otherwise compete for attention.

Harmonious colours work together more subtly than complementary colours, and convey a sense of balance and order. They most obviously include those which lie next to each other on the wheel, but you can also achieve harmonious combinations by selecting triadic colour schemes, using colours which fall where the points of either an equilateral or an isosceles triangle would sit on the wheel, the former giving three equally spaced colours, the latter combining two from one side and one from the opposite side of the wheel. These are useful in showing colour combinations that might not seem immediately obvious. Another harmonious scheme can be created by working with any four colours distributed evenly around the wheel. Warm colour palettes, such as yellows, oranges and reds, are also harmonious, as are cool colours.

RGB additive colour wheel: red, green and blue are at the three equally spaced points on the wheel (with cyan, magenta and yellow in the spaces between).

to give an impression of harmony. Or you might want to use a strong colour to help identify the subject, making it leap from the frame by setting it against a more muted background; you can take this further by desaturating the image and leaving colour in a single element (see p.153).

For inspiration, look at the way colours work together in nature: the warm palette of autumn leaves, the way the early morning winter light gives everything a harmonious range of blue tones, or the complementary greens and pinks of a rose bed. Get a feel for the way the relationships on the colour wheel work in reality, or simply develop your sense of what looks striking, what grabs your attention and what looks insipid or clashes unappealingly.

Using harmonious colours: a range of warm tones that lie next to each other on the colour wheel.
1/40, f/2.8, ISO 500, 55mm

Black and white

Despite the many benefits of colour, there will be occasions when you want to strip it all away and work in black and white, for the sheer starkness and simplicity it offers. Several genres work particularly well in monochrome: in portraits, you remove the potential distractions of coloured clothes and backgrounds, drawing attention to the subject's eyes and face. In landscape and architectural photography, too, stripping away colour helps focus attention on the shapes, textures and forms, and how the light and shadow falls.

What makes an effective black and white image?

When shooting black and white you lose one of the key pointers in your image, and so the job of leading the viewer's eye where you want it to go falls on other elements, such as shapes, patterns and textures. On the other hand, a simple scene will often prove more striking without the distraction of colour, and a compelling pattern might become apparent when colour would have obscured it. Starting to see in black and white is something that takes a little practice, but before long you'll start to develop a sense of whether the light and texture in an image are compelling enough not to need colour for additional impact, and whether your subject will still stand out sufficiently.

The colour in this shot draws your attention to the flower and makes it harder to appreciate the stark contrast of light and dark. Converting to black and white removes the distraction of colour and brings out the strong shapes and tonal contrasts in the composition.
1/640, f/2.8, ISO 100, 60mm

When distracting colour is stripped out, the lines and patterns created by the branches and the fountain come to the fore.
1/320, f/2.8, ISO 100, 67mm

The practicalities of shooting black and white

Many cameras let you shoot in black and white, but be warned that a preset mode like this may limit your options later on. Perversely, shooting in colour is a better idea, as it's quick and easy to convert your images to black and white in most software packages, while if you shoot in black and white to start with you'll lose any colour detail from the shot (unless you are working in RAW). If you are shooting RAW, it comes down to personal preference, and whether you want to review your images in black and white on the LCD as you go, but doing the conversion in the digital darkroom gives you real flexibility and precise control of tone and contrast. For more on black and white conversion techniques, see p.165.

Without colour contrasts you become much more reliant on the contrast between light and dark, whether shooting a high-contrast image featuring extreme brightness and crisp black shadows, or a low-contrast image full of soft grey midtones. Images with low contrast can seem a little soft or flat, but they can be good for bringing out texture that gets lost in a high-contrast photo, and an overcast day can be a great opportunity to work with this kind of soft light.

Pattern, shape and texture

The eye naturally looks for patterns and shapes, or symmetry and leading lines, in order to make sense of an image, to interpret its balance or contrast. By providing these you give the viewer something to latch onto, making the image much more interesting and satisfying.

Lines

Lines give structure to your photograph. Using diagonal lines and leading curves is an effective way of drawing the viewer's eye to the point of interest. Or you can use them to lead the eye from one part of the picture to another. Lines can lead your eye to a vanishing point or to infinity, starkly divide an image into parts, or simply create appealing patterns. Once you start looking for them, you'll find lines everywhere, whether they're physical shapes such as a path or a line of trees, or more subtle elements such as transitions between colours.

The path leads your eye right into the image and echoes the curve of the hill.
1/80, f/16.0, ISO 100, 27mm

Horizontal and vertical lines can feel static, creating a sense of continuation and timelessness; they tend to be less dramatic than **diagonals**, which suggest movement. You can use this to create contrast in an image, with horizontals broken by a diagonal to set up a tension between two parts of the picture. Converging lines, which come together to a single point from different parts of the image – like the two sides of a road meeting as they reach the horizon – lead the eye into the frame and convey a feeling of space and distance.

Shapes

Shapes can be found in anything, from the curves of a sea shell to ripples curling outwards across water or the jumble of petals in a flower bed. As with lines, horizontal or vertical shapes come across less powerfully than those on a diagonal, with rectangles and squares more static than triangles and circular shapes. Jagged, uneven and jumbled shapes can give a feeling of tension in an image.

To give balance to an image, try placing key focal points on the points of a triangle or other geometric shape, harnessing the power of the diagonal, and drawing an interesting path around the image. Combine shapes with colour and you can make them leap out of the frame, or strip them back to essentials and capture them as silhouettes.

Strong diagonals and curves lead your eye around each image and create a sense of movement.
Top: **1/1600, f/8, ISO 400, 200mm** Bottom: **1/1000, f/7, ISO 400, 70mm**

Pattern and texture

Look around you for patterns on a large and a small scale – the curves of a sand dune, bricks in a wall, or the sea of heads in a crowd. Keep your eyes open for repeated shapes, lines, colours and tones, any of which can work effectively together. Filling the frame with a repeated pattern can make a great abstract, somehow dissociating these smaller shapes from whatever it is they make up as a whole, and giving it a fresh perspective.

Texture, too, can have the same power as strong colour or a dramatic shape. You can use texture as an end in itself, in the form of a strikingly detailed close-up of an interesting surface, or use it to convey a message as part of a larger image, for example using the texture of decaying wood or crumbling bricks to add to a sense of dereliction within a composition. Also look out for contrasting textures, like the smoothness of flowing water against the rougher texture of a mossy stone, the detail of a leaf against the sky, a piece of fruit on a rough-grained chopping board, and so on. The right lighting conditions can help here – sidelighting often brings to life the intricacies of a texture better than a light directly overhead.

Texture can add interest to the picture, here creating a sense of wear and tear.
1/100, f/2.8, ISO 500, 46mm

These images show the use of repetitive patterns, from the striking light and shade created by the row of trees on the left to the abstract effect created by the umbrellas dotted around the frame on the right.

Reflection

Reflections can transform an image from the mundane to something far richer or more abstract. The obvious composition is a perfectly symmetrical image of the subject and its reflection, but it can be more interesting to capture the reflection alone or let it dominate the picture, making the viewer pause to work out what they're seeing. Playing with reflections can add a new dimension to a conventional subject – even the most overdone tourist cliché in the world can be given a fresh angle when captured upside-down in a puddle. If you're looking for them, you'll start to see reflections everywhere, from the feet of a crowd reflected in the rainwashed pavement to myriad reflections of one building in the mass of glass panels that make up another.

Using reflections can throw up some **exposure** issues, however. Depending on the available light, the reflection may be lighter or darker than the scene itself, in part because light is being bounced into the scene from the reflective surface. And if you're trying to include both the subject and its reflection, that can make it difficult to expose. If you're using a polarizing filter, try rotating it to see how the different positions change the image. If there's a significant imbalance in light between subject and reflection, you can use a neutral density filter (see p.31).

If you're hoping to include the subject as well as its reflection, you'll need to think about which one should be in focus, if you aren't equidistant from the two. Say you're shooting the side view of a friend and their reflection in a mirror, or capturing a building as well as its reflection in an adjacent window. Does it add more to the picture to have the reflection in crisp focus and the subject itself slightly unfocused, or the other way around? And how does shifting your focus from one to the other change the relationship between the two?

This image allows the reflection to dominate, showing the people and statue mainly in their inverted, reflected forms. Including the feet in the top left corner helps the viewer make sense of the image.
1/250, f/2.8, ISO 200, 40mm

>> QUICK TIP

If you need to use flash to increase the light in the scene, position yourself so that the flash won't be caught in the reflection.

The line of symmetry doesn't have to be horizontal or vertical: consider symmetry along a diagonal, or radiating out from a central axis, like a starfish.

To enhance the symmetry in an image, contrast it with asymmetry of tone or colour, such as a centred road leading into the frame, where the fields on either side are dramatically different in colour, or where one part of the image is light and the other dark.

The dramatic structural symmetry here is broken up by the reflected clouds and internal lines of the building.
1/500, f/4.5, ISO 200, 11mm

Symmetry

Symmetry can make for some striking photographs, particularly those that play around with the balance. It often breaks the rule of thirds, of course, by centring the subject, but like most such rules, this one can be turned on its head for visual effect. The danger in this case is that a perfectly symmetrical image can look a little predictable and lack tension. The eye follows an anticipated path, which works if you have a strong point of interest, but can be a bit underwhelming if you don't. Centring a subject demands something dramatic to give the image impact, otherwise you risk your picture looking as though its composition hasn't been properly thought through.

It's useful to think in terms of **visual balance**, working with a centred image but perhaps giving different weight to the two halves of the image. Alternatively, you can make your viewer work to find the symmetry, whether it's implied by two elements confronting each other (such as a person looking at a statue in a museum) or takes the form of two different elements – a tree and a building, say – in symmetrical positions. Or you might compose in such a way that you have a perfectly symmetrical scene bar one element: an architectural image, say, where all the windows are closed except for one at the edge of the frame.

Use of light and shade

Photography is, at its core, the capture of light, and the right light can make colours more vivid and textures leap out of the photograph: it can transform an everyday scene into something spectacular and is one of the most powerful tools you can harness as a photographer. It can, quite simply, make or break a photo.

Natural light

Light can change dramatically over the course of a single day, its quality and colour depending on the weather, the season, the time of day and where in the world you are. The direction of light changes as the sun moves across the sky, altering its strength along with the shape and softness of the shadows it creates. It may seem counterintuitive, but the bright midday sun isn't necessarily the best time to be taking pictures. Harsh, overhead light can strip the life from a scene, making some colours stronger but washing others out altogether, and creating hard shadows and high contrast. An overcast day often makes for better pictures: cloud, pollution and mist can all diffuse sunlight, making highlights duller and producing softer shadows. You can even create beautiful images using moonlight, if you set up a tripod and are prepared to wait around for some long exposures.

This image emphasizes how the light falls, managing extremes of light and shade. Sidelighting also picks out the texture in the adjacent wall.
1/250, f/4.0, ISO 160, 40mm

Although you can use the flash to compensate when the available light in a scene isn't up to scratch (see p.65), existing light will nearly always look more natural than flash, however skilfully you use it.

Directional light

Once you develop an eye for the light in a scene, you'll become more aware of where the shadows are falling, and how to work with the available light to best effect. Move around to get a sense of how your viewpoint changes the way the light falls on your subject, and try different angles and perspectives.

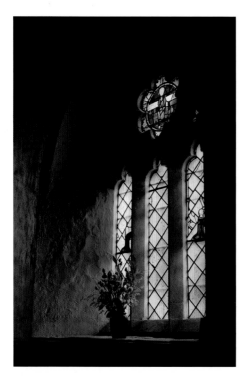

An image taken in low light to emphasize the way light comes in through the window.
1/125, f/4.0, ISO 500, 32mm

>> QUICK TIP

See p.36 for some useful pieces of kit that will help you catch the golden hour, no matter where you are in the world.

- **Frontlighting** It might well be the first piece of photographic advice you were ever given: make sure the sun is behind you when taking a picture. Frontlighting is when the light comes from behind the photographer and falls uniformly on the front of the subject. Of course, it's a straightforward way to ensure there's enough light on your subject, but it will usually flatten out any texture or depth, and can leave your photos looking dull. But there are cases where frontlighting is useful for its even lighting – in architectural shots, for example.

- **Sidelighting** When the light is coming in from the side, it will pick out every detail, creating shadows from even the smallest variation in texture. This can work well in black and white, where texture and tone are critical to the success of an image. Sidelit images have a three-dimensional feel, and working with sidelight from different angles can have a dramatic effect on your photographs, whether they're people, landscapes or buildings.

- **Backlighting** Here the light is coming straight at the camera from behind your subject – exactly what you were always told not to do. Backlighting can create some extreme effects, rendering your subject as a silhouette, or giving them a halo of light. It can be difficult to manage, though: you may get what's known as "flare", where bright rings of light appear in your photo caused by rays of light hitting the lens, and you also have to manage the extremes of dark and brightness when exposing the image. Exposure compensation can be helpful (see p.53), or you can expose for the area of shadow (either manually or by setting the camera to spot meter from the shadowy area). If you're taking pictures of people, backlighting will mean they aren't screwing up their eyes against the light, though you may need to use a reflector to bounce some light back into the shadows on their faces, or even try fill flash (see p.65).

The golden hour

The brief period of time just after sunrise and just before sunset is known as the "golden hour" or "magic hour", a time of day when the sun is low in the sky and everything is bathed in warm, diffuse golden light, accompanied by soft, long shadows. This is a very popular time among photographers, as it brings stunning colour variations, and adds drama to almost any scene. Perhaps part of the reason it's magical is that it's so fleeting; it doesn't necessarily last an hour, but depends on your latitude and the time of year. Generally speaking, the closer you are to the equator the shorter your "hour" becomes, because the sun takes less time to move between the horizon and the low altitude that creates the effect. It's a good idea to turn up a little earlier to find a vantage point and play around with your settings, so that you don't blow your chance of capturing this elusive light.

1/400, f/4.0, ISO 100, 24mm

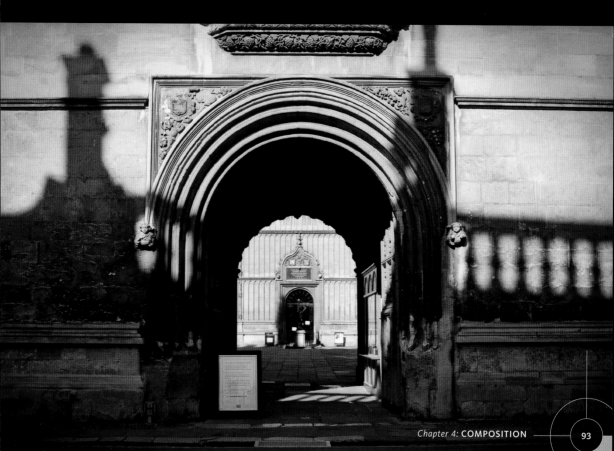

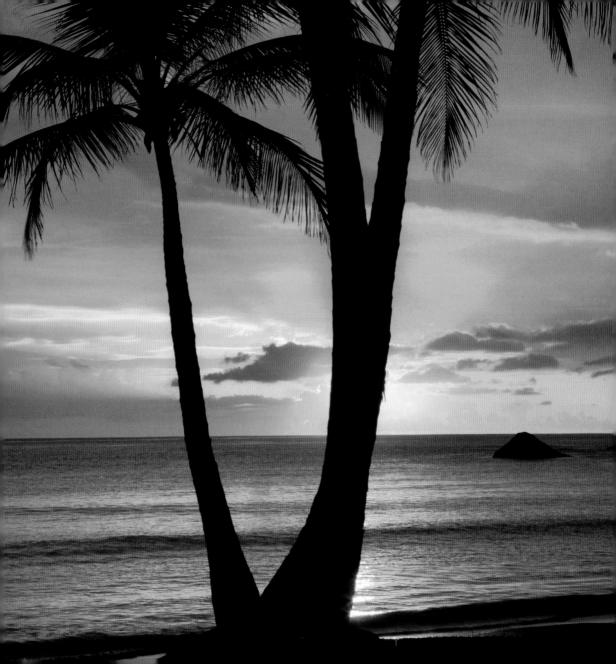

5 GENRES AND STYLES

From travel to street photography, portraits to still life – tips, techniques and sources of inspiration

So, you've got to grips with the basics of technique and composition, and now you want to get out there with your camera and put it all into practice. Whether you're drawn to the candour of street photography, keen to capture characterful portraits of your family and friends, or simply want to evoke the memory of an amazing travel experience, this chapter will give you some ideas to help you think about your subjects and suggest places to look for inspiration, along with some practical tips for getting stunning results.

Travel

For most people travel and photography go hand in hand. Whether you're grabbing your two weeks in the sun, travelling for business or heading off on a round-the-world trip you'll want to record the places you're visiting. You may simply want some snapshots as souvenirs and to share with friends, or you may be keen to experiment with different styles of travel photography. Either way, there are plenty of sources of inspiration and ways of thinking about what you're taking, to ensure that your photos will bring your journey back to life whenever you look at them.

It's often hard to find an original angle on the over-photographed icons of the tourist trail.
1/60, f/5.6, ISO 1600, 38mm

» QUICK TIP

Do some research into the place you're visiting. See whether there are religious festivals, parades or street markets due to take place during your stay.

» QUICK TIP

Get into the habit of carrying a notebook and recording dates, times and places, and keeping a note of where you've been each day: by the time you get home, it's often difficult to remember where you were when you took a particular shot.

Subjects and themes

There are some places on the well-worn tourist trail where you may feel it's impossible to take an original image. The Eiffel Tower, for example, or Machu Picchu. But there are fresh perspectives to be found for even these much-photographed **landmarks**. Get there early in the morning or as the sun is setting, to make the most of the light and miss most of the tourists. Look all round the scene for unusual views, framing the image with something in the foreground, or looking for the reflection of an iconic building in a window or water nearby, and try shooting from unusually high or low vantage points. Or focus on something of local interest in the foreground, and have the iconic landmark looming, out of focus but still identifiable, in the background. Think about the rule of thirds, the colours and textures in a scene, and all the other compositional tricks you have up your sleeve (see Chapter 4). Alternatively, if you're just one of many people pointing your camera at the same thing, consider including your fellow tourists in the image, to underline just how frequently that photograph is taken, or simply to add scale and set the scene.

Capturing local shops and workers can give a good feel for what a place is really like. **1/125, f/6.3, ISO 200, 70mm**

The Eiffel Tower from an unusual perspective, reflected in a shattered pane of the nearby Peace Wall monument.
1/1250, f/4.5, ISO 200, 62mm

Don't just take photographs of the tourist sights, but document everything that's different about the place you're visiting, from the local dress to the street signs, the goods for sale in the shops, even your own food and drink. Wander down side streets or just put your camera down and people-watch for a while, adapting to the rhythm of the place. You want to capture its character, to convey how you felt when you were there, so that your images will trigger memories when you get back home, and help transport your friends and family there too.

Images of **people** will often bring your travel photos to life. Think about their context: showing people at work can be a great way of emphasizing a different culture as well as getting a natural-looking shot, or you might focus on the smallest detail of someone in national dress. Sometimes people will ask to be paid, and there's no right and wrong here: it depends whether you feel comfortable paying for the image you want to take or not. You might want to carry a few balloons or pencils to give to local children rather than money. It's also worth checking local customs to see if there are any cultural taboos about photography. Sometimes photographing in a place of worship is considered disrespectful or offensive, sometimes it's considered

Small details, like this Keralan cow defying local parking restrictions, can help convey the feel of a place.
1/500, f/5.6, ISO 200, 78mm

>> QUICK TIP

Learn the local phrase for "May I take your photograph?" This can be invaluable, especially if you're keen to take a lot of portraits. It's nice to show your subject their image on the LCD screen, too. You might even want to email it to them when you get home, so that notebook will come in handy again to record their contact details.

>> QUICK TIP

Move around the scene, wherever you are, to see what grabs you. You don't want your only experience of a country to be through the viewfinder or LCD screen, and your photos will be enhanced by taking a little time out to try and get a feel for what's going on around you.

Images of people help bring your travel photos to life.

a good way of making money from tourists and permits are sold. It all depends on the circumstances. But always be respectful and polite, and if someone clearly doesn't want their photo taken, leave them be.

You might have one eye on what you'll do with your photos when you get back home, and this can inform what you take while you're out and about. Maybe you're interested in creating a photo journal of a family trip, or doing a **project** on a particular subject from wherever you've been – perhaps recording local faces or looking for architectural features such as doors or windows from around the world.

Panjiayuan antique market, Beijing, China.
1/5, f/22, ISO 400, 38mm

Technical tips

Travel photography encompasses many different styles: people, wildlife, landscape, architecture, macro and many others. You can draw on all of them to make the images you come home with as varied as possible; see the other sections in this chapter for tips on some of the other different styles.

Think about the photos you've been inspired by, and what made them stand out, and then look at your subjects in the same way. It's great to have a record of the whole scene, wherever you are, but don't just stand back and try to get everything in: think, too, about focusing in and capturing tiny details. For instance, not only capturing the bustling market square, but also taking a few shots where you fill the frame with a close-up of the produce on a stall or money changing hands between a customer and market trader. Or take a panoramic beach shot, but also photograph an abstract of the rows of colourful umbrellas or deckchairs. Vary your focal length, your viewpoint, use depth of field to show everything in a scene or just to hint at it with creative blur. In short, experiment as widely as you can.

Inspiration

Because travel images straddle so many different genres, you can find inspiration from the work of the best landscape and nature photographers, people who specialize in portraits, or from great photojournalism – check out the other sections in this chapter.

Simply browsing illustrated travel guides to wherever you're going can fill you with inspiration, or try compendia such as Rough Guides' *Make the Most of Your Time on Earth* or the online photo gallery and related app. Check out Flickr groups for the country to see the sort of images other people are taking and posting, and look at postcards once you get to your destination. The following are some great sources of inspiration.

The Guardian www.guardian.co.uk/travel/photography Competitions, helpful articles and readers' photo galleries.

Paul Harris www.paulharrisphotography.com Beautiful images of people and places around the globe, including work for ecological charities.

National Geographic www.nationalgeographic.com More inspiring images than you could ever dream of.

Andrew Newey www.andrewnewey.com Inspiring travel shots, often focusing on traditional cultures.

Rough Guides Photo Gallery www.roughguides.com/photo Lots of travel photos, as you'd expect, viewable by continent, country and theme.

Top 100 Travel Photography Blogs www.photography-colleges.org/top-100-travel-photography-blogs Helpful for finding photographers specializing in particular areas, such as food or specific regions.

Travel Photographers Network www.travelphotographers.net Online magazine with challenges and critiques, plus lots of members' images.

Steve Watkins www.stevewatkins.com Striking shots from over sixty countries by the author of the photography advice column in *Traveller* magazine.

Wanderlust www.wanderlust.co.uk/magazine/photography Browse the winners of Wanderlust's annual photography competition.

Nevada Wier www.nevadawier.com Stunning images documenting far-flung corners of the globe and the peoples that inhabit them.

Jodi Cobb www.jodicobb.com Inspirational images by a *National Geographic* photographer, exploring the human condition in some of the world's most inhospitable environments.

Policemen guarding Tian'anmen Square, Beijing, China. **1/30, f/22, ISO 100, 200mm**

Travel photography (clockwise from top left) Carnival in Old San Juan, Puerto Rico **1/250, f/11, ISO 400, 30mm**; Theatre, Tian'anmen Square, Beijing, China **1/200, f/11, ISO 400, 70mm**; Fisher women, Morjim, Goa, India **1/125, f/5.3, ISO 320, 240mm**; Route 66, California, USA **1/200, f/8, ISO 100, 24mm**; CN Tower reflected at the Air Canada Centre, Toronto, Canada **1/400, f/4.5, ISO 100**; Pho Bo (beef noodle soup), Vietnam **1/25, f/6.3, ISO 400, 70mm**; Prayer flag on the Everest Trek, Nepal **1/60, f/22, ISO 100, 24mm**; Reindeer in Lapland, Finland **1/400, f/4.8, ISO 200, 17mm**

Landscapes and cityscapes

>> QUICK TIP

Look for natural frames in doorways and arches, through trees or rock formations, to add depth and help focus the viewer's eye on the subject.

>> QUICK TIP

Use a cut-out card to frame the landscape, planning your composition by moving it closer and further away. You might feel a bit silly, but it's a great way to help focus your eye on what's actually going to be within the frame. Make one by cutting a 3:4 or 2:3 proportioned section out of a piece of card (depending on the aspect ratio of your sensor – see p.13).

>> QUICK TIP

Avoid breaking the horizon: if you're using it as a strong line within the image, it can be distracting to have a tree cut through it. Consider changing your position, getting up high or lower down so that the line can remain unbroken.

Landscape photography is often thought to be predominantly about the natural world, and its vast, sweeping vistas – from beaches to snow-covered mountains, and everything in between – and these are indeed great landscape subjects. But it's also about the places that surround you, from a bustling city environment to those empty spaces where the land and sky are left to interact without interruption. With so many people living in built-up environments, it's no wonder that urban areas and their architectural details are such popular subjects. Stations, shop windows, derelict buildings, graffiti-covered underpasses, stairways and even whole city sky-lines all offer fantastic potential for striking urban images. The line between urban landscape and street photography (see p.119) can be blurred, but cityscapes tend to focus more on the physical space, its structure and architectural features, rather than the people who inhabit it.

The strong lines of these trees from Namibia's Dead Vlei break up the horizon, distracting somewhat from the overall image. **1/160, f/9.0, ISO 100, 21mm**

Subjects and themes

All the elements of composition come together in landscape photography, where you're often looking to create big pictures that convey a sense of scale. Consider any lines or objects in the frame, such as the horizon, items in the foreground, roads or paths leading in, and so on – how do they work with the rule of thirds? The relationship between the different elements takes on critical importance as you consider the way the viewer's eye will travel through the image, so look out for **symmetry** and other patterns, such as the way a curved crest of a mountain mimics the shape of a row of trees below it. Look for the natural **pathways** around an image – roads and tree lines, flights of steps and bridges – all of which will help draw the

The viewer's eye is drawn deep into this urban street scene from Siena, while the glistening wet road adds some interest in the foreground.
1/125, f/4.0, ISO 200, 70mm

>> QUICK TIP

Use a remote shutter release or timer delay as well as the tripod, and on an SLR use the mirror lock-up function, as the internal workings of the camera – as the mirror swings up to allow the shot to be taken – can themselves cause camera shake.

>> QUICK TIP

Use your camera's depth of field preview button to check that you have enough of the scene in focus (see p.60).

You don't necessarily need to focus on the overall scene: small details, such as the repeated pattern made by these railings, can make for interesting images.
1/320, f/2.8, ISO 160, 43mm

viewer in. Where the setting permits, try to find something in the **foreground** to focus on, which will add interest and help provide a sense of depth. The focal point is important in landscape photography, as it can be difficult to work out where to look in a really wide scene packed with detail: there's often no obvious subject.

You might decide to focus on **details** rather than trying to capture the scene in its entirety, picking out small sections rich in texture and shape, an abstract image of pebbles on the beach, say, or a frame filled with identical office windows. Including people in your image can give a sense of scale to a landscape, or underline the relationship between a building's form and function.

Try putting together a **themed series** of images based on a single natural or architectural feature, such as trees or cloud formations, gargoyles or neon signs. Or marry the two together, looking for landscapes with a man-made element as a recurrent

theme – pylons dotted through a rural scene, or the posts of a jetty stretching out into the water. Look for features which are themselves reflected in the glass of neighbouring structures, in water, or even in someone's sunglasses. **Colour** is often an important feature in landscape, but the strong, graphic lines of a building or the textural detail of a natural scene can work well in **black and white**, which will help bring out the contrast in the image.

Clever use of **light** can bring a landscape to life, picking out contours or casting long shadows around a building, and giving the two-dimensional image depth. The low light of the sun just after dawn or before dusk – the "golden hour" (see p.93) – provides a warm sidelighting that emphasizes every line and curve, so get up early or hang around before sunset, pre-planning your composition to make the most of it. If you're shooting architecture, note that plenty of buildings are beautifully lit up at night, so think about waiting till dusk has fallen, or using backlighting to create dramatic silhouettes. Try using a graduated filter to balance out the light levels between foreground and sky, or a polarizing filter to deepen colour saturation and bring out the blue in the sky. If the sky is so dull that even a filter won't do much to rescue it, give it less space in your image, dedicating more of the frame to the landscape in the foreground.

Technical tips

Landscape photos often use a wide depth of field, to ensure that as much of the scene as possible is in focus. Select the landscape mode on your camera or use a small aperture – perhaps around f/11 or f/16. Taking the aperture down will mean less light entering the camera, so use a tripod if you have one and use longer shutter speeds, which will also give you the chance to work creatively with cloud or water movement in your image.

Perspective distortion can be used to create interesting effects, like these skyscrapers leaning away from each other in a classic cityscape.
8 sec, f/8, ISO 200, 19mm

Using a tripod will also encourage you to spend some time reading the landscape in front of you, looking for the compositional elements you want to build on. Be prepared to walk some way to find the best scenes and winning vantage points from which to capture them, and spend some time walking around the scene to get a feel for it even before you press the shutter. A bit of planning and thinking through your compositions in advance really pays dividends in landscape photography.

Inspiration

Landscape photography has a long history, and it's easy to find inspiration in the work of great photographers, beginning with masters like **Ansel Adams** and **Edward Weston**. From a more urban perspective, plenty of photographers have focused on documenting a particular city, from the work of **Eugène Atget** on Paris to **Charles Sheeler** and **Berenice Abbott**'s New York or **Bill Brandt**'s portrayal of Blitz-torn London. And there are, naturally, lots of landscape groups on Flickr. Check out some of the sites on pp.108–109 for more ideas.

EQUIPMENT

The competing demands of large vistas and close work mean that you'll want a decent zoom range to give you flexibility when shooting different kinds of landscapes. Compact and bridge cameras will normally give you the range you're after, and if you're taking an SLR you will probably want to cover the 28–300mm range, either with a single zoom or a series of lenses. Filters are often useful when shooting landscapes, too, letting you use the longer exposures you might need when working with a smaller aperture without blowing out the highlights in the brighter sections of the image: experiment with neutral density, graduated or polarizing filters. And if you have a tripod, take it along, to give you more flexibility again with long exposure shots.

Landscape photography (clockwise from top left) Monument to the Sun, Zadar, Croatia **1/200, f/16, ISO 400, 24mm**; Clevedon Pier, Somerset **1/160, f/9, ISO 200, 75mm**; Tuscan landscape **1/500, f/6.3, ISO 100, 88mm**; The Himalaya viewed from the Everest Trek, Nepal **1/160, f/22, ISO 100, 30mm**; Westminster Bridge, London **1/320, f/10, ISO200, 300mm**; Broadway Tower, Worcestershire **1/250, f/13, ISO 200, 18mm**; London skyline at night **30 secs, f/9, ISO 100, 70mm**

Joe Cornish www.joecornish.com Luminous landscapes including some fascinating rock formations.

Michael Frye *Digital Landscape Photography: In the Footsteps of Ansel Adams and the Great Masters* (ILEX, 2010) Inspiration and instruction.

Fay Godwin www.djclark.com/godwin Beautiful, though-provoking images, often in black and white, documenting the rural and urban landscapes of the British Isles.

Fran Halsall www.fran-halsall.co.uk British landscape photographer whose work also encompasses monuments and architecture.

Jason Hawkes *London at Night* (Merrell Publishers Ltd, 2010) Collection of aerial photographs of the Big Smoke.

Tom Mackie www.tommackie.com Hundreds of landscapes and architectural shots from across the globe.

Viaduct and aqueduct over the River Tweed by Joe Cornish.

David Muench www.muenchphotography.com Around 14,000 images of wild places, mainly in North America, but also covering Iceland, Japan, Morocco, Patagonia and more.

Marion Patterson www. marionpattersonphotographer.com Intimate, meditative images of the West Coast of America and the deserts of California.

Take-a-View www.take-a-view.co.uk Great showcase for new work, followed by an exhibition of the winning and shortlisted entries and an accompanying book, *Landscape Photographer of the Year: Collection 4* (AA Publishing, 2010).

Christopher Thomas et al. *New York Sleeps* (Prestel, 2009) Miraculous cityscapes revealing the 24-hour city without a soul in sight.

Charlie Waite www.charliewaite.com Serene, captivating landscapes, capturing light, shape, colour and composition in harmony.

David Ward www.into-the-light.com Packed with abstract, intimate landscape images by the author of *Landscape Beyond: Insights and Inspirations for Photographers* (Argentum, 2008).

Portraits

From formally posed images to casual snaps of family and friends, wedding photos or candids taken on the street, many of the photos we take have people as the subject. This genre includes any kind of image which seeks to convey something about the person or people therein, to capture their likeness, mood, environment, the relationships between different people in a group, and so on. Portraits are often the most fun to shoot, though they can be difficult to do well, particularly if you want your subject to be happy with the picture too.

Subjects and themes

What makes a portrait special is aiming not just for a likeness, but to allow your **subject's character** to shine through. Plenty of people simply freeze up when they have a camera pointed at them. Talking to your subject or making them laugh will help draw them out and get them to forget the camera. People don't always have to smile, nor to look at the camera; a thoughtful expression, looking away or a shared look demonstrating a connection between two people can add interest. On the other hand, having the subject look directly at the camera can make a portrait seem very intense, as anyone looking at the photo will automatically lock onto their gaze.

A portrait doesn't have to be a conventionally framed image of a person's face. Some particularly striking portraits feature an almost abstract **detail**: the hands of a streetseller doing business, a traditional necklace curved around someone's neck, or the eye of a child peering out from behind its mother's skirt. Such images can also tell a story in an indirect way – illustrating a person's work, their role in society, or something about their relationship – and can command attention by virtue of being different.

>> QUICK TIP
Always focus on the eyes. Viewers will naturally be drawn to them, and focusing anywhere else will seem instinctively wrong.

>> QUICK TIP
If you're using a very narrow depth of field and filling the frame with your subject's face, focus on the eye nearest to the camera. Try taking a few pictures in which you focus on different parts of the face, and see what a difference it makes to the final picture.

A thoughtful expression can convey character better than a full-beam, "say cheese" smile.
1/400, f/2.8, ISO 100, 70mm

> QUICK TIP

The tiny lights you often see in the subject's eyes are known as catchlights: try and position your subject so the light source is reflected in their eyes.

> QUICK TIP

Give your subject space to look into, and let their look lead the viewer into, rather than out of, the frame. If they seem to be gazing out of the frame it will distract from the image.

Children

Photographing children can be tricky, as they tear about and find just about anything more interesting to look at than the camera. Try giving them a toy, or a balloon or ribbon to hold which will keep them amused and add to the shot, captivate them by blowing washing-up liquid bubbles or making silly noises, get them to jump as high as they can, or even ask them if they can see the tiny creature hiding inside your lens. Getting down on their level will give you a different perspective and help remove any barriers between you and them, and try using your camera's continuous shooting setting, if it has one, to give you a burst of images which might help you capture that perfect moment, or even to create a great series of shots.

Sometimes sharing the images you've already taken with them is helpful. Children are often fascinated by seeing their own image on the LCD screen, and it might just persuade them to play ball. Or give them a toy camera, so they can take pictures of you as you take pictures of them, turning the experience into a game.

Sometimes a detail makes a great portrait: here the focus is on the fisherman's hands, and the nick on his finger is perhaps a battle scar from the sharp teeth of the fish he's holding.
1/250, f/8.0, ISO 100, 78mm

When taking a picture of someone, think about the **background** and the context. You might want to isolate your subject from their surroundings, positioning them in front of a blank background that won't distract from them, or using a very narrow depth of field to throw it out of focus (see p.58). Alternatively, you might want an image rich in context, offering the person within a setting which helps tell their story – an artist in their studio or a mechanic working on the engine of a car, for example. Try to strike a balance between providing enough background to add context, but not so much that your subject is lost. You can also use relationships to tell a story, showing a grandparent surrounded by their grandchildren or siblings arranged by height.

Get in close sometimes too, filling the frame with your subject's face, to give the image more impact. The picture is all about your subject, so give the

...ding photos are the most obvious example of pictures being used to ...trate a whole series of relationships. If you've been roped in to help ...the photos for a wedding, think about interesting ways of capturing ...day. Find out, too, whether the couple prefer formal or candid shots – ...ed groups or people milling around having a good time – or a mix of ...two. You might find it useful to put a shot list together beforehand.

There are a number of classic images, more or less expected in most wedding albums: the bride arriving in the car, the couple exchanging rings, the first kiss, signing the register, confetti being thrown, cutting the cake, and so on. If you're taking pictures during the ceremony, turn off the sound on your camera.

Make sure you know how many people there are in both parties, and that you get a photo of each of them, in the candids too if you're taking casual shots.

And ask whether there are any family sensitivities: you don't want to be putting the two members of the family who haven't spoken for twenty years or a recently divorced couple next to each other in a group shot.

We've all been at weddings where the formal, post-ceremony portraits have taken hours, till the kids are all fed up and the adults looking longingly at the bar area, so if you are doing group shots it helps to plan the groups you need (the newlyweds, their respective families, the parents-in-law, all the children, etc) and to enlist someone else to help you round them all up when the moment comes, to keep things moving.

Pictures of some of the decorative and other details – such as the rings, place settings, menus, the flowers and bouquet, the cake and the car – can help give shape to a wedding album that's otherwise full of pictures of people.

The couple sometimes want photos taken as they get ready: here you might look for interesting details such as a close-up of the fabric in the dress or veil, or shoes lying ready to be slipped on.

And the happy couple will also usually want photos of the two of them after the ceremony: if you have a chance to scope out the venue and its surroundings before people arrive, you'll increase your chances of being able to find a well-lit location that will provide a nice backdrop for these images.

Look at pictures from friends' weddings, wedding magazines or the online galleries of a few wedding photographers to spark your ideas for the day.

Finally, make sure you have spare memory cards and a spare battery, even a back-up camera if you have an old model, just in case.

EQUIPMENT

You don't really need special kit to capture good photos of people. You'll often be working relatively close up, and most cameras have a zoom range that will give you more than you need. Use the portrait setting on your camera, if you want to knock the background out of focus, and if you're using an SLR try a lens in the 50–85mm range, as these give flattering proportions, or try and zoom to this range on your compact or bridge.

whole frame over to them, or frame them with something else in an interesting and creative way: shoot them through a window, for example, or simply resting their face in their hands. Use focus creatively, perhaps focusing on footprints in the foreground as your subject walks away from you and into the frame, or focusing on a toy and having a child running towards it slightly out of focus.

Technical tips

If you have the chance to **position** your subject, seat them at a slight angle to the camera, so that they turn their head towards the viewer. This looks more natural, and can also help create a gentle diagonal with the shoulders, which is structurally more dynamic than a straightforward horizontal. Turning the neck can also help stretch out or conceal a double chin. Make sure the face is nicely lit: soft, natural light is most flattering for portraits, but not always available. If you're shooting indoors, position your subject close to a window. If you're working in the sun, try and move them away from harsh sunlight, and use a reflector or fill flash if there are hard shadows falling on their face.

Think about your composition, too. Check what's behind your subject and move if it helps to avoid a distracting background. Looking down on your subject can have a distancing effect: if you want the connection between viewer and subject to be more direct, position the camera slightly below their eye level. Try lying on the floor and looking up, or finding a way to take the portrait from above: different positions can lead to very striking images.

Inspiration

There is a vast amount of inspiration out there, ranging from **Julia Margaret Cameron**'s portraits of celebrities of the mid-nineteenth century to **Annie Leibovitz**'s iconic and lavishly stage-managed portraits today, by way of countless masters of the art such as **Irving Penn** or **Philippe Halsman**. The 60s saw the rise of the celebrity photographer, when the likes of David Bailey, Terence Donovan and **Terry O'Neill** became as notorious as those they photographed. Set against this is the more graphic depiction of day-to-day life and loves in the work of **Nan Goldin**, the unsettling black and white images of her children by **Sally Mann**, or the curiously dispassionate adoles-

cent portraits of **Rineke Dijkstra**. We've listed websites documenting the work of some of these photographers below, but you can simply search for examples of their images online to get a feel for their work. Look, too, at the photographers listed in the street photography section on p.119, as they often include candid shots of people, coming at them from a different direction.

Diane Arbus diane-arbus-photography.com Classic and moving black and white portraits of people regarded as being on the margins of society.

Richard Avedon www.richardavedon.com Elegant and sometimes minimalistic portraits, from miners and war protesters to the high fashion requirements of *Vogue*.

David Bailey www.david-bailey.co.uk Faces from the Swinging Sixties, alongside affecting nudes and many other photographic projects.

Jane Bown www.guardian.co.uk/artanddesign/interactive/2009/oct/22/jane-bown-photography Carefully revealing portraits of famous faces from the 20th and 21st centuries.

Woman with veil on Fifth Avenue, NYC, 1968 by Diane Arbus.

Bill Brandt www.billbrandt.com Sculptural nudes, sometimes with an almost otherworldly feel.

Bambi Cantrell www.cantrellportrait.com Celebrity wedding photographer.

Terence Donovan www.terencedonovan.co.uk Iconic fashion images from the Sixties and starkly beautiful black and white nudes and other portraits.

Michael Greco *Lighting and the Dramatic Portrait: The Art of Celebrity Editorial Photography* (Amphoto Books, 2007). This well-known American celebrity portrait photographer shares some of the secrets of his craft.

National Portrait Gallery www.npg.org.uk Holds an extensive collection of original portraits, many of them in photographic form, hosts regular exhibitions of portrait photographers' work and runs the annual Taylor Wessing Photographic Portrait Prize, accompanied by a subsequent exhibition and book.

Arnold Newman www.arnoldnewmanarchive.com Environmental portraits, capturing his sitters in their familiar settings, to reveal more about them.

Bryan Peterson *Beyond Portraiture: Creative People Photography* (Amphoto Books, 2006) Reveals how to create portraits that really say something about their subjects.

Lisa Visser www.hamiltonstudios.com Portraits of children with a distinct style, from an award-winning fine art portrait photographer.

THE ROUGH GUIDE TO DIGITAL PHOTOGRAPHY

Portrait photography (clockwise from top left): Jerzy **1/60, f/1.9, ISO 400, 50mm**; Joe **1/60, f/1.4, ISO 1600, 50mm**; Adwoa Brown **1/125, f/2.8, ISO 160, 28 mm**; Katz's Deli employee **1/80, f/3.5, ISO 320, 28mm**; Bridgetown busker, Barbados **1/130, f/4, ISO 100, 148mm**; Mousel **1/125, f/5.6, ISO 200, 125mm**; Russian bus driver **1/250, f/4, ISO 400, 200mm**

Macro image of a bee on a flower, showing the detail in its fur and wings.
1/100, f/4.0, ISO 400, 24mm

Macro and still life

One of the many exciting things about photography is the way it can be used to reveal a miniature world, capturing in luminous detail things we walk blindly past on a daily basis and playing with our sense of perspective. Macro photography turns the scale of something tiny on its head with unsettling effect, making the most mundane object utterly captivating. While it doesn't always go hand in hand with still life, many of the same issues – lighting, arrangement, composition – apply when shooting inanimate objects at any size.

Subjects and themes

Experiment with small objects from around the house, such as coins or stamps, small toys or food; or from outdoors – flowers and insects, and close-ups of **textured surfaces** such as moss or bark all make great subjects. Macro photography can be used to capture details the eye wouldn't notice: the refraction in a droplet of water, the veins in a leaf or the ice crystals in a hard frost. Shot up close everything is transformed.

Still life is a good place to start, with **inanimate subjects** allowing you all the time you need to work on your composition and the freedom to use whatever shutter speed you want, making lighting and exposure straightforward and depth of field therefore easier to control. Composition is every bit as important in a macro image as in any other, so you'll want to think about positioning your subject and how the image will lead the viewer's eye around the frame.

Even using a narrow DOF, the **background** can still distract if it features patches of brightness or colour, so be prepared to move position if you need to. If you're working indoors, experiment with different backgrounds, using sheets of paper or cloth, smoothed out or wrinkled for different effects. A thick, dark-coloured cloth, such as velvet, will absorb the light so that you don't get unwanted bright patches in your image, or you might want to use a more reflective surface like bright paper, or even a mirror, depending on what you're shooting.

>> QUICK TIP

Use your camera's depth of field preview button, if it has one, to check you are capturing the detail that you want in focus (see p.60); however, reviewing such a narrow depth of field isn't always easy, so it's safest to take several images and select the best on your computer later.

Technical tips

In macro, the focus and depth of field are critically important, and you'll need to control both as precisely as possible by making sure that you focus on the right part of the image (use **manual focus** if you have it) and that you shift your distance from the subject in order to widen or narrow the DOF. Conventionally, macro shots have a very narrow depth of field, sometimes just a couple of millimetres, so that tiny crisp details are highlighted against a nicely blurred background.

If you're able to adjust the **aperture** on your camera, opening it up as wide as possible will help create a narrow DOF, though whether you want this depends on what you're shooting – you may prefer every detail to be as crisp as possible. Most cameras include a dedicated macro mode: selecting this will ensure that the camera works at its minimum focusing distance, to allow you to get in really close, and will usually select a wide aperture to help you knock the background out of focus.

When you're working with tiny subjects, any camera shake will be painfully visible. Working with a tripod will help eliminate this, as will image stabilization if your lens or camera has it.

>> QUICK TIP

Working with a small subject and trying to be precise about every detail, including the framing, can make the fact that an SLR's optical viewfinder won't show you exactly what you're cap may simply have to crop the image slightly in post processing.

>> QUICK TIP

Try spraying flowers or fruit with droplets of water from a plant sprayer. If you place something a few centimetres behind them, and focus on the water, you should be able to show the object at the back refracted in the droplet.

Still life of a centred subject, showing the subtle variations of light and shade and the fan-like pattern created by the flowers, against a neutral background. **1/125, f/1.8, ISO 200, 24mm**

Most cameras will have a macro setting, which will allow you to focus close to your subject and provide a wider aperture to narrow the depth of field and blur the background. Dedicated macro lenses for SLRs come in a wide range of focal lengths, from around 24mm to 200mm. The best lens will depend on your subject – a shorter focal length means you'll have to get very close to your subject, which is fine if you're shooting flowers or objects around the house, but if you're shooting insects or wildlife a longer focal length will give you the same results from further away.

If you're using an SLR, you can also use an extension tube, which sits between the camera body and the lens, to move the optics further away from the sensor and thus increase the potential magnification of the lens, though this also has the effect of reducing the light reaching the sensor because the maximum aperture has effectively decreased (see p.44) and therefore increasing the depth of field. Also, a ring flash fitted around the end of the lens can be useful to avoid the lens casting shadows on the subject itself.

In terms of **lighting**, for macro photography you want a soft, diffuse light that won't create harsh shadows, which can detract from your final image. If you're working inside, try and work in a space with good natural light, and to use a tripod so that you can benefit from slower shutter speeds. If you need more light, a speedlight or off-camera flash is useful for controlling the direction of the light, or use your built-in flash with tracing paper taped over it to make the light more diffuse. Experiment, too, with something reflective – such as white paper or aluminium foil, if you don't have a reflector – to bounce light back into shadowy patches. This can apply to still life too, though you may want to build the shadows into your image, so might choose to create exaggerated shadows through the positioning of your light source or the time of day you opt to shoot.

Inspiration

There aren't many photographers famous specifically for macro work, though plenty are known for their still lifes. Google image searches will bring up some superb examples. As well as the books and other sites listed below, there are plenty of Flickr groups dedicated to macro, still life and tabletop photography.

Wilson Bentley snowflakebentley.com Macros of snowflakes on black velvet, captured in the late nineteenth century.

Harold Davis *Creative Close Ups: Macro Photography for Gardeners and Nature Lovers* (John Wiley & Sons, 2009) Tips and techniques to help you capture small objects and close-ups with flair.

Bryan Peterson *Understanding Close-up Photography: Creative Close Encounters With or Without a Macro Lens* (Amphoto, 2009) Capturing macro subjects in new and inventive ways.

Horacio Salinas www.horaciosalinas.net Inspiringly creative and conceptual still life and macro photography.

Smashing Magazine www.smashingmagazine.com/2008/09/21/25-beautiful-macro-photography-shots-photos A roundup of some captivating examples of macro photography at its best.

John Stewart john-stewart-photography.net Mainly monochrome still lifes of cloth, fruit, flowers and more, inspired by great painters.

Street photography

Increasingly in vogue, partly because so many people always have some form of camera with them, street photography is a candid form that seeks to illustrate the day-to-day, whether recording significant events or simply life as it's played out in public spaces. The blurred line between street and documentary photography is a widely discussed topic: if an image has a political or newsworthy element it might be considered to lean more towards the documentary end of the spectrum. Street photography often has a gritty, realistic feel, because the photographer is in the swing of things and can go unnoticed by the subject. This type of shot's immediacy and candour can be what documentary photography lacks, having more of an air of distance, reportage and deliberate representation. The street photographer is down there in the crowd; the documentary photographer observes from the sidelines. Either way, if you enjoy taking photos of people on your travels, doing the same thing back home can be just as much fun. Street photography doesn't have to be restricted to the streets, either: cafés, museums, shops and social gatherings can all be great sources of the same kind of candid image, shot from the hip.

>> QUICK TIP

Respect your subjects. If someone spots you and asks you not to take their photo, or demands that you delete the photo you've just taken, do what they want. There's also some debate about the ethics of taking pictures of the homeless, who may not necessarily be voluntarily on the street.

>> QUICK TIP

Shoot from the hip, literally. Hold your camera at waist level and get in closer to the scene. It increases the sense of immediacy and being in the midst of the action, and has the benefit of being unobtrusive.

>> QUICK TIP

To stay safe, and avoid confrontation, don't take photos of situations such as people breaking the law or fighting.

Street photography often involves capturing subjects unawares, such as these tourists, immersed in their own image-taking in Oxford.
1/800, f/2.0, ISO 500, 50mm

Candid iPhone shots of a couple of classic street details, using colour to make the subjects stand out.

Subjects and themes

One of the compelling things about street photography is the ease with which the viewer can bring their own interpretation to an image. Because images are unstaged, and can feel like they've been snatched or stolen, capturing a self-contained moment in time, it seems that you're viewing them free from the photographer's own interpretation. Although, of course, what they've chosen to photograph, how they've positioned themselves, and the precise moment at which the shutter clicked do all reflect interpretative decisions by the photographer, and a degree of deliberation about what they want to portray, with commentary implied.

Despite its immediacy, the genre still benefits from some thought being put into composition – even images grabbed on the fly need a dash of creativity if they're to attract attention. If you see an interesting-looking place, or person, hang about for a bit to see whether anything happens to bring an image out of the scene. Markets, parades, festivals and the like often provide good hunting grounds. Look for interesting connections and humorous juxtapositions, the tiny details that seem incongruous in a larger scene, and get in close and take lots of photos. Street photography is often shown in black and white, to strip away the distraction of colour in what can be typically busy images, though there's no reason you can't use colour if you'd prefer.

Technical tips

Street photography can be hard to do: you might worry about coming across as creepy or just find it embarrassing pointing your camera at a complete stranger. Many of the most successful street photography shots are taken up close with a small camera, which is much less conspicuous than an SLR with a huge lens, and because you can compose your images on the LCD it may not even be obvious what you're looking at. A swivel LCD can also be a bonus here. Keep your camera in your hand but be casual about it. Deliberately trying to be surreptitious will attract more attention than taking relaxed photos and behaving as if you're just going about your day. As with so many other genres, it's about timing and anticipation, about

reading the scene in front of you and capturing the essence of the moment as it happens. Snapping a couple of trial shots and adjusting the exposure, so that you're always ready to fire the shutter, will help ensure that you don't miss the moment.

Because there's a lot of movement on the street, you might want to select a shutter speed of 1/125 or faster, if you can control those settings, but you might prefer to record slight motion blur to convey the sense of action. Shooting on auto or program mode is often the best way to work. Whatever camera you're using, go wide with the lens, capturing as much of the scene as possible. If you're using an SLR, try anything between 28mm and 50mm. And make sure you've turned the flash off, so that it doesn't fire at inopportune moments.

Inspiration

Today's tradition of street photography began in the 1930s when **Henri Cartier-Bresson** and others, such as **Brassaï**, **Robert Doisneau** and **André Kertész**, moved away from large studio cameras and started to take small cameras out onto the streets and work unobtrusively to capture whatever they found there (see p.69), and it found later expression in the work of **Garry Winogrand**, **Lee Friedlander**, **Helen Levitt** and others. You can find plenty of images from these photographers online. More recently, in 2007, a chance auction purchase turned up more than 100,000 prints and negatives by the late **Vivian Maier**, a previously unknown street photographer whose work has been making waves online ever since.

With street photography now highly fashionable, there's a great deal of information and inspiration on the web, with collectives debating their principles and exhibiting their work, extensive street photography galleries, articles on street photography, and so on. There are, of course, several Flickr groups on the subject: check out www.flickr.com/groups/onthestreet.

"I'm a photographer, not a terrorist!"

If you're taking photos on the streets, note that anti-terror legislation is increasingly being used as a justification to stop photographers taking images in public places. The group "I'm a Photographer, Not a Terrorist!" was formed in the UK to protest against the use of these stop and search powers against photographers, and their website (www.photographernotaterrorist.org) features a "bust card" which explains your rights should you be stopped by the police or private security guards.

Section 44 of the Terrorism Act 2000, which does not require the police to have "reasonable suspicion" that any offence has been committed in order to stop and search, has since been ruled unlawful by the European Court of Human Rights, and has been suspended as far as searching an individual is concerned. But there is still plenty of legislation in place under which the right to take photographs in a public place can be threatened and any photographer – amateur or professional – targeted as a potential terrorist, and so the campaign to protect photographers' rights continues.

Polly Braden www.pollybraden.com Acutely observed images of people going about their everyday lives.

Maciej Dakowicz www.maciejdakowicz.com Colourful, larger-than-life street images, including the infamous "Cardiff After Dark" series.

Elliott Erwitt www.elliotterwitt.com Candid images from the streets, often capturing the absurd in a beautifully understated fashion.

Sophie Howarth and Stephen McLaren *Street Photography Now* (Thames & Hudson, 2010) An inspiring look at contemporary street photography, crammed with images from many of its most popular practitioners.

Vivian Maier vivianmaier.blogspot.com Explores what is known about Vivian Maier's life, and provides the base for the ongoing project to develop, scan and share more of her work.

Joel Meyerowitz www.joelmeyerowitz.com Online portfolio of the great New York City street photographer.

Martin Parr www.martinparr.com Quirky site showcasing the brilliantly eclectic work of one of the most popular photographic chroniclers of our age.

Clive Scott *Street Photography: From Atget to Cartier-Bresson* (I. B. Tauris, 2007) Documents the history of street photography, and illustrates the different forms it's taken over the years

Seconds2Real www.seconds2real.com Site run by a co-operative of Austrian and German street photographers, featuring great images, articles and interviews.

Elliott Erwitt at a retrospective of his work in Düsseldorf, with an image shot in New York City in 1974.

779 www.sevensevennine.com The website of London street photographer Nick Turpin, who also runs the international street photographers group in-public (**www.in-public.com**).

David Solomons www.davidsolomons.com Online gallery for the contemporary street photographer from London.

Matt Stuart www.mattstuart.com Another well-known street photographer's portfolio, featuring beautifully honest and often humorous images from the streets of London.

Chris Weeks (ed) *Street Photography for the Purist* (free PDF download) cweeks.deviantart.com/art/Street-Photography-38038974 A PDF download full of musings about street photography from a number of photographers, alongside a great quantity of inspirational images.

Wildlife

There is something magical about capturing another living creature with your camera. Great wildlife photographers speak of the fleeting spell of that relationship, about the excitement of tracking and getting close to their subject and the need not to compromise its welfare or disturb its natural behaviour – not to frighten a nesting bird nor to stop a hunter capturing and killing its prey. But taking pictures of animals isn't limited to getting out in the wild: it might equally mean a portrait of the family pet, taking photos in zoos or even shooting underwater.

>> QUICK TIP

Disable any of the sounds your camera makes, so you don't frighten your subject off by beeping at an inopportune moment. And do the same with your phone.

Subjects and themes

Taking photos of animals calls for long lenses, quick thinking and a great deal of patience. If you're interested in taking photographs of a particular animal or bird in the wild, you'll want to study its behaviour, research its habitats, and consider the precise vantage point that will help you capture the shot that you're after. The photographers who deliver compelling images of a particular creature have in many cases spent years studying it, taking photos over and over again, and learning all the way along. But you might be on a guide-led safari, having all the planning done for you, trying to get a good photo of your dog as it rushes about in the local park, or taking photos of the birds that visit the bird table in your garden. In fact, if you're going on safari, practising on the birds in your backyard or the squirrels in the local park isn't a bad idea at all. You'll get a feel for your zoom range and the settings you need to use, as well as a sense of just how quickly you need to react to get a good shot.

>> QUICK TIP

Focus on your subject, using focus tracking if it's in motion, and checking the focus point at intervals. If you're shooting a close-up, focus on the eyes.

Technical tips

Planning aside, what a great animal photo will come down to at the end of the day is shooting and composing instinctively, as the most striking images often capture a single moment, the flash of blue as a kingfisher dives into a stream, say, or the instant your dog jumps for a ball. Keep the rules of a strong composition in mind: try and capture the animal facing or moving into, rather than out of, the frame, and think about the rule of thirds. Once you're in situ,

Underwater photography

If you have a chance to go diving or snorkelling, and have an underwater camera or a casing for your normal camera, you might want to have a stab at underwater photography, getting up close and personal with shoals of dazzling fish and creating colourful, otherworldly images. It can be difficult to compose a strong photograph in an environment where moving can be a little slow and positions hard to hold, and taking pictures can be dangerously distracting, particularly if you're diving, so make sure you know what you're doing in the water before you start trying to take photos as well.

If you're shooting at any kind of depth, you'll need some kind of artificial flash, as light levels fall away quickly the further down you go, though you can shoot with natural light in the shallows if you're just snorkelling or swimming. Colour is also lost the deeper you go, starting with the red end of the spectrum, and this applies to distance from your subject too, so working close up is the best way of maximizing colour and avoiding everything turning out a murky blue-green. The macro setting will enable you to close focus. Using the flash will help preserve colour, for any photos not taken in the shallows. Your camera may also have an underwater mode which will automatically colour correct, but don't use this as well as the flash, as you'll end up with some odd results. Experiment with the underwater mode first, to see precisely what effect it has on your photos. A better alternative is to set a custom white balance (see p.61), so you know you're working with the best possible settings for the specific environment you're in, and take some test shots to get the rest of your settings ready.

If you're shooting pictures of fish or other marine life, you still want to focus on the eyes if you can – though if you're focusing on a shoal of smaller fish, this won't be possible, and you'll need to be prepared to spend some time to let the creatures get used to you being there. Using continuous focus mode will increase your chances of getting an image that actually works, and as usual you can adjust your shutter speed to represent the movement of whatever you're trying to capture in different ways (see p.79).

have your sports mode selected, or take a couple of shots to get your exposure right, so that you're ready for action. Select continuous shooting to give you more chance of getting the shot. Think about panning with the subject if it's fast-moving, or introducing motion blur to convey a sense of its speed (see p.80), use image stabilization if your camera or lens has it, and take a lot of photos to increase your chances of getting the one where everything comes together.

Inspiration

There are plenty of places to find inspiration online. The Veolia Environnement Wildlife Photographer of the Year prize showcases some astonishing new work, followed by a travelling exhibition of the winning and shortlisted entries. Check out some of the following for a wealth of advice and ideas.

Mark Carwardine www.markcarwardine.com Wildlife, nature and environment images from the conservationist and broadcaster who also chairs the Veolia Environment Wildlife Photographer of the Year prize.

David Doubilet www.daviddoubilet.com Awe-inspiring portfolio from a well-known underwater photographer.

Martin Edge www.edgeunderwaterphotography.co.uk Website of the author of the classic underwater photography text, *The Underwater Photographer* (4th edn, Focal Press, 2009), which is regarded as a classic reference guide to the subject. The website features a gallery of images as well as information about the courses Edge runs in the UK.

Stephen Frink www.stephenfrinkphoto.com Captivating underwater images from an established photographer in the field.

National Geographic www.nationalgeographic.com The usual range of stunning and inspiring photographs, including plenty of underwater images.

Anup Shah and Fiona Rogers www.shahrogersphotography.com Strikingly beautiful images of African and Asian wildlife.

Richard du Toit www.richarddutoit.com Portfolio of inspirational aerial and nature photography from a photographer who has worked for National Geographic and BBC Wildlife, among others.

Underwater Photography Guide www.uwphotographyguide.com Features extensive and easy-to-understand beginners' tutorials and general advice on starting out.

Art Wolfe www.artwolfe.com Beautiful images of wildlife, including portfolios on marine life and birds.

EQUIPMENT

Consider whether you want to capture the animal in context, to illustrate its habitat or behaviour, or to take close-up portrait images of the animal itself – or just a part of it – as this will affect your lens choice on an SLR. On any camera, wildlife is one genre where your zoom range is important, and something which goes up to 300mm or higher will really help. You can add teleconverters to extend your zoom range, though not without reducing image sharpness and your maximum aperture.

THE DIGITAL DARKROOM

Managing and editing your digital photos

Unless you were a serious photographer with access to a darkroom and bottomless funds for photographic supplies, editing film photos simply meant throwing away any particularly bad prints. These days, anyone with a computer (or a smartphone) can correct exposure, improve contrast or convert to black and white. You already decide what to shoot and how, and bringing the best out of your images involves a similar series of creative decisions. A huge range of powerful tools is available for managing your pictures as well as editing them, some of which require nothing more than a computer and web connection.

Software

Software packages vary from free online versions through which you can run your photos without even registering to eye-wateringly expensive professional-level packages with more functionality than you can ever imagine needing. Your camera will probably also come with proprietary software, including RAW conversion software, if you're able to shoot in RAW, as well as workflow and editing tools, and this may be all you need. But if you're interested in experimenting further, take a look at some of the most popular packages, outlined below.

Working with a **desktop program** may give you more security: some of the online programs occasionally crash while you're working on an image and you can lose your changes, and you won't want to rely solely on an online library for

> **>> QUICK TIP**
>
> Even the priciest software is usually available as a thirty-day free trial, so you can have a play with various options and choose the one that best fits your needs.

Proprietary software

Check that any software that comes bundled with your camera is up-to-date and works with your computer system. Sometimes it can be fairly high-spec, such as Canon's Digital Photo Professional and Nikon's Capture NX, both for SLR cameras, though if the kind of work you want to do leans more towards the design end of the scale than the straight edit end, you'll need to look into getting something else.

storing your photographs. But **web applications** are great for when you're away from your computer and want to run a picture through a quick edit and share it online, or simply don't want to invest the money and time required in learning your way round one of the higher-spec packages.

Choosing software

It's easy to be seduced into buying the most elaborate package available, but if all you're really going to do is basic editing and correction work you might be better off with the software that came with your camera, or even a free download, at least to start with. If you do then need to upgrade later, you'll be in a better position to know exactly which features you're looking for. Layers and curves, for example, are two valuable features which allow you to tailor very specific adjustments (see pp.148 and 156). Otherwise, the crucial elements to check are as follows:

- **System requirements** Photo-editing programs can be very memory hungry. Check that you have the RAM you'll need, and that the software will work with your operating system.

- **Camera compatibility** If you have a very recent camera model, check that the software is compatible. Most software manufacturers' websites list the models they support.

>> QUICK TIP

If you're likely to spend some time tagging and keywording your images (see p.142), check that your software allows you to update the metadata embedded in the actual image files, and doesn't just update it in the catalogue index within the program itself – that way any work you do will stay with the image file, whatever you do with it.

- **File formats** If you're shooting in RAW, ensure that the software supports RAW file processing, and that it will let you save and export in a range of file formats.

- **Workflow and organization** Check what the software offers in this area, especially if you already have a system you want to maintain.

- **Web integration** At the least, check you can export pictures in web format, for upload to photo-sharing sites or to email to friends. Some software integrates

directly with sites such as Flickr or Picasa, allowing you to work on images online, or to upload them seamlessly once edited.

- **Support and information** Look into the availability of online support, not simply from the software provider itself, but in the form of unofficial blogs and sites with tips and tutorials.

Web-based and free software

There's no shortage of free downloads or web-based photo software out there. If none of those we've covered does the trick for you, a search online will turn up plenty of other options.

Picasa

Mac OS X, Windows, Linux; picasa.google.com; free

Unlike most of Google's software, Picasa is not a web app but downloaded to your computer. It offers free photo-editing and organization software with particularly good sharing capabilities: you can create galleries and send the link to your friends, compile slideshows for the web, put your images on a map with Google Maps or geotag them to My Places in Google Earth. Several photo-sharing sites including Flickr and Facebook have Picasa plug-ins to facilitate direct uploading. You can also share images online through Picasa Web Albums (see p.175), though the two work independently of each other. Picasa's face-detection technology starts to build recognition of the same faces as they appear in your images, to aid the tagging process. Picasa also supports most file types, including RAW. The editing tools are limited in the main to one-click fixes and a few effects, such as sepia and soft focus, though it has a very intuitive user interface.

In-camera editing

Camera manufacturers are starting to add in-camera editing functionality to their models – especially compacts – to allow you to make a few quick changes to your images before downloading them. You're limited as to what you can do, usually things like rotating and cropping, fixing red-eye, or applying an effect such as black and white, making the colours more vivid, or making the image soft focus. If you have a lot of images to process, editing in-camera will be pretty tedious, and you can't review focus and sharpness properly on a screen the size of the LCD. But it can be worth experimenting if you're reluctant to get into post processing on the computer, or simply need to print or share an image online straight from the camera.

Image adorned with a funky floral border in Picnik.

Picnik

www.picnik.com; basic version free

Since acquiring free online photo-editor Picnik, Google has taken steps to integrate it with Picasa, and you can also use Picnik's editing tools within Flickr. The site is also linked to Facebook, Photobucket and other sites, so you can grab photos from your albums there and run them through an edit (Picnik doesn't itself provide storage). The editor doesn't support RAW files, and has a 16MB file size limit, so TIFF files will often be too large to import. You don't have to register to use the basic service, simply upload a photo, make your changes and download the result. The editing tools contain everything you'd expect, plus a bunch of fun effects, and you can print your own photos or, with an account, order prints, books and cards. Upgrading to Picnik Premium ($24.95 per year, also monthly) gets you access to advanced tools, including Curves and Layers, plus the ability to upload up to 100 images at a time. If you just want to run your images through a light edit before sharing them online, or you're away from your computer and don't have access to your usual software, as a free service this takes some beating.

Photoshop Express

www.photoshop.com; basic version free

Web application Photoshop Express is a very different proposition from either Photoshop or Elements (see below), designed to edit your photos (JPEG files only) without saving them back to your desktop. It currently works with Facebook, Flickr, Photobucket and Picasa and comes as a free basic version with 2GB of storage or an upgraded Plus account with 20GB of storage at $49.99 a year (either gives you additional storage for an annual fee), and you can create albums of uploaded images to share with your friends. The editing tools are, for the most part, quick fixes, plus there's a decorate mode for adding frames, speech bubbles and so on. It's a useful alternative to Picnik

>> QUICK TIP

See what's available online in the form of popular plug-ins for the program you're looking at, reading the reviews, and factoring in the cost or whether there are free plug-ins available.

if you want to make a quick change to something in your Flickr account, for example, especially if you want to create an album for sharing, but in editing terms there isn't a great deal to choose between them.

Windows Live Photo Gallery
Windows; www.windowslive.co.uk/essentials/photogallery; free
A free download for Microsoft Windows users, providing image organization and editing tools as well as online storage. It accepts RAW files, though you'll have to download and install the file support for your particular camera model first. You can post photos direct to Facebook or Flickr, or to the Windows Live SkyDrive photo storage and sharing site, and add tags and rate your images. It's also good for sharing via email: your images appear as thumbnails and the recipient can click through to the larger versions in your gallery. The editing tools allow you to tidy your images up and apply a couple of effects, but overall it's geared to organizing and editing images you don't want to do anything too elaborate with. It has some nice features, like the ability to stick photos into a panorama or fuse different versions of a photo together to create one image (useful when working with group portraits), and if you're used to Windows you'll find the interface easy to use.

GIMP
Mac OS X, Windows, Linux; www.gimp.org; free
GIMP is a free open source image editor whose functionality is often said to rival that of Photoshop. As a UNIX application it doesn't have the glossy user interface of Apple's or Adobe's offerings, which means you'll need to spend some time finding your way around. But there are lots of sites offering free tutorials and help, and plenty of plug-ins available, several of which streamline processes such as reducing noise or improving contrast. It's worth starting with some of the more basic tutorials on the GIMP site itself, and working your way up. GIMP is absolutely packed with features and high-end tools, including Levels, Layers and Curves and a RAW conversion tool, though you can't output to CMYK for printing without using a separate plug-in, such as Separate+. But it compares very favourably with the higher-end paid-for products.

Software tutorials
Whatever your software, there are lots of sites – some provided by the manufacturer, some not – which offer free tutorials, and can talk you through shortcuts for particular techniques, or how to get the best out of the program in a way even the most comprehensive manual may have overlooked. Try the following sites, as a starting point, or just Google tips and tutorials for your particular application:

Photoshop Tips
www.photoshoptips.net

Planet Photoshop
www.planetphotoshop.com

PhotoshopEssentials.com
www.photoshopessentials.com

Lightroom Killer Tips
www.lightroomkillertips.com

The Aperture Blog
www.theapertureblog.com

GIMP Tutorials
www.gimp.org/tutorials

Entry-level software

The software covered in this section should offer all the functions most amateur users need, along with a relatively straightforward user interface.

The Adobe Elements organize interface.

Adobe Photoshop Elements

Mac OS X, Windows; www.photoshop.com; £79/$100

Elements is a pared-down version of Photoshop, aimed at amateurs and available for about a sixth of the price. It contains most of the basic tools you're likely to need for enhancing your images, plus some cut-down design features such as adding text. The benefits are a simpler interface with fewer menus and toolbars to trawl through, and a number of fully automated steps, but you lose some of the more advanced features such as exporting as CMYK for printing, and a number of adjustment tools including Curves and colour balance. It's compatible with some of the most popular Photoshop plug-ins, which helps fill some of the gaps, and it does include Adobe's Camera RAW converter. It also offers a few things Photoshop doesn't, including Quick Fix modes, frames, and online sharing options for Facebook, Flickr and other sites.

Corel PaintShop Photo Pro

Windows; www.corel.com; £59.98/$79.99

Covering both photo-editing and management, this inhabits territory somewhere between the basic offering of Elements and the fuller functionality of Photoshop. It offers basic RAW support and a very useful Express Lab feature, which contains one-

step tools for the most commonly used adjustment and retouching functions. More detailed editing work can be carried out in the Full Editor mode, which includes layers among a bunch of advanced features, though the interface is less intuitive than the Adobe products. You can output as CYMK for printing, and PaintShop also supports Photoshop plug-ins. The bundle includes PaintShop Photo Project Creator, which facilitates online sharing through Flickr, Facebook and YouTube and lets you create cards and photo books.

iPhoto

Mac; www.apple.com; £8.99/$14.99 in the Mac App Store
Part of the iLife suite of applications bundled with every new Mac, iPhoto is designed to help organize, edit and share your photos, and includes a RAW-to-JPEG conversion tool. The retouching tools cover some basic edits – brightening exposure, straightening a horizon – and are easy to use, laid out in a neat Quick Fixes panel.

Viewing images in the iPhoto gallery.

There's also an Effects panel through which you can convert to black and white or lighten your photo with a single click, while an Adjust panel gives you a little more control over the tools. Editing is non-destructive, iPhoto creating a new version of the image every time you make changes to it, though this can tie up memory and make your libraries hard to manage. It integrates with Flickr and Facebook, as well as Apple's own online gallery site MobileMe. This synchronizes in both directions, so any changes you make to tags or titles on these sites will flow back into iPhoto, though if you delete an album on iPhoto it will vanish from the sites too. You can also create slideshows using animated themes with different layouts and transitions, and you can design books, cards and so on, though you have to get these printed through Apple.

Pro software

Should you want to spend a little more in return for more advanced editing and organizational tools, there are a number of packages targeted at professional photographers, with a higher price and more complicated user interface to match.

Adobe Photoshop

Mac OS X, Windows; www.photoshop.com; £644/$699

Since its creation in the late 1980s Adobe Photoshop has become the image-editing industry standard, spawning dozens of sites and blogs on how to use it. At the time of writing it's in its 12th release, as part of Adobe Creative Suite 5 (which includes Adobe Bridge, the image management part of the package), and has become ever more complex, making it a challenging program to learn and tricky even just to find your way around the many hundreds of menu commands. Advanced tools include extensive colour management options, creating animated GIFs, drawing and creating artistic text. You'll almost certainly need to consult some of those websites and blogs, or buy a manual to help navigate its functionality, and you're unlikely to ever use all it has to offer, though there's nothing out there that will give you more control over your photographs. It's targeted at professional users, from photographers through to designers and web developers, and priced accordingly.

Adobe Lightroom's library interface.

Lightroom

Mac OS X, Windows; www.adobe.com/lightroom; £232/$299

Also from Adobe, Lightroom is an image processor and database management system. While Photoshop undoubtedly has the edge in terms of pixel-level control in the edit and creative manipulation of an image, Lightroom allows you

to make all of the basic editing changes, giving you a simpler interface to work with, though you're limited to global adjustments to an image for the most part and can't use layers. Unlike many other applications, including Photoshop, the editing process is non-destructive: your edits are stored in the metadata alongside the image and applied if you want to view or export it. Lightroom draws together the tools that most photographers use regularly and omits some of the more designer-oriented features of Photoshop, providing a better organizer and a seamless workflow from upload through RAW conversion to processing and output for printing or the web.

›› QUICK TIP The open source program GIMP is a pro-level package, but without the price tag; see p.131.

Aperture

Mac; www.apple.com/aperture; £44.99/$79.99 from the Mac App Store

Aperture is Apple's photo-editing and management software, which – like iPhoto – allows you to upload images to Facebook and Flickr, includes a face-detection algorithm, and uses the Google Maps API to facilitate geotagging as part of your workflow. These are all features which outpace Lightroom, despite a lower price-tag, although the two programs are constantly leapfrogging each other with updates. Aperture also offers a custom book feature, enabling you to design and order photo books from within the application, and you can upload video files and integrate them into slideshows (unusual for a stills photo application). It features an advanced RAW workflow and, like Lightroom, non-destructive saving, so you can't overwrite your original by accident. If you're used to iPhoto, Aperture will seem like an intuitive next step. Mac users can download free trials for both Aperture and Lightroom and see which suits them best.

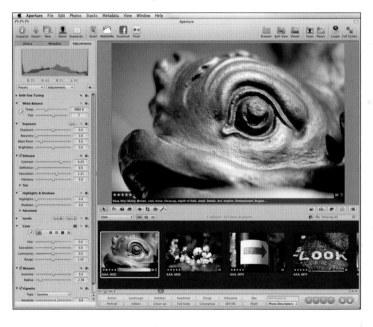

Aperture's processing interface.

Smartphone apps

The ever-growing list of photography-related smartphone apps ranges from those which allow you to add effects to your images or share them with an online community to others with fuller editing functionality. Here's a handful of the most popular apps, from the purely functional to the gimmicky:

100 Cameras in 1 One hundred different filters and effects to be applied to your iPhone photo library or via the camera – see also Trey Ratcliff's blog, p.187.

Camera+ Helps you take better photos with your iPhone, improving control over focus and exposure and allowing you to line your pictures up on a grid. It also offers scene modes, such as sunset or portrait, and a selection of effects and frames to enhance your final image.

Camera360 Ultimate Offers HDR-style enhancements for Android, alongside many other effects.

CatPaint Paste a variety of cats all over your iPhone photos, adjusting their size with sliders, and opting to let them shoot laser beams from their eyes around your images if you like. The cats mew as you move them into position, making this a fun app to amuse the kids.

Darkroom If you're shooting in low light, this iPhone app features a steady mode which will only take the photo once there's no movement. The Pro version also offers a self-timer, so you can be in the photo yourself or prop the camera on a firm surface to further reduce movement.

Hipstamatic An iPhone app where you select from different lenses, flashes or films to lend your images an old-school toy camera look and feel. You can purchase additional HipstaPaks from within the app to increase the range of effects, though sadly you can't import images from your library for a spot of post processing.

Instagram As much about sharing as anything else, this iPhone app features easy uploads to a range of popular services, including Flickr, Twitter and Facebook, and an ever-growing Instagram community, where you can follow other users, see what's popular and leave comments. Also includes a great range of filters to add effects to your photos, whether new pictures or ones from your library.

Hipstamatic

Pano or **AndroPan** A pair of apps (for iPhone and Android, respectively) that let you stitch photos together to create great impressive-looking panoramas. Exactly how many photos you can take depends on the model of phone.

PhotoCalc Not itself designed for taking or editing photos, this iPhone app is a handy reference guide for when you're shooting with your main camera. As well as the settings you need for correct exposure, depth of field and flash exposure, it includes a sunrise/sunset calculator to tell you when the sun will rise and set wherever you are.

Photography Calculator Offers something similar for calculating depth of field, though not the other settings, for Android.

Photoshop Express A Photoshop-based app for both iPhone and Android, which lets you apply some very basic edits to new photos or images already on your phone, such as cropping, desaturating or lightening exposure, and a handful of effects. You can then upload to Facebook or TwitPic as well as your gallery on Photoshop.com.

PicSay A photo-editor for Android, letting you correct elements such as colour or brightness, crop or distort your images, and also add text or speech bubbles and graphics like light sabres or lipstick kisses.

ProHDR An iPhone app which captures two images, one exposed for the highlights and another for the shadows, and then aligns and merges them into a single HDR image.

Retro Camera Very similar to Hipstamatic, Retro Camera for Android and iOS phones adds a toy camera look and feel to your photos, inspired by popular cameras such as the Holga and Lomo.

Vignette An Android app that lets you zoom and crop as you take images, and set your cameraphone on self-timer. It also features a bunch of film or camera effects you can add to your photos, both those taken using the app and those from your photo library, from vintage styles to a Lomo or Polaroid look.

Camera+

The Best Camera (see p.187).

Plug-ins

There are plug-ins available for all of the pro software packages, and some of the entry-level ones too, providing additional functionality that ranges from creative effects such as film grain to finely tuned black and white conversions. Some provide a simplified interface for a function the program already handles, others enhance the capabilities of the original software itself. Most come with a thirty-day free trial, so you can experiment before you buy. Check out our selection below as a starting point; a search online will uncover plenty more.

- **Alien Skin Exposure** www.alienskin.com Gives your photos the look and feel of film, with presets that recreate the distinctive look of popular film types like Fuji Velvia or Polaroid, plus a huge range of effects including infrared and dust and scratches.
- **Color Efex Pro** www.niksoftware.com A range of options to enhance images and speed up your workflow, with effects such as graduated filters and film grain.
- **LucisArt** www.lucisart.com Gives a very distinctive, gritty look to your images, a little like HDR, with enhanced detail in shadows and highlights, brought out of a single exposure.

The Silver Efex Pro plug-in.

- **PhotoFrame** www.ononesoftware.com Add photo frames and edges to your pictures, from traditional film borders to complete layouts into which you can drop your photos to create scrapbooks and photo albums.
- **Photomatix Pro** www.hdrsoft.com Helps you merge multiple exposures into a single high dynamic range (HDR) image – see p.154 for more on HDR.
- **Silver Efex Pro** www.niksoftware.com For the creation of high-quality black and white images, with precise control over tonality, contrast and grain, and presets which emulate classic black and white film types.
- **Topaz Adjust** www.topazlabs.com Creates very dramatic effects which make colours pop, with images that have a little of the HDR look to them.
- **Virtual Photographer** www.optikvervelabs.com Lets you add drama and artistic effects to your images, with lots of presets, such as glamour, sepia or spooky. A quick way of enhancing images that just need a little push.

Digital workflow

Film photography involved a relatively straightforward workflow, not that you'd have called it that at the time. You took photos, processed them, looked at them, and stored them – maybe framing some, putting some in an album, and keeping the rest in the packs you got back from the shop. The digital version is a little more complicated. For a start, you'll have many more pictures to sort and file on your computer, since the cost of firing off another digital frame is next to nothing. You're processing them yourself, too, which means you may have several different versions of the same image, including those you've saved to share in your online albums or through Facebook. And then you have regular back-ups to worry about, whether on a separate hard drive or saved to the cloud.

›› QUICK TIP

When labelling by date, use reverse date format (YYYY-MM-DD): these will be listed in a more logical order when your computer orders files by name, and you won't have to scroll through hundreds of folders or files starting with "01" to find the one you're after.

Organizing your images

Organizing your photos involves coming up with a system for all new uploads and working through the photos you already have with a view to implementing it retrospectively there too. If you've got a lot of photos, this can be a long and tedious task, but it will be worth it when you can find the image you're looking for in an instant. Start by gathering your images together in the same place: if you haven't always specified that photos upload into a "My Pictures" folder or equivalent, run a search for all items with the relevant file extensions (.jpg, .tif, .dng or your camera's RAW extension). If you've posted your pictures on image-sharing sites and not kept any kind of back-up on your computer, copy those back as well.

Your software may dictate how you order your files: for example iPhoto will simply create a library of photos with a folder for each date. But if you're using a package that offers more flexibility, decide on a **folder structure** that works for you, whether that is organizing image folders by date, or by categories such as "Travel" or "Family", or particular events. Some people rename individual photo files, overwriting the camera's **file names** (e.g. DSC8036.jpg) with perhaps the date, the event and a sequenced number from the photo series (e.g. 2010-07-01-Dadbirthday-001). Others prefer to keep the

camera file names, and simply use folders and tags to find a particular image. You'll want another system for edited versions, maybe adding a suffix such as "edit-001" to the relevant files, or one which indicates the destination of the file, e.g. "web-001", "print-001". Any system is fine, as long as you can find your unedited original if you need it and can tell which is the most recent edit. So once you've settled on a system, stick to it.

Local storage and back-up

Having an effective back-up system is essential to protect your photos in the case of a computer crash or file corruption, something that all too many people learn only when it's happened to them. If you rely on a single device, such as your computer, you risk losing the lot. Options include **external hard drives**, or backing up online and saving your photos to the cloud. There are plenty of applications that will automate the process for you, allowing you to schedule when and how often back-ups run, and which folders they scan for new data. Running manual back-ups every time you modify your files is an option, but only as effective as your ability to do it faithfully every time you make a change to your files.

As part of the back-up, remember to include **catalogues** created by your image management software too, which will usually appear by default in the "My Pictures" or equivalent folder, in a subfolder with the same name as your software. Programs which offer non-destructive editing don't change the original image but instead store a series of instructions about the edits you want made in the metadata alongside it – applying them on the fly if you want to view, print or export the image – so you'll lose them if you don't back up the catalogue, unless you've exported and saved these edited images. For extra security, back up in at least two places, and keep one of them offsite. Cloud storage can really come into its own here.

Cloud hosting

Cloud storage involves uploading your data to be held on a **remote server**, rather than on your desktop computer. You can then call your content back down wherever you are, as long as you have an internet connection, and know that it's backed

>> QUICK TIP

Once you've decided on a folder and file structure for your images, replicate it on your back-up system, making it a mirror of your internal hard drive. This will make it easier to back up new data and to find files. An automated back-up program will do this for you if you simply select the folders and files to include.

>> QUICK TIP

Once you've uploaded your images, don't wipe your memory card until you've backed up, so that you have a copy of your originals right from the start.

up elsewhere so you don't need to worry in the event of a computer crash. With a growing trend towards hosting music, books, documents and other content in the cloud, and anxiety about the safe storage and back-up of an increasing number of – often very large – photo files, cloud hosting for photographs represents a logical meeting of the ways. Most of the companies already offering **file hosting** are geared up to take photo files, though while the basic free packages might suit your needs when backing up the odd document, you're likely to have to pay a subscription for the amount of storage most photo catalogues will need, and the fees can mount up quickly if you need a lot of space.

The MobileMe log-in page.

If you're sharing your photos online, you're already using a cloud-based service, and most of the sites covered on pp.167–181 double up as a form of storage, though unless this is explicitly stated in their terms and conditions it's unwise to rely on it as your only form of back-up. Even Flickr have been known to delete user accounts, usually for contravention of the community guidelines, and once they're gone they're permanently deleted and can't be restored. Some sites where photo-sharing is the main aim, again including Flickr, will also automatically downsize extremely large files if they exceed their maximum upload sizes, so if you aren't backing up separately elsewhere, you risk losing your highest-res versions.

Look for a site where storage is explicitly part of the package. If it's included as part of a photo-sharing site, look for an assurance that photos are never deleted, and check for the maximum file size, any resizing guidelines, and the overall storage space provided. If you're just after storage on its own, then try one of the cloud storage services listed below. Bear in mind that if you have even a reasonably substantial catalogue the initial back-up can take days, or even weeks. And just as you wouldn't rely on a single back-up offline, don't assume that just because it's in the cloud it's completely secure. Running a local back-up is still a sensible move.

>> QUICK TIP

If you decide to deactivate your sharing or storage account, make sure you download any photos you aren't holding elsewhere beforehand, as some services will wipe your data immediately.

Dropbox www.dropbox.com
MobileMe www.me.com
Google Docs www.docs.google.com
Amazon Web Services www.aws.amazon.com
Mozy www.mozy.com

Metadata and tagging

Metadata is descriptive information embedded in the file itself, which can therefore be exported alongside the image to a website or application. Some of this information – the date and time the image was taken and the camera settings used – comes automatically from the camera in the form of **EXIF data** (see p.15), recorded with the image as it's taken. Most image management programs will also allow you to add further metadata yourself, such as tags or keywords.

Tagging comes into its own both when cataloguing and retrieving images and also when sharing pictures on the web. Photo-sharing sites like Flickr make a feature of tags, and just as others can find your photos through a tag search, you can click on the tags added to your image and jump to other people's photos tagged with the same thing. When you're adding keywords, think about the elements of the photo, its location, people or objects, actions and events, anything you might be looking for if you were to land on this image – all of this will improve the chances of others discovering your photos.

Resizing for the web

If you want to post images online, or send them via email, you'll need to reduce them in size. Uploading very large image files to the web takes a long time and they often can't be viewed onscreen without scrolling – online sharing sites and galleries often stipulate a maximum file size for this reason. It's particularly important that you work on a copy here, and avoid overwriting the original, as you'll otherwise lose your higher-resolution version and won't be able to use your photo file for anything else, such as making prints.

Many programs have a "**save for web**" setting, which will select JPEG by default and allows you to adjust resolution, pixel dimensions and file quality. Most monitors have a resolution of 72 pixels per inch (ppi) and will display your images at that resolution, so it's fine to select that here. Inputting a maximum number of 800 pixels for the longest edge gives an image size which will work well in most cases, even on larger monitors. If you only have the option of selecting a high-, medium- or low-quality JPEG, which determines the degree of compression the file undergoes in the process of saving, medium should give you a good enough image for web use – but view your image at actual size to check what it will look like. This process should give you a file size under 300KB, which will upload quickly and easily to the web, or as an email attachment.

Saving processed images

One good habit to get into is to start any editing work by making a copy of the file and working on that, rather than the original. Editing may change the image irreversibly, particularly if you've cropped it and thrown pixels away, and repeated saves in lossy formats such as JPEG will degrade the image, so having the option of going back to the original can be very useful.

If you shoot in RAW, you'll have to save as a different file format (RAW is a format for unprocessed data). But whatever kind of file you start with (see pp.10–11), the following are the most common options for saving your processed images on computer:

Digital workflow

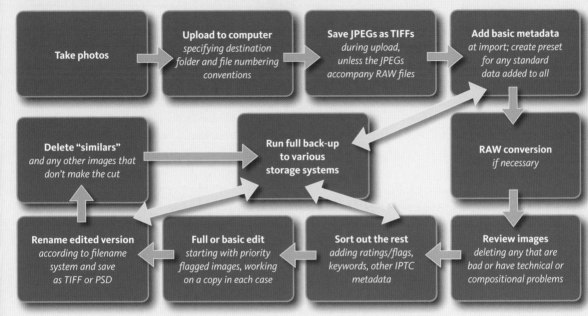

- **JPEG** A lossy format, which means that repeated edits and saves will result in a degraded file where detail is lost and the image looks blocky and pixelated. Saving images captured in JPEG as TIFFs on upload and after editing will prevent further data loss. If you want to keep them as JPEGs, try completing all your edits in one go and only saving once. This is the format most often used for images on the web.

- **TIFF** High-quality, lossless format, so your image can be saved repeatedly without losing data. Takes up a lot of space, though.

- **PSD** Photoshop files, which preserve separate layers from the editing process. These take up a lot of space: if you're sure you've finished editing, you can flatten the layers down and save as a TIFF file.

- **GIF** Small, lossless files, better used for animated graphics than for photos, as they only have a limited palette of colours (which means missing colours will be substituted with their closest match).

- **PNG** Saving in PNG format creates files which are usually smaller than a TIFF, though typically larger than the JPEG, without significant loss in quality. The format supports the same wide range of colours as a JPEG, too. Also handy if your edited image contains some transparency (if, for example, you've deleted the background), as PNG supports this while JPEG doesn't. PNG is sometimes used for online sharing, though not very widely to date.

Sharing offline: printing

For details of sites that also offer printing, or for other things you can do with your images
▶▶ see Chapter 7 and pp.200–201

It wasn't so long ago that printing in some form or other was the only way to share your photos, but now that digital has freed us from the high costs of film development, we probably take many more photos than we'd ever want to print in any case. But printing can still be a good way of archiving your favourite images and sharing them with family and friends. There are several ways to ensure the prints you end up with do your images justice.

Printing basics

Printing at home is straightforward, though can be pricey when you look at the cost of photo papers and the ink you'll use. But if you have a printer that's suitable for photographs (see pp.40–42), it's the easiest way to make sure that the colour, tone and dynamic range come out properly, adjusting the image file if you need to brighten a particular picture or to push its saturation. If you want your prints to look good, it's worth buying high-quality **photo paper**, and it will also help them last longer. They'll still fade over time, but if you use archival quality photo paper and inks they should last for 25–40 years or more, if kept out of direct sunlight and ideally under glass (which protects against pollutants in the air).

Colour management

Although it sounds daunting, colour management simply involves aligning the colour characteristics of each device used in your workflow – namely your camera, computer monitor and printer – so that they render colour consistently and correctly, and so that your prints end up looking the way you expect them to. Every pixel in your image is composed of different proportions of **red**, **green** and **blue**, but the colour profile or response of a particular piece of equipment is device-dependent. This means there's no guarantee that the version of red (or green, or blue) captured by your camera or shown by your monitor matches the colour that is considered to be standard red. It's worth saying, though, that if you don't feel comfortable playing around with the various set-tings, the default is probably good enough, so unless you start to see an actual problem in terms of print colour, you may just want to leave the settings alone.

However, if the photos you're printing (or getting back from a print company) look significantly differ-ent to what you're seeing on screen, your **monitor** is the best place to start (see box). Try and look at your prints in daylight, so that their appearance isn't dis-torted by an artificial light source. If your printer has a colour management or colour correction option (you may need to look in the Advanced Properties box for this), what you need to do here is simply turn it off, as otherwise you'll be colour managing twice and are likely to end up with inaccurate, and sometimes simply nasty-looking, results.

Most digital cameras have more than one option when it comes to colour space, most commonly sRGB and Adobe RGB 1998, as do most photo-editing pro-grams. If you have this option, setting each one to the same colour space will also help keep the colour pro-file of your images consistent. **sRGB** is the best colour

Calibrating your monitor

If your monitor isn't calibrated, you have no way of knowing what an image really looks like, so it's well worth spending a few minutes doing this, and then repeating the process every month or so. Monitor colour tends to drift as the device ages.

The most basic way of adjusting the monitor, without shelling out for dedicated software or a colorimeter, is to check that all the settings are optimized, and then to make a print and compare it with the image on screen. Allow the monitor to warm up for about thirty minutes first, as colours can also drift during warm up, and try to ensure your screen is angled away from sources of either direct or reflected light; then check that both your screen resolution and colours settings are set to the highest available setting. Next, adjust brightness and contrast using an online calibration tool (try **www.displaycalibration.com**), in the form of a gradient strip showing a range of grey tones all the way from pure black to pure white. If you're losing detail at either the darker or the lighter end of the strip, adjust both brightness and contrast settings until you can just make out each tone in the range.

Now print an image, ideally something well exposed, with a wide dynamic range and plenty of colour, printed at the highest quality settings and on photo paper. Hold it next to the open image file on your monitor and compare the two. Adjust the custom colour settings on your monitor, and tweak brightness and contrast again if need be, to get the two to match as closely as possible.

profile for displaying images on the web, because it most closely approximates the colour gamut of the most common monitors and display devices, which means when using sRGB you have the best chance of ensuring that your picture looks the same on your friend's computer monitor as it does on yours. **Adobe RGB 1998** has what's known as a broader colour space, which means it offers a wider range of colours, but because this can't be accurately displayed by any Windows-based browser, the colours will actually tend to look duller than they do in sRGB, meaning it isn't a good choice for sharing images online. Most commercial printers will also expect customers to be working in sRGB, and again this means that files supplied in Adobe RGB 1998 may look washed out.

Some specialist printers will ask you to supply files in the colour space **CMYK** (cyan, magenta, yellow, key black), as these are the primary colours used in printing inks. Many of the basic editing packages won't let you convert to CMYK, but most of the outfits which offer photo prints on the high street (or its online equivalent) will work with sRGB. If you do convert an image to CMYK for printing, you'll notice a change in the way its colour and brightness appears on your monitor, and while the monitor has an

It's impossible to show in print the effects of converting an image from RGB to CMYK because the page you're looking at is printed with CMYK inks, but the above pair of images is an approximation of what happens when you convert the colour of an image from the RGB gamut (top image) to the slightly smaller CMYK gamut (bottom image).
1/640, f/5.6, ISO 250, 32mm

RGB colour space, pushing the colour, brightness and contrast until the image looks good again on screen is the best you can realistically do in terms of getting the file right to send off.

Resizing and resolution

You may not need to resize your images. Your home printer usually gives you print options ranging from a single full-page image, through a couple of conventional print sizes, to a sheet of tiny thumbnail prints. And when you're ordering prints through an online service, you'll select the size you want as you place your order, and the site will let you know if your image file is too small to give a high-quality reproduction at a

particular size. But if you want to print at an unusual size, perhaps to fit an unconventionally sized frame, or are using a bespoke online service that requires you to upload correctly sized files, you may need to resize them beforehand.

Most editing programs will let you alter the size of an image in terms of either **pixels** or its actual **dimensions**, or both. File resolution is an important element here too, just as when displaying an image on screen, because if a file is not sufficiently high res for the size you're printing at, you'll end up with a blocky-looking, pixelated print. If you're ordering a photo product online, the site will often warn you if the image you've uploaded is too low res for a particular purpose, but some labs simply request files at 200 or 300dpi or ppi. If you have the option of selecting resolution, specify 200 or 300 as appropriate, and then input your file size in whatever unit you prefer to work with; if not, you'll need to work out the dimensions in pixels that will give you the file size you need at the resolution specified by the lab, and input those figures. For example, if you wanted to make a 6"x4" print, and the lab required 300ppi, your dimensions in pixels would be (6 x 300) x (4 x 300), so 1800 x 1200 pixels. Critically, whichever method you're using to resize your images, ensure that you have selected the "constrain proportions" box first, or you may end up changing the relative dimensions of your photo and making it look very odd indeed.

Editing techniques

Whatever your photo-editing program, there are certain **basic tools** you can expect to find, while the higher-end applications tend to share the same range of additional tools, even if they are packaged differently. Some changes can be implemented with a single click, whereas others take more time to master. The following section runs through the tools that will give you most bang for your buck in terms of delivering knockout results while being relatively straightforward to master, starting with selection tools and layers, which are both helpful in implementing the other techniques that follow.

>> QUICK TIP

You'll find that dpi (dots per inch) and ppi (pixels per inch) are often used almost interchangeably when talking about sizing and printing your images, which can be confusing. Technically, this is inaccurate: computer screens and cameras should be referred to using the term ppi, as they display the image in pixels, and printers or printing using dpi, which refers to the dots of ink which make up the image. But it doesn't make a material difference when planning and sizing your prints and isn't something to worry about.

>> QUICK TIP

Several of the higher-spec packages, including Lightroom, Photoshop and Aperture, will allow you to batch edit a number of images in one go, applying specific settings to all of them. This can be a very useful time-saver, if you have a large number of images taken in broadly similar lighting conditions or of the same subject, though you may need to tweak individual images afterwards.

Layers

If your software includes Layers, you can use this sophisticated tool when making most of the editing changes discussed in this chapter. Basically, it enables you to alter your images non-destructively by overlaying effects on separate layers: imagine stacking several clear plastic sheets over your image, and making a different edit on each one. When you look down through the layers, the changes appear to be made to the original image, but you haven't touched a single pixel in the photo itself. All of the basic editing techniques that follow can be implemented on layers, rather than straight onto the original. It's still sensible to work on a copy of the original image though, in case you ever want to revisit the pre-edited version. There are several types of layer to choose from:

- **New layer** Places a new, blank layer over your image. This can be transparent or opaque, and is useful for adding elements such as text or borders, or for painting colour onto part of an image.

The texture layers have been named here to identify the type of texture in each one – background, framing, and so on.

- **Duplicate layer** Allows you to duplicate whichever layer you currently have selected. You might want to work on a copy of the background layer, for example, rather than the background itself.

- **Fill layer** Creates a new layer which you can fill with a solid colour, gradient (where one colour fades into another) or pattern, for example if you want to create a new background for your subject.

- **Adjustment layer** A new layer used for adjusting your original image, for example making changes to levels or brightness and contrast.

One reason layers are so useful is that they enable you to apply **localized edits**, by making a selection or erasing the part you don't want to work on in the layer. Any layer will usually affect all the layers beneath it, though you can limit the effect to the layer immediately below by locking the two together. You can delete or re-edit any layer in the stack, or change their order by dragging them higher or lower, if you want the layer to affect different layers in the pile; and you can also adjust the opacity and blending of each layer, changing the effect it has on the image. You can also turn the visibility of a particular layer on and off, if you want to be able to work on the layers beneath it without distraction. When you're ready to save the image, you can save as a PSD file with the layers intact, or, if you know you won't want to go back and make changes in future, **flatten** the layers down to save space.

Selection tools

Sometimes you won't want to make a global change but to edit only a particular area of the image, for example to brighten a dark area or reduce the saturation of the background so that your subject jumps out. The most common selection tools allow you to define an area to work on either by drawing round its outline or by selecting pixels of a particular colour. Once you've made a selection, you can apply changes to that area alone, and the rest of the image will be protected. If you want to edit the rest of the image and protect your selection, click on Invert Selection.

>> QUICK TIP

As well as the selection tools listed here, you can use the Eraser to work on just part of an image, by creating a duplicate layer and erasing the parts of that layer you don't want to edit.

Selection using the Magic Wand tool.

The best way to get to grips with the different selection tools is to experiment with them and see how they differ from each other. Which one you should choose for a particular task depends on what you're intending to select:

- **Quick Mask** protects areas of the image that you don't want to select. Pick a brush and paint over or "mask" the area, click Quick Mask, and everything else in the image will be selected. You can also choose to invert the selection and select the part you've painted over instead.

- **Magic Wand** lets you select large areas of a single colour quickly. Click on an area and the tool will automatically select other pixels which are the same colour and in contact with each other. You can modify its tolerance to include or omit subtle differences in colour.

- **Lasso tools** allow freehand selections. With the basic lasso you simply mouse around the object you're trying to select, keeping the left button of the mouse held down. The Polygonal Lasso consists of a series of straight lines. Left-click the mouse at each corner, and the lasso will draw a straight line between them, until you get back to your starting point. The Magnetic Lasso works best if the object stands out from the background. Roughly trace the outline, clicking periodically, and checking that the fastening points are all on the border of the object (you can go back a step to delete any that aren't), until you join the first fastening point to the last.

- **Marquee tools** are useful for grabbing selections which are more or less square (use the Rectangular Marquee) or round (the Elliptical version). Click on your image at a point which will fall on one of the corners or edges of your selection, then drag the shape outwards until it covers the area you want to pick up.

>> QUICK TIP

Feather the edges of your selection if you want to create a smoother transition between the changes you are applying to the selected area and the rest of your image.

Brightness and Contrast

The Brightness and Contrast tools do just as you'd expect, and are usually presented as a pair of **sliders**. If you don't have the option of using layers to make a selection, these changes will be applied to the whole image, making them a bit of a blunt tool – you could make the shadows in a particular image brighter, for example, so you can see more detail, but this might also result in blowing out the highlights. But if you can work on a selection, the sliders are a handy way of adjusting shadows and highlights.

The brightness control will lighten or darken the image, and can help improve a slightly over- or underexposed picture; the contrast tool will adjust the difference between the darkest and lightest pixels in the shot. Experiment with the levels of both, adjusting the whole image or using one of the selection tools to work on a particular area that looks flat and lacking in detail.

Many packages have an "**auto contrast**" or "**auto levels**" setting, which will maximize the tonal range of an image, optimizing the contrast. Give this a try, as it can be a useful starting point for further adjustments.

>> QUICK TIP

Increasing the contrast can make colours look richer and more saturated, but don't push it so far that your image looks unrealistic (unless that's the effect you're after).

>> QUICK TIP

There are several ways of using your software to adjust the areas of light and dark in an image, including the Levels and Curves tools, covered on p.155–156.

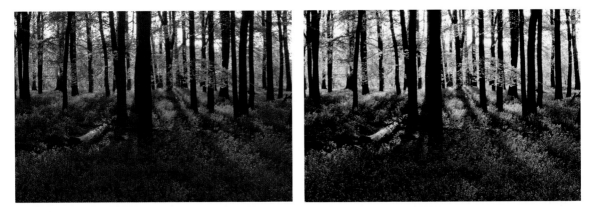

Here the brightness and contrast sliders have been used to lighten the image and to enhance the contrast between the brighter background and the darker foreground. You can see how flat the image looks beforehand in the version on the left.
1/13, f/8.0, ISO 100, 35mm

Dodging and Burning

The Dodge and Burn tools have their origins in traditional darkroom techniques for darkening or lightening small sections of a photograph, and are particularly useful if your software doesn't allow you to use layers to make precise selections for the purpose of brightening and contrast. They're great for helping to direct the focus of your images, for example, darkening a background to help draw attention to your subject or brightening unwanted areas of shadow. The **Burn** tool darkens the image, and the **Dodge** tool lightens it. Use them with caution, though, as it will usually take a number of mouse clicks to get the effect you're after, meaning you may not be able to undo all your dodging or burning; it's best to save a version of the image before you start using these tools.

Select brush size and a hard or soft edge. You can also select the **exposure percentage**, or the degree to which you are decreasing or increasing exposure in the area you're working on, and whether you want it to work on shadows, midtones or highlights, which helps to fine-tune the area affected. If you have layers in your software, but still want to use Dodge and Burn, work on a duplicate layer (see pp.148–149), so that it's easy to reverse the action if you overdo it.

The photographer has dodged, or lightened, some of the unwanted shadows in this shot – particularly those on the child's cheeks and chin – in order to brighten the image.

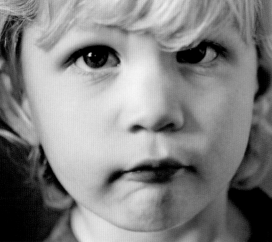
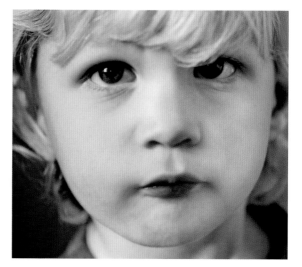

Selective colour

An eye-catching technique, where the bulk of an image is converted to black and white, but some parts are left in colour. You might do this to highlight something in the frame, play down a distracting background, or just to create an interesting visual effect. Selective colour is often achieved by using layers to create a desaturated layer over the original, then painting it out or erasing it where you want the original colour to show through. It can also be done just by using the selection tools: select the object you want to remain in colour, invert the selection so you've selected everything else in the image, and convert to black and white. The object you've excluded from the selection will remain in colour.

1/25, f/2.8, ISO 3200, 70mm

High Dynamic Range imaging (HDR)

HDR is a technique designed to recreate in a photograph the dynamic range visible to the human eye – see p.68 for more on why photos tend to fall short – by taking and merging a number of different exposures. It's easily taken to excess, producing overblown and unrealistic-looking images (Google "HDR images" and have a look at the results), but used with care it can genuinely enhance an image.

Once you've taken your multiple exposures (see p.55), you can use your software or a plug-in to layer them on top of each other in the processing. **Photomatix Pro** is a popular HDR application, also available as a plug-in for Photoshop, Lightroom and Aperture, while Photoshop itself has a "merge to HDR" function (File > Automate > Merge to HDR).

If you're using your software without a plug-in, you essentially have to merge the exposures yourself in the processing, layering the exposures one on top of the other, and then using the selection tools to select the highlight details from the underexposed version, the shadow details from the overexposed one and so on. This is known as "exposure fusion", and can be difficult to achieve without strange looking "halo" effects where an object is against a bright background, unless you spend a lot of time editing the layers at individual pixel level.

Full HDR results tend to look more professional because they combine all the exposures and then follow a second, "tone mapping" stage which renders the resulting image for display on a monitor or for printing. You can also use the HDR software to work on a single RAW exposure, because RAW captures more detail than JPEG in the shadows and highlights, though the dynamic range will inevitably be more limited than it would be if you had taken several separate exposures.

Levels

The Levels tool allows you to work on brightness in an image by targeting just the brightest or darkest pixels, or working solely on the midtones. It's a fairly precise way of selecting particular parts of the image according to their degree of brightness, rather than by area or colour, though Curves (see p.156) gives even more control.

The tool takes the form of a **histogram**: a graph tracking the different levels of brightness along an axis from shadows on the left to highlights on the right, with its height at each point showing how many pixels are at that level of brightness. A correctly exposed image will have a graph that looks a bit like the jagged peaks of a mountain range, with pixels recorded from left to right the whole way across the chart and coming neatly down to zero at each end. A high bar at either end, i.e. at 0 or 255, indicates clipped shadows or blown highlights, respectively: areas of the image which are so dark or so bright as to have lost detail. While you can't fix a badly over- or under-exposed image by using levels, you can make targeted adjustments to get the best out of what you actually captured.

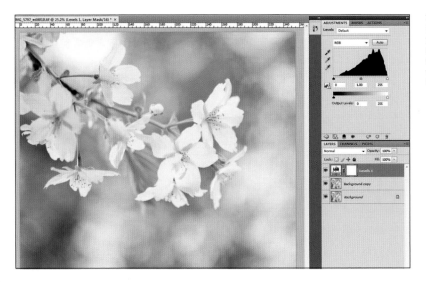

The histogram here shows the balance of pixels in this image tends towards the bright end of the scale, although there are some dark pixels towards the left-hand end, and while the image is quite bright the highlights are not clipped.

The Levels histogram features three sliders at the bottom of the graph, one each at what's known as the **black point** and the **white point**, and a third in the centre for the **midtones**. Drawing the black- and white-point sliders in towards the middle of the histogram slightly can help boost contrast in the image, by indicating that these are the points which should be black and white, and thus making the pixels between those points darker and lighter, respectively. The middle slider will brighten or darken the midtones in your image. It will always automatically move to the middle of the range, whatever changes you make to the position of the black and white points. Moving it to the left will brighten the image, and moving it to the right will darken it.

Curves

The Curves tool makes possible very precise, subtle adjustments to brightness, contrast and tones: whereas the Levels tool limits you to working with highlights, midtones and shadows, Curves allows you to adjust any point in between. It appears as a graph with a single line at 45°. The point at the top right corner is the **white point**, and the point in the bottom left-hand corner is the **black point**, while the three **anchor points**

in between (where the diagonal intersects with the graph beneath) represent highlights, midtones and shadows, as you move from white to black down the graph. You make changes to your image by changing the shape of the curve.

Start with the anchor points, until you get used to how Curves works, and work in an adjustment layer rather than on the original. Click on one of the points and drag it to a different position, noticing the change in the image: even fairly minor movements can have quite a radical effect. Moving the curve up will lighten the image, moving it down will darken it, and

the point on the curve at which you're working will affect whether you are working with the image's highlights, midtones or shadows. You can even move the black and white points to different locations and see what effect that has.

You can create as many different points as you need, by clicking on the graph and dragging the curve around. The one you clicked on most recently will be "live" and will show as a solid black dot; if you want to work with a different point, click on it to select it, and if you need to delete a point, just drag it off the graph and it will disappear.

Hue, saturation and luminance

The colour in your images can be adjusted by making changes to one or more of its elements – hue, saturation and luminance. **Hue** simply means what we usually define as "colour", **saturation** is the intensity or strength of the colour, and **luminance** is its relative brightness or darkness. Many of the more sophisticated packages will let you control these three elements separately. But if not, you should have at least one slider to adjust colour, and may also have a **colour temperature** slider, which will warm or cool the tones in the image, and a **vibrancy** setting, which increases the intensity of the less saturated colours in an image but doesn't affect those which are already highly saturated.

The colour adjustment tools can do a great deal to enhance your image, but go easy with those sliders, at least while you're still getting used to them. Oversaturating an image can result in pictures which look unrealistic.

>> QUICK TIP

If a particular colour starts to look too strong and you have control over the individual colours, desaturate it a little.

>> QUICK TIP

If you're planning to share your images online, push the saturation a little further than normal, as some colour will be lost through file compression.

Altering hue, saturation and luminance: (clockwise from top left) original shot; the hue slider pushed towards the purple end of the spectrum; the luminance is reduced; highly saturated.

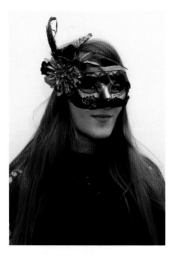

This image was taken in a strip-lit room using a flash, leaving it with a bluish cast. The top image shows it as taken, while the bottom image has had the colour balance corrected using Photoshop. **1/60, f/4.5, ISO 250, 40mm**

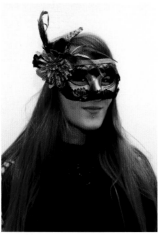

Colour Balance

Colour balance adjustments (including adjustments to **white balance**) allow you to remove unwanted colour casts, such as the yellow or green tinge produced by artificial light, and render colours – particularly neutral colours, such as white or greys – correctly in the image. You do this by adjusting the relative intensities of the additive primaries red, green and blue (**RGB**), whether by using colour sliders or the Levels and Curves tools outlined above.

- **Colour Balance** These sliders allow you to make global adjustments to the relative proportions of RGB in your image. You may be able to choose to work only on the highlights, midtones or shadows. Watch the image as you work, to check that you're getting rid of any unwanted colour cast, and that you aren't going too far and introducing a new one. You'll notice that each slider is marked with red, green or blue at the right-hand end and with cyan, magenta or yellow at the left, because if you move one of the sliders all the way over to the left-hand side, you've stripped that primary colour from the image and are left with the complementary subtractive primary.

- **Levels** Making levels adjustments separately in each colour channel gives you more control over brightness than the colour balance tool. For example, if an image shows a strong yellow cast, you would select the blue channel (yellow being the subtractive primary that complements blue) and expect to see the histogram showing pixels bunched towards the left-hand or yellow end of the scale. By moving the right-hand pointer towards the "blue" end of the scale you'll correct the yellow cast. Adjust the middle pointer until you're satisfied with the balance of warm and cool tones. You can do precisely the same for red/cyan and green/magenta tones.

- **Curves** These can also be applied separately to the individual colour channels, but with the added ability to adjust any precise point on the tonal curve, representing each pixel in the image from light to dark. You can simply remove a yellow cast from the highlights, for example, and leave the rest of the image unchanged.

Textures

If you spend any time looking at images on Flickr or other photo-sharing sites, sooner or later you'll be struck by an image which seems to have a kind of vintage patina or a look that doesn't seem to have been achieved just by taking a photo. This is often the result of importing another image, often a photograph of a texture – such as rough plasterwork or a scratched metal surface – and adding it as a layer, to bring extra depth and detail to the picture.

To add a texture, open it alongside the image you want to work on, and drag it onto the image, so that it appears as a new layer. You can then adjust the blending modes (which affect the way the texture will interact with the layers below it, for example Colour Burn increases the contrast in the image, Luminosity simply picks up the luminance of the texture), the opacity, erase parts of the texture if there are sections of the image where you don't want it to appear, adjust its colour or brightness, and so on – just play around until you end up with an effect you like. Adding layers like this allows you to embellish an image with handwriting or make it look scratched and aged, to tone down a distracting background or drag a Polaroid frame over the top of it.

Textures are widely available for download, often for free, or you can create your own by taking photos of interesting surfaces around you – a wooden bench or piece of cloth, say, and then layering them into your images. Check out the following links. And be sure to always check the licence type, whether the creator requires attribution and whether commercial as well as non-commercial use is permitted if there's a chance you might want to sell any of the images you create.

The CoffeeShop Blog www.thecoffeeshopblog.com/p/textures-and-digital-paper.html

Grunge Textures www.grungetextures.com

PhotoRadar www.photoradar.com/techniques/technique/100-free-textures-for-photo-editing-in-photoshop

Textures for Layers www.flickr.com/groups/textures4layers

Cropping into unusual shapes may make it harder to get the image printed, particularly if you're taking it into a print shop. You can get around this by constraining proportions, or by specifying a particular width and height you want the crop to be, though if you actually want an oddly shaped image you may just have to pay for the next print size up and cut the white borders off your image later.

For more on composition and using the rule of thirds ▶▶ see Chapter 4

The dance of the backing singers is emphasized by cropping out the lead singer from the frame. **1/100, f/5.0, ISO 4000, 56mm**

Cropping and rotating

Cropping is probably the most drastic tool at your disposal, allowing you to do anything from tidying up the edge of an image to altering the composition entirely. Perhaps you've included something in your frame you didn't want – remember you won't get exactly the same image as appears on the sensor when you look through the viewfinder (see p.14) – or maybe the background is more distracting than you expected. It may just be that you want to improve the composition by shifting an element onto one of the thirds lines.

In most programs, the Crop tool shades the area you're proposing to cut away, so you can see what the crop would look like. You can often turn on a thirds grid in the viewing window to help you. In this case more than any other, it's essential to always work on a copy: cropping changes your image radically, and you may need to be able to go back to the original. There's a limit to how many pixels you can cut away – whatever kind of file you're working in – before you'll end up with a low resolution, blocky or pixelated photograph. How much you can cut away will depend on how many pixels you had to start with, and thus your camera's sensor size and resolution, and the file format you're shooting in. If you know you'll want to print your photo, make sure that your crop leaves you with enough pixels to make the size of print you want, at around 200–300dpi (see p.8).

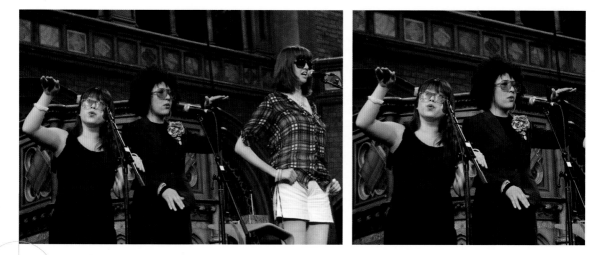

A **sloping horizon** isn't just annoying; it's a distraction that can undermine the image. Use the Rotate tool to adjust the image by degrees until the horizon is level, using the grid to ensure you get it right, and then tweaking the crop, as rotating will leave gaps around the edge. Alternatively, look for a tool that corrects camera distortion.

Correcting camera distortion

Horizontal and vertical lines will often appear distorted in your photos, either curving outwards towards the edge of the frame (**barrel distortion**) or inwards towards the centre (called **pincushion distortion**), or simply converging towards one edge of the image instead of running in parallel (**perspective distortion**). It's particularly exaggerated in images taken at short focal lengths, or using a wide-angle lens, and is most noticeable in images that include a lot of straight lines. Distortion can really spoil your shot (unless you're deliberately using it for creative effect), as it jars with the viewer – we can usually tell when lines should be straight.

The tool to correct this kind of distortion usually includes filters that adjust horizontal or vertical perspective, or which compensate for barrel or pincushion distortion, and it layers a grid over your image so that you can work precisely with the adjustment sliders to match the image to the vertical or horizontal lines. To get as accurate a result as possible, aim to line up a central vertical or horizontal line, and work from there. Once adjusted, the image will usually show some blank space within the edges of the frame, caused by rotating or tilting the image, and you'll need to crop it down to get rid of this; there may be a setting in the correction tool that will do the crop for you automatically.

St. Pancras station, London, before and after correction.
1/125, f/4, ISO 800, 18mm

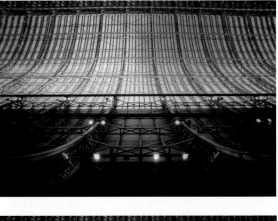

Cloning

Cloning is an extremely useful way of covering up something you don't want in your image – an object protruding into the edge of the frame, perhaps, or specks of dust. The Clone tool, sometimes called the **Retouch** tool, works by copying pixels from one part of an image to another, and is very straightforward to use. Select your source point, or the area of the image you want to copy from, and then click to paint it somewhere else in the picture. If you're cloning out something larger than a couple of spots, it often looks more natural if you work from a few different source points, particularly if you're painting over something with variations in colour and brightness.

Take source points from as close to the destination as possible, to match colour, texture and brightness as best you can. You can adjust your brush size to cover a larger or smaller area, and also select whether you want it to have hard edges, or softer, less defined edges. Some packages also have a **Healing Brush** tool, which matches the cloned spot to the colour and brightness of the destination area, so the edit is even harder to detect.

Image shown before and after cloning to remove a car and a line of overhead cables.
1/100, f/11.0, ISO 125, 106mm

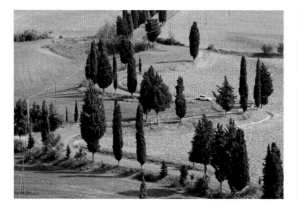
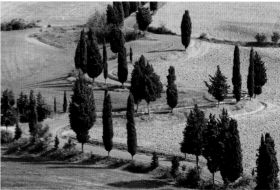

Sharpening

Used to make an image look crisper and better focused and to make the subject jump out of the picture, the tool commonly used for sharpening is, counterintuitively, called

Unsharp Mask. (Most software has a quick-fix auto sharpen tool, but this will usually over-sharpen your image.) It finds the edges within an image, and then makes them more distinct by highlighting the greatest areas of contrast, lightening the pixels on one side and darkening them on the other. Sharpening should always be the **last step** in your editing workflow, because it changes pixels in the image in a way that will affect any subsequent changes. Also try to work in a duplicate layer if you can.

You'll usually see three adjustment sliders: amount, radius and threshold.

Image shown with slight sharpening and then with extreme over-sharpening. There are slight halos of light around the edges in the second, over-sharpened version.
1/125, f/4.0, ISO 250, 100mm

- **Amount** controls the intensity of the sharpening, i.e. how much darker and lighter pixels will become. Start with a value between 80 and 120, and adjust as necessary.

- **Radius** defines the width of the area being adjusted. Start with a setting at around 0.8–1.2 and go from there. A higher radial setting may create strange-looking halos of light, so use with caution. You're unlikely ever to need to take it above 4.0.

- **Threshold** specifies the levels of contrast which should be sharpened. A higher value specifies greater contrast, which means that fewer sections will be sharpened, and vice versa. Start at 3 or 4, which is fairly high (despite a slider range of 0–255, the bulk of the variation here is between 0 and 5) and adjust as you need to.

It's very easy to over-sharpen, so use this tool with caution. Sharpening can also enhance digital artefacts or noise, which isn't the effect you're after. Work with the image preview at 100%, or **actual size** – or even bigger if the image itself is fairly small – so you can see the effect of what you're doing, because even if it looks all right on screen it may not when you print it.

Actions and presets

Most of the advanced programs allow you to create your own actions or presets, or to upload those you've found elsewhere, as a way of creating a shortcut to a particular group of settings that you use a lot or might want to revisit. For example, if you often shoot pictures in very similar lighting conditions, you might create one that adjusted the exposure, brightness and contrast in a certain way, or if you frequently convert your images to high contrast black and white you could save those settings so you can re-use them with a single click of the mouse.

There are lots of actions and presets available for download online, many of them free. They range from subtle image enhancements to heavily stylized actions, and everything in between. You can find presets to make your images look like Polaroids, to add a vintage look, or just to make the colours in your photos really pop – the sort of effects that have also spawned dozens of cameraphone apps – see pp.136–137.

As well as checking out the links below, try searching Flickr or DeviantART.

The CoffeeShop Blog www.thecoffeeshopblog.com/p/coffeeshop-actions-and-presets.html

Lightroom Killer Tips http://lightroomkillertips.com/category/presets

Adobe Blog http://blogs.adobe.com/lightroomjournal/2009/01/free_lightroom_presets_for_dow.html

PhotoTuts+ http://photo.tutsplus.com/articles/post-processing-articles/100-free-photoshop-actions-and-how-to-make-your-own

Background blur

You may have got your depth of field right in-camera, but if you weren't able to you can remedy this in the edit. Most programs offer a range of filters which apply different types of blur, including **Radial Blur**, which radiates out from a central or selected point, as if you were speeding into a tunnel or as if your subject was speeding out of the frame and straight towards you; and **Motion Blur**, which recreates the sense of motion in your image by blurring it along a line of movement across the frame (you can usually edit the angle and so on, to follow your subject and make it look realistic). The best to use for a natural-looking background is **Gaussian Blur**, which adds a smooth and subtle blur to the image, but experiment with the others to see what effect you get.

Work in a new layer, if you can. Alternatively, you'll want the blur to apply to the background without affecting the subject, so use one of the selection tools to select your subject and/or the foreground, and then invert the selection so the background is selected. Select the Gaussian Blur filter and adjust the radius slider until the preview box shows the effect you want, perhaps starting at 4.0 and moving it as far as 7.0 if you need to. If the blur looks too strong once you've applied it, you can undo it and start again (or simply adjust the opacity of the layer, so that the effect is less intense).

For info on how to control depth of field when shooting
▸▸ see pp.58–60

Converting to black and white

While you can choose to shoot in black and white with many cameras, converting your images from colour later allows much greater control over the quality of your image. Most editing programs either have a **grayscale conversion** option, or simply allow you to desaturate the image with the colour sliders, and then you'll need to adjust the brightness and contrast to suit the image. Once you've done that, adjust what are known as the Colour or Channel Mixer sliders, which allow you to change the relative contributions of the three colour channels (red, green and blue) to the final grayscale image, and thus to darken or enhance different parts of the image.

To get a feel for how they work, start all three at zero or at 100%, and then adjust one at a time to see how it affects the overall image. Think in terms of the original colours, so darkening the blue channel would darken the sky, and so on. The sum of the three percentages should add up to 100% in the final image unless you want to change its overall brightness.

>> QUICK TIP

If you want to replicate the brightness perceived by the human eye, or at least to see what that looks like in your image, the balance is 30% red, 59% green and 11% blue.

For more on shooting in colour versus black and white
▶▶ see pp.84–85

There are many different ways to convert a colour image into black and white, each affecting the colour channels in different ways. Below are three common methods, each of which gives a different look to the final image.

The original colour image...

simply converted to grayscale

converted using the black and white adjustment layer facility in Photoshop, with red reduced and yellow increased

converted by applying a red filter simulation in Aperture

PHOTOGRAPHY ONLINE

Photo sharing, online communities, magazines and blogs

It isn't so long ago that sharing photos meant dragging your friends and family round for a slideshow. But the internet has transformed photography along with so much else, and sites like Flickr offer a forum for sharing your pictures not only with your nearest and dearest but with like-minded others too. People seem to enjoy talking about photography almost as much as they like taking pictures, and whether you want to pick up tips, find inspiration and advice, read the latest camera news or find photographers' twitter streams to follow, going online is a great way to connect with other photographers.

Flickr

Whether you're just starting to take photos, want to share holiday snaps with friends and family, or take your photography more seriously, Flickr almost certainly has something to offer. Though there may be a larger number of photos on Facebook, Flickr has set the standard for online photo-sharing and management through its intuitive user interface and the provision of additional tools and applications. At the time of writing it has more than 40 million members and some 6 billion uploaded photos, with thousands more images being uploaded every minute, making it an active and well-populated online space. News organizations draw on the site for images of current events as they happen from people at the scene, and a Getty/Flickr partnership allows any Flickr user to flag their images as available in principle for licensing via Getty.

Flickr features a great line-up of tools to manage your photos, with the **Organizr** providing efficient shortcuts for sorting through your content, allowing you to add tags or descriptions to multiple images in one go, sort them into sets and groups, drag them

For more on Flickr and Getty's partnership and how to sell your pictures online ▶▶ see pp.198–199

Choosing a photo-sharing service

QUICK TIP

Check your chosen hosting site will allow you quick upload of lots of pictures at once. There's nothing worse than trying to set up a gallery and having to send each picture one by one.

There are dozens of sites hosting photos online. Choosing the right one is a matter of working out your priorities – no one (except perhaps Flickr) ticks all the boxes. Following are some of the issues you might want to consider.

- **Flexibility and ease of use** You don't want to have to spend ages working out how to upload and then organize your images; and you do want to make it easy for others to find and browse them. Does the service offer straightforward tools for everything from uploading to networking, including uploads by phone or email as well as from your computer, and can you tag images easily and move them around into albums or sets?

- **Editing tools** You may plan on editing your photos before you upload them, and have your own streamlined workflow, but if you're more likely to want simply to give your photos a quick tweak before you share them, check that the service has in-built editing tools or offers access to an online editor.

- **Storage space** You shouldn't be using your photo-sharing service as your only back-up option (see p.140), but neither will you want to have to delete older albums to make way for new images. Check that the site will give you enough storage in its free account, or that you're happy to pay the cost of upgrading to a premium account if that's what you need.

- **Prints and other products** If you're keen to make prints or even to create photo gifts, see if the site offers this as a feature. As long as the files you've uploaded are large enough to print in a sufficiently high-res format, this will save you uploading the same images twice to different sites. And even if you do have to upload a higher-res version, you might just prefer to have everything in the same place.

- **Community and networking** Can you share albums with your friends without them having to register on the site, and what's the sharing mechanism? Can you email album links or does the site send emails on your behalf? If you want to share them more widely, does the site allow people to comment on or "favourite" your images and let your images be found via their tags both within the site itself and via image search tools on the web? And does it allow you to integrate

make use of its community tools, you'll want to know it has lots of other users.

Security Can you determine whether your photos are public or private, and precisely who you want to share them with? If you want to limit access to invited viewers only, is the site password-protected or does it use an algorithm to create encoded weblinks for your albums which other people couldn't simply guess?

Help and support However straightforward the site seems, as with any other online service, things can go wrong. Look for good, clear FAQs and how-to guides on the site, and check whether its forums indicate that other users are generally happy or whether customer service appears to be slow and indifferent.

Terms and conditions What line does the service take on photo storage? Will you be able to download your high-res versions from the site without charge? And what rights do they claim over your images? Both Facebook and Twitter's terms of service include clauses that state that – although you retain your rights – by displaying content on or through their sites you grant them a worldwide, non-exclusive, royalty-free licence to use your photos any way they want. Dedicated photo-sharing sites tend to offer you more control, but it's always worth checking the small print.

Family-friendliness If you want to use the service to share your images with family and friends, check how the site regulates its content, and how adult or NSFW (not safe for work) content is flagged. You don't want your contacts inadvertently stumbling across things they don't want to see. Arguably, if your own content is NSFW, you might not want it surrounded by holiday snaps or

The Flickr Organizr, showing a selection of groups.

onto a map to plot their locations, or change their privacy settings. The site is also second to none when it comes to sharing your images elsewhere on the web. You can set up automatic Facebook updates, tweet your uploads as they happen, and post photos or embed a slideshow on your blog. You can also use **Picnik** (see p.130) to edit your photos within Flickr, order prints through Snapfish, or use your Flickr photos to make other products such as Blurb books or Moo cards (see pp.200–201).

A **free** account allows you to upload 300MB of photos and two videos in each calendar month (maximum 15MB per photo). Upgrading to a **"Pro"** account costs $24.95 per year and gives you unlimited photo and video uploads (maximum file size 20MB and 500MB, respectively), plus unlimited storage space and archiving of your high-res originals, and the ability to create collections and post an image to many more groups than you can with a free account. You can upload images direct from your mobile phone, via email or through your browser, by using a Flickr desktop widget, or direct from many photo-editing programs.

Exploring Flickr

One of the most exciting features of online photo sharing is being able to browse, learn from and be inspired by many thousands of images at the click of a mouse. There are several ways to discover other people's photos on Flickr. To start, click on **Explore**, which features the top 100 photos each day, ranked by "interestingness". You can choose a particular day or month to explore further, or simply hit refresh. If there's a subject you're interested in, then look at the **Galleries** members have curated on that particular theme, or just dive in by searching on tags that interest you. The **Commons** section allows you to browse the contents of some of the world's great photo archives, such as the Imperial War Museum or the Library of Congress – and you can even help add to the descriptions of these images via comments and tags – or you might use

>> QUICK TIP

For a jumping-off point, check out the Flickr blog, whose daily posts range from what's new on the site to collections of images on a particular theme or current event, or simply something that's caught the admin team's eye in one of the groups or galleries.

Ten tips to get the most out of Flickr

1 Upload regularly Make your photos public, and ensure that the image at the top of your stream is the best of the bunch. This is the photo that will show up in your contacts' thumbnails and the one any visitor is most likely to look at. If you want to capture people's attention, it's the place to start, and if you want to keep their attention, avoid following it with another ten images of the same thing.

2 Submit to groups But rather than merrily submitting to the maximum number for each photo, find a cluster that reflects your interests and really engage with them, visiting people's streams and commenting on photos that appeal to you. Don't be shy of making comments: people love feedback, and it's the way to get involved in the Flickr community, as people start to visit your stream in return.

3 Tag your photos Add tags that will make your photos discoverable by place (including geotags), subject, image type, colour, and any other keywords people might use to search for a photo like yours.

4 Take photos of popular subjects Click on the Explore tab to get a feel for what's popular. This doesn't mean you should change the things you want to photograph, but if you want to attract people to your photostream it helps to get a handle on what Flickr likes.

5 Build a group of contacts Choose people with similar interests and with whom you want to engage, through groups or images that catch your eye. Interact with their photos, and in all likelihood they'll do the same with yours.

6 Organize your photostream Make sure it's easy for visitors to find their way around and get to the content that interests them. Group photos into sets according to subject, theme, style or even colour, so visitors to your stream who like a particular photo can find others like it.

7 Create smart sets These are then automatically updated according to parameters you define, such as "interestingness" or tags.

8 Start a Project 365 There are lots of 365 groups on Flickr, which are all about committing to take a photo a day for a year. They often run challenges or collate lists of ideas for those days when inspiration runs dry, and are a good place to find smaller, active communities. It's also an excellent way to make sure you take lots of pictures.

9 Pimp your Flickr page out Set it up to automatically update Facebook whenever you update your photostream, tweet your Flickr uploads, and so on.

10 Curate your own galleries Select and group images from other people's photostreams around a particular theme... or just because you like them. You can write an introduction and even add notes explaining why you have picked each image, or simply let the photos speak for themselves.

The Explore page on Flickr, showing one of the day's most interesting images, and a range of other ways to explore the site's content.

the **Places** tool to trot to images covering every corner of the globe. The "people you may know" feature makes it easy to find new contacts based on mutual friends or to search your Facebook friends for anyone who is also on Flickr.

There's also always plenty to discover in **Groups** pages: amongst the many thousands of groups, there's almost certainly at least one that will dovetail with your interests; and if there isn't, you can set it up yourself. Searches by keyword or theme will turn up a group for just about everything, from "Stuffed animals lashed to truck radiators" to "Cow assassins" (cows who are also assassins, rather than people assassinating cows...), and from "Girls eating sandwiches" to the rather sorry-sounding "Dead pigeons found in cathedral towers", a group which after a number of years still contains just a single photograph. Or you can sign up to a daily themed groups, particularly useful if you're struggling for ideas, and shoot something for Bench Monday, Self Portrait Tuesday, Wall Wednesday, Gorgeous Green Thursday, Fence Friday, Cliche Saturday or Strobist Sunday, among others.

If all this sounds a bit too trivial, lots of Flickr groups are focused on different photographic **styles and techniques**. Most of the established groups feature a number of helpful discussion threads, and there's usually someone – or a whole host of people – who will happily answer any question you might have, or who can at least point you in the right direction, whether you want to learn about lighting (Strobist.com), taking portraits (The Portrait Group) or even about film photography (I Shoot Film). You might find a local group where photographers post images from your area or join up for photowalks, or both. Or one focused on sharing ideas to help photographers set up in business, if that's what you're thinking of doing. You might have taken the plunge and bought a new camera, cameraphone or lens and just want to pick up a few tips, and in many cases there will be a group dedicated to that very piece of kit. Alongside the groups, you can learn from simply browsing images, reading descriptions of how people took a particular picture, or looking at the EXIF data for photos where it's provided (via Actions > View EXIF info) to see what settings the photographer used.

Flickr's mysterious algorithm for measuring interestingness changes periodically, to avoid people learning how it works and starting to "play" it. But it takes into account a combination of the number of views, comments and favourites a photo gets, and how quickly, alongside the number of groups it's in.

The App Garden

The App Garden is basically a huge, free app store where developers can showcase the web apps they've created to interact with Flickr. There's a huge collection of tools and widgets that help you to share, organize and view photos in convenient and creative ways, find new people and images that inspire you, analyse your own Flickr data, specify parameters for organizing your photos into sets, turn your photostream into a magazine, create badges for your profile, and many more. You can search by tags, browse featured developers and apps, or search by name, if you know what you're looking for.

Some of the most popular apps are listed below, but new content is added all the time, so it's worth dropping into the Garden every now and then.

- **Bulkr** Backs up your photostream and lets you download your photos and sets to your computer, including titles, tags and descriptions, which are written to your EXIF data.

- **Colour Hunter** A great source of design inspiration, this app lets you take a photo you like and extract its colour palette.

- **Docent** Aggregates galleries from your contacts, so you can keep track of what they've been curating.

- **Dopiaza's Set Manager** Automatically creates new sets from your images, based on parameters you define such as interestingness or tags.

- **fd's Flickr Toys** Collection of web-based toys, games and utilities, including Scout, which lets you find out if any of your photos have appeared in Explore, and Mosaic Maker, which allows you to create a mosaic from your own images or your favourites which you can post to your profile, plus tools to create jigsaws and movie posters, Hockneyize your pictures or turn them into Pop art.

- **Flickr for busy people** A quick, at-a-glance overview of recent activity from your contacts.

>> QUICK TIP

If you want to customize the layout of your homepage, organize your contacts into specific groups, set up notifications when posts you haven't read are available in your favourite groups and photo pages, or modify your Flickr interface in other ways, check out the Flickr Hacks group, where you'll find some cool third-party tools and non-API ways to get the best out of your Flickr experience.

>> QUICK TIP

If you find yourself running short of inspiration, sign up for the Monthly Scavenger Hunt group, where you're given a list of 20 items to photograph each month – some abstract, all open to your interpretation – which can help get your creative juices flowing again.

idée **Multicolr** Search Lab

Your search colours

« Previous 1 ... Next »

We extracted the colours from 10 million of the most "interesting" Creative Commons images on Flickr. Using our Piximlar visual search technology you can search the collection by colour. Check out the FAQ. Have feedback?

10,044,701 images provided by Flickr.
Multicolr Search Lab © 2011 idée Inc.
This demo uses the Flickr API but is not endorsed or certified by Flickr.

FACEBOOK TWITTER SHARE

The Multicolr Search Lab, showing Flickr images grouped by a selection of colours.

- **Flickr Hive Mind** This data-mining tool allows you to search for photos by tag, user, groups, interestingness, licence, and more.

- **Flickriver** A great tool for exploring Flickr, letting you view hundreds of photos swiftly, on a black background, from your own photostream or from your contacts, favourites, groups or Explore.

- **Multicolr** Search Flickr photos by their colour palette, whether picking a single colour or a combination of up to ten different shades. The Multicolr Search Lab is not in the app garden itself but an external site, at http://labs.ideeinc.com/multicolr

- **Statsr** Stores your Flickr stats (Flickr only provides access to the last 28 days of detailed stats) and lets you track which groups send most traffic to your photostream, your interaction with other Flickr users, and so on.

Other photo-sharing sites

While Flickr is clearly the leader in terms of sheer scale, there are lots of other photo-sharing sites, and if you're looking for a site with a smaller community feel, there are plenty of options. If your priority is purely to have a user-friendly space for sharing your images with family and friends, there are sites set up with that in mind, and several with group sharing facilities so you can pool photos of a particular trip or event. And if you're still focused mainly on getting a nice set of prints, several of the more popular alternatives are digital printers first and foremost, which have bolted some sharing and community functionality onto their sites in order to attract users.

MobileMe Gallery

www.me.com

Part of Apple's online subscription-based service, the MobileMe Gallery tool allows you to create a nicely laid out online gallery with a simple interface, containing still photos and video content. MobileMe is well integrated with iPhoto, making uploads straightforward: simply create an album in iPhoto and click the MobileMe button. The two are fully synchronized, so any changes to the album in iPhoto will be reflected in your gallery, and likewise any changes you make to your tags or titles in MobileMe will flow back into iPhoto. You can also upload direct from Aperture or from your iPhone. A free app for iPhone, iPad or iPod Touch lets you view your own photos and videos, and email image links to your friends, as well as viewing the MobileMe galleries of any of your contacts. There's no social networking element, as it doesn't allow anyone you haven't specified to view your gallery, and it only comes as part of a MobileMe subscription (£59/$99 per year at the time of writing).

Picasa Web Albums

www.picasaweb.google.com

Google's free photo-sharing site, which works independently of the Picasa editing software (see p.129), provides you with 1GB of free storage, plus you can purchase additional storage space (from $5 per year for 20GB or $20/yr for 80GB right up to $4096 for 16TB) that can be shared across all your Google accounts, including Gmail, Docs and Blogger. What Picasa Web Albums excels at is flexible photo sharing. You have a number of upload options – including through Picasa or iPhoto (via a plug-in), from your phone (via apps such as PicasaFoto or iPicasso) or by email, as well as from your computer – and you can add captions, tag your images and organize them into albums, then share them as widely as you like. Any geodata in your EXIF data will be used to map your photos, or you can drag and drop them onto a map, and users of Google Earth can view them in that space. If you're using Picasa to edit your pictures on your computer, you can set your online albums to synchronize, so that any changes you make there will feed through into the online version.

Rights and wrongs: Creative Commons

When uploading photos to a sharing site like Flickr, you'll usually have the option of picking a licence type for each image. Selecting "all rights reserved" is fairly self-explanatory – this means you reserve all rights in the image yourself, prohibiting re-use without permission (though this won't do anything to deter image thieves, see p.181). But there's another licensing category, Creative Commons, created by a nonprofit organization with the aim of increasing the range of creative works available for legal modification and sharing (**www.creativecommons.org**). Creative Commons defines a range of options between full copyright or all rights reserved and work in the public domain with no rights reserve, which basically allow you to preserve your copyright while simultaneously permitting certain forms of re-use, outlining the degree to which you want to make your work available for others to share or repurpose. There are six different licence options:

Attribution The most flexible licence, which lets people use your work, whether sharing it as is or modifying and building on it themselves, even on a commercial basis, as long as they credit the original to you.

Attribution-No Derivs Allows redistribution of your work, commercially or non-commercially, but doesn't permit the work to be changed, and requires that it be credited to you.

Attribution-NonCommercial-No Derivs The most limiting of the six licences, allowing people to share the work as is, for non-commercial purposes only, and with a credit back to you.

Attribution-NonCommercial Allows the work to be modified and shared as long as only for non-commercial purposes and with a credit to you for the original.

Attribution-NonCommercial-ShareAlike People can repurpose and build on your work for non-commercial uses only, as long as they both credit you and also license their own derivative works on the same basis, i.e. their subsequent creations must also be licensed to allow non-commercial derivative work as attribution/sharealike.

Attribution-ShareAlike As above, though permitted for commercial as well as non-commercial uses.

Albums can be private, shared with named individuals who have to log in through a Google account, viewable by anyone who has the link you send out, or set to public, which means they can be seen by anyone who knows the URL of your public gallery and found in web searches. If you change your mind, though, it can take a few days for your pictures to disappear from search engines. Like Flickr, Picasa Web Albums has an Explore page, showing interesting public photos from across the site, and you can browse featured photos, watch a stream of recent uploads, or search by tags. You can also create a friends network of other users, linking to and commenting on their photos, and following their feeds via RSS, though there isn't the wide community of groups and pools found on Flickr.

›› QUICK TIP

Like several other sites, both Picasa and Photobucket allow you to let certain people add photos to an album, which is a good way of gathering together images from a particular trip or event.

Photobucket

www.photobucket.com

Popular and easy-to-use, Photobucket offers 500MB of free storage and lots of great features, from in-browser editing quick fixes and special effects to the creation of slideshows, collages or scrapbooks. There are plenty of tutorials and FAQs to get you started quickly. The Pro account provides unlimited space for non-commercial use for $24.95 per year, allows you to upload high-res images (images are automatically downsized when uploaded to the free account) and gives you a ten percent discount on prints and photo products via Qoop. The basic layout is a bit cluttered with adverts, which are removed in the Pro account.

Sharing photo and video content with sites including Facebook and Twitter is straightforward, and a Yahoo! app also lets you share images with family and friends as thumbnails in the body of an email, linked to the full-size photo in your Photobucket album. You have complete control over who sees your photos, can create group albums into which you and your friends can all upload images, and can personalize your pages with album themes. You can upload by email, via FTP (Pro users only) or from your mobile, using a Photobucket app for iPhone, iPad, Android or Blackberry. There's an active Photobucket community, with groups, comments and access to viewing stats on your own photos.

SmugMug

www.smugmug.com

Another great photo-sharing site, though there's no free option, just a trial period of 14 days before signing up to a Basic ($40 per year), Power ($60) or Pro ($150) account. All three provide unlimited photo storage, plus good privacy and image security controls, with apps allowing you to upload photos direct from Lightroom, Picasa, iPhoto and others, by email or from your phone, and flexible sharing options via Twitter, Facebook, Tumblr and Friendfeed. You can customize the look of your gallery and can even create full-screen slideshows to show your photos off to best effect. And you can order prints of your images, plus products such as cards or photobooks from a range of partners including Blurb Books and Moo (see pp.200–201). There's a community element, too, and you can design a customized gallery for your blog or club. All accounts include backing up of photos in JPG, GIF and PNG formats to Amazon's data centres, but if you want to include original RAW and TIFF files, or other file types, you'll need to create your own SmugVault, which will be billed directly from Amazon.

The Power and Pro accounts also let you add video to your gallery and allow further levels of customization; in fact, the Pro account competes favourably with many of the template sites (see pp.190–193) with its plentiful e-commerce options. SmugMug has a reputation for good customer service too, with the kind of personal touch you might expect from a company that prides itself on its niche character.

DeviantART

www.deviantart.com

Artists of every description, not just photographers, use DeviantART to share their work, whether that be fine art or poetry, and the site has a very consciously artistic vibe, letting you "exhibit" to an audience and build an "art collection", rather than simply sharing images and marking other people's work as

favourites. But it does have the tools to let you build an interesting looking portfolio of images, including a slideshow set-up, and you can get comments on your work from a vibrant and engaged community of users, often very ready to give advice or share information on how a particular piece of work was created, as well as accessing a wide range of tutorials. The user interface can be a bit confusing at first, with cluttered layout and navigation. You can track your visitor stats and page views, and "watch" other users (or others can watch you), which means you'll be notified whenever they post new work. And you can sell your work, too, in print, poster or canvas form, all the practicalities of which – such as printing, framing and shipping – are handled by the DeviantART print service.

Signup is free, but the Premium Member subscription of $29.95 per year removes adverts, allows you to give and receive critique, customize your pages with different skins and widgets, and opens access to a range of commercial tools for selling your work. Ideal if you're coming at your photography from an artistic perspective, or are just keen to engage with a very active art community.

Kodak Gallery

www.kodakgallery.com

A free, basic photo-sharing and print-ordering service, capitalizing on the Kodak brand name, and aimed at those who want to share their photos with family and friends and let them order Kodak prints. You simply have to buy something once a year to keep your account active and your pictures from being deleted. The service lacks the advanced photo-sharing functionality and features of the more active networking sites, but has a very user-friendly interface and streamlined print ordering process. There's also an iPhone app.

You can create slideshows to show your images off, and control who sees your photos and whether people have to sign in. It's also possible to post your slideshows to your Facebook wall or send email invitations with viewing links. Upload is straightforward either via the browser, by email, by using

Kodak's desktop widget, or from within Elements or Lightroom via a plug-in, and you can upload, work from (and store) high-res versions of your images to make prints or mugs, T-shirts and photobooks. You can also run your pictures through a basic edit if need be. Print prices aren't the cheapest around, but the prints are usually good quality.

ImageShack

http://imageshack.us

A free and very basic but user-friendly image-hosting service, allowing unlimited uploads. You can subscribe to a Premium Service for $68 per year, which lets you upload higher-res files, and provides free upload tools and automatic image back-ups, but most users stick with free, ad-supported accounts.

ImageShack doesn't offer any editing tools for your images, nor the option of creating galleries, but it does have its uses. The site is designed to host images you don't want to host elsewhere and provide each one with an individual URL which you can then post on a blog or discussion forum elsewhere on the web. Your image files are private until you share their links with your contacts, and their security is guaranteed by the algorithm ImageShack uses to generate these web links. If an image isn't accessed in twelve months it will be removed.

Shutterfly

www.shutterfly.com

A popular digital printing service with a degree of online sharing attached, Shutterfly is good for creating albums of images which you can then share with friends and family and use to order prints and other products such as photobooks, mugs and T-shirts. You get fifty free prints on sign-up. The site is US-based and ships internationally rather than printing locally for different markets, so turnaround times are slower and shipping fees higher for any non-US customers, though the sharing aspects are better than most of the other print product sites. There's unlimited storage space and high-res files are stored at full resolution rather than being downsized. The site offers easy-to-use organizational tools and includes a basic photo editor.

Uploading is simple either via Shutterfly's desktop software or the Shutterfly app for the iPhone and iPad. Best of all, Shutterfly say they never delete photos.

As well as giving you your own personalized web page (Shutterfly Share), which you can set up for a group to share content, there's a wider community sharing element with themes, comments and tagging; Shutterfly has an active Facebook community page too.

Snapfish

www.snapfish.com

Now owned by Hewlett-Packard, Snapfish is a worldwide photo-sharing site with digital printing and photo gifts at its heart. You get forty free prints with your first upload, and unlimited storage for your images, though you have to place an order at least once every twelve months or they'll be deleted. Uploading from your phone (via an iPhone app, with Symbian and BlackBerry apps due to follow) or by email, as well as from your computer, you decide which photos and albums you want to share, and then Snapfish sends an email invitation to the people you want to view them, or you can share them via a web link or through various social networking sites. Alternatively, you can set up a group room, where you and your contacts can post and access photos, projects and messages. The huge range of competitively priced photo gifts includes jigsaws, mouse mats and fridge magnets.

What about image theft?

Copyright exists in your photos the moment you take them. Regardless, once you've posted your images online, there's nothing you can do to stop someone stealing them if they're sufficiently determined. Even if you've disabled the right-click pop-up menu on the image (control-click on a Mac), anything that can be viewed in a browser can be downloaded via a simple screengrab or by getting into the HTML source code to find the URL of the image. You won't always know, of course, but sometimes you'll come across one of your images used somewhere else, or you can carry out a reverse search by using a tool such as TinEye (www.tineye.com), which can track down modified versions or examples of use elsewhere on the web, so long as it has indexed the relevant web pages.

If you're really bothered about this, the only failsafe solution is not to put your pictures online. But there are a couple of things you can do to help discourage image theft: by resizing for the web (p.142) you ensure that while your image can be posted elsewhere online, the file is pretty much useless when it comes to printing it or blowing it up to a larger size. You can also add a watermark or logo to your images, for example one showing your copyright line, which is offputting to would-be thieves and a nuisance to clone out of the image. However, watermarking may be unpopular among the people you do want to view your images and is likely to stop them being blogged elsewhere with a credit or link back to your website. Finally, posting your copyright line (the copyright symbol ©, plus the date of first publication and your name) under your photos, and embedding it in your IPTC metadata might help remind potential thieves that they are in breach of copyright. Unless you're trying to sell your images, though, you can avoid a lot of grief by simply accepting that anyone determined to steal them will do so, while limiting their subsequent usability by reducing file size and resolution.

Photography sites and blogs

Just as digital has breathed new life into photography, opening it to a wider community, so the spread of information and image-sharing online has reinvigorated the discussion of how, what and where to shoot, and with which piece of kit. Following are some of the most inspiring online spaces: **community sites** where you can hang out and chew the fat with other, similarly minded photographers as well as reading up on various topics; and **online magazines**, featuring a range of content and approaches, which are sometimes the internet arm of print magazines. Idiosyncratic by definition, there are also countless **photography blogs** – for every blogger simply posting a photo journal of their day-to-day lives, there's another sharing great swathes of information, debating photography in its broadest terms, or quite simply working as a hub and drawing together the best links they can find to photography information online.

Online communities

- **Epic Edits** http://blog.epicedits.com A great resource, with feature articles covering topics such as portrait techniques, plus quick tips, reader polls and a round-up of interesting links from other sites. An accompanying Flickr group – Epic Edits PhotoDump – lets followers share their images, some of which get featured on the blog.

- **Light Stalking** www.lightstalking.com A lighthearted community site which mixes great tips and articles on different genres – from iPhone photography to black and white portraiture – with pieces showcasing images grouped on a theme or the work of a particular photographer. Its active forum features a weekly photo challenge as well as interesting discussions on a range of topics.

- **The Photo Argus** www.thephotoargus.com Offers a series of consistently interesting articles, from inspiring reviews of the work

of a particular photographer or a range of images showcasing a certain style or theme to clearly written pieces on technique and post production. The site runs themed photo challenges, and members post their submissions, and other work, into the Photo Argus Community Portfolio pool on Flickr.

- **PhotoRadar** www.photoradar.com From the publisher of *Digital Camera* and *PhotoPlus* magazines, PhotoRadar is a fantastic resource, with news and reviews of new kit, alongside a wealth of tutorials and videos on technique, user galleries, an active discussion forum, plus interviews with stars of the photography world. PhotoRadar also plays host to the annual Digital Camera Photographer of the Year competition.

- **Pixiq** www.pixiq.com A great collection of articles from a large number of contributors, ranging from gear to technique, and from photo theory to inspiration, and with a regularly updated news page reviewing all of the latest developments and issues in the field.

- **Shutter Sisters** http://shuttersisters.com A friendly, collaborative blog designed for women, sharing the stories behind the pictures along with inspiration and ideas. An accompanying Flickr group lets followers share photos, some of which are featured in the "Daily Click" on the blog, plus there's a monthly community project (the One Word Project).

Online magazines

- **ePhotozine** www.ephotozine.com An online photography magazine with a strong community element, featuring news coverage, a wealth of useful photography tips and advice, product reviews and buyers' guides, a photo gallery for members, active forums discussing every photography topic imaginable and monthly themed competitions.

- **Flak Photo** www.flakphoto.com A website celebrating the art and culture of photography, highlighting new work, publications and exhibitions from an international community of contributors.

- **Foto8** www.foto8.com The online home of *8 Magazine*, associated with London's HOST Gallery, with incisive and thoughtful pieces on photojournalism and documentary photography.

- **Photo District News online** www.pdnonline.com The online arm of *Photo District News* magazine, with a great mix of industry news and information aimed at the professional photographer, including articles giving business and marketing advice or covering legal issues, as well as thoughtful feature pieces on photographic topics and initiatives, coverage of interesting portfolios and contests.

- **The Photography Post** www.thephotographypost.com Online magazine with interviews, columns and articles discussing the current state of photography, plus an aggregated newsfeed drawing content from other sites and blogs. Features the Museum of Online Photography Collections, where a new favourite photography collection is added each week, ranging from the very traditional to the wholly wacky.

Photography blogs

- **Beyond Megapixels** www.beyondmegapixels.com A site with articles on subjects ranging from how to read a histogram to how to get great shots of your children, with clear and easy-to-follow explanations.

- **Chase Jarvis** http://blog.chasejarvis.com/blog Blog posts, tips, photographic projects and links to videos of shoots and interviews from the commercial photographer, along with information on the Best Camera iPhone app, which has its origins in his hit book of iPhone photography, *The Best Camera is the One That's With You*.

Photo tweets

The amount of photography information shared on Twitter is astounding, although it can be hard to pin down the more useful nuggets among the sheer volume of tweets. Following a good mix of individual photographers and community sites (many of the websites, photographers and magazines cited in this book have their own twitter feeds, which are not duplicated below) will provide you with links to tutorials, articles and inspiring photographs, all of which can be invaluable as you learn more about photography and develop your own personal style. Here are a few, not mentioned elsewhere in the text, that you might like to check out.

Photographers

@chromasia Photographer David Nightingale tweets links to his images and blog posts.

@DamienFranco Weekly links to great photos, tutorials and news, as well as links to the photographer's own work.

@jimgoldstein Professional photographer specializing in nature and outdoor photography, and linking to his work among other things of interest.

@photojack Great links to all manner of things photography-related from travel and stock photographer Jack Hollingsworth.

@RoshSillars Photographer and digital marketer posts links to great photos and articles of general interest, as well as tips for marketing your photography.

Blogs and articles

@AmazingPics Shares inspiring images from around the web.

@FPblog Links to articles on the Fashion Photography Blog, covering everything fashion photography-related from lighting to instructing make-up artists.

@lensculture The feed of online magazine *Lens Culture*, with great links to all kinds of exhibitions, images and initiatives.

@photocritic Twitter feed of Haje Jan Kamps, whose blog has now moved across to Pixiq.com, tweeting links to inspiring photos, interviews and articles.

@Photomonthly Twitter feed of *Photography Monthly* magazine, featuring links to events, product launch information, photos and exhibition news.

@photonaturalist Links to articles on nature photography and related images.

@photopreneur Links to articles on the Photopreneur blog about ways of marketing and making money from your photographs.

Tips

@dailyshoot Daily shooting assignments to help inspire and motivate you. Share your results through a tweeted link.

@TheLightroomLab Lightroom tips, tricks and tutorials.

@PhotoshopPLUS Photoshop tutorials, tips and freebies.

Photo of the day

Photojournalists continue to take risks and push boundaries to find new ways of delivering stand-out images that will leave readers gripped, with the result that newspaper and photojournalism blogs from around the world are among the best places to turn for sheer variety and inspiration. Sometimes these include articles about the unique challenges of photojournalism, but often the images are left to speak for themselves. Try dipping into some of the following sites, to find anything from the most heart-rending and devastating images to the funny or just all-round weird.

BBC www.bbc.co.uk/news/correspondents/philcoomes

Boston Globe www.boston.com/bigpicture

The Guardian www.guardian.co.uk/inpictures

Los Angeles Times http://framework.latimes.com

NY Times lens http://lens.blogs.nytimes.com

Reuters http://blogs.reuters.com/photo

The Telegraph www.telegraph.co.uk/news/picturegalleries

Wall Street Journal http://blogs.wsj.com/photojournal

- **Joe McNally** www.joemcnally.com/blog Photography genius and lighting guru whose posts illuminate life in the field, working for *National Geographic* and *LIFE* among others, as well as sharing a variety of lighting set-ups, tips and tricks.

- **PetaPixel** www.petapixel.com This photo blog is geared towards "tech-savvy" digital photographers, with articles on anything from idiosyncratic DIY projects, such as using coffee cup lids to customize white balance, to product rumours and useful tutorials and tips. Never fails to be a fun and interesting read.

- **Photofocus** http://photofocus.com A well-established online photography magazine, run by photographer Scott Bourne, featuring tips, tricks, news and reviews, alongside interviews with prominent photographers and educational videos.

- **The Photoletariat** http://thephotoletariat.com Small but lively community, sharing artistic advice and technical tips, as well as information on how to build a photography business. The site mixes blog posts and videos to deliver a great range of photography news pieces, kit reviews and "how to" guides, and is well worth a visit.

- **Small Aperture** http://smallaperture.com Small, friendly blog, offering cutting-edge photography news, views and reviews, with some great feature pieces on anything and everything photography related, and collections of inspiring images, plus themed competitions run through a group pool on Flickr.

- **Strobist.com** http://strobist.blogspot.com A hugely popular free resource for learning your way around off-camera lighting, David Hobby's blog is widely read and cited, with tutorials in the Lighting 101 series and related Flickr discussion groups providing support and answering questions. If you want to get to grips with lighting, this is absolutely the place to start.

- **Thomas Hawk's Digital Connection** http://thomashawk.com With a mission to take, process and publish 1,000,000 photos before he dies, Thomas Hawk's blog is a great combination of images and posts engaging with what's going on in the world of online photo sharing, among other things.

- **Trey Ratcliff** www.stuckincustoms.com A fascinating travel photography blog with an award-winning HDR tutorial attached, the site features helpful reviews of the kit and software that Ratcliff uses, along with his portfolio, photographic and other musings, and information on his iPhone app, 100 Cameras in 1 (see p.136).

iPhoneography

If you're interested in shooting more with your iPhone, or indeed any other cameraphone, there's a growing "iPhoneography" movement on the web, and a bunch of sites worth browsing.

- **iPhoneography** www.iphoneography.com An iPhone photography and videography blog, reviewing new and updated apps, showcasing photographers, and with a user forum for sharing tips and tricks.

- **The Big Hipstamatic Show** http://community. hipstamatic.com Runs a monthly themed competition where you can upload your favourite Hipsta photos for a chance of winning a prize, or simply browse the gallery of former entrants for inspiration.

- **The Best Camera** http://thebestcamera. com The website accompanying Chase Jarvis's app of the same name is a community hub for uploading and sharing your iPhone photos taken using the app.

- **Pixels: The Art of the iPhone** http:// pixelsatanexhibition.com Founded to call for submissions for an exhibition of iPhone photography in California, Pixels remains a popular online gallery for iPhone images, where you can upload and share your pictures, browse the gallery by keyword or theme, and see calls for future exhibitions.

- **iPhoneArt** www.iphoneart.com Building a gallery of mobile images, iPhoneArt lets you create your own cameraphone portfolio and browse the work of others, alongside app reviews and a discussion forum.

For our pick of the best smartphone apps
▶▶ *see pp.136–137*

8 **TAKING IT FURTHER**

Selling your photos, shooting stock, starting a blog

Perhaps you're already sharing your photos – either just with friends, or with the wider world – and people seem to like them. Every now and then you get a query about one of your prints on Flickr, and you start to wonder if there might be something more you can do with them. In fact, there are plenty of ways to take your photography further and this chapter points you in a few directions, whether you want to display your images in an online showcase, start up your own photo blog, shoot for a stock agency, create a photo book of your best work, or sell canvas art prints or coffee mugs online.

Creating an online portfolio

Flickr and the other photo-sharing sites covered in Chapter 7 are flexible and user-friendly, but they're designed for uploading and displaying masses of pictures; you may want to create a more tailored showcase for your work, where you can highlight the best of your images in a professional-looking portfolio. You can then use this website to promote your work or, quite simply, so you can share your photography with people you might not necessarily want to see pictures of your family or your cat.

If you're well versed in HTML, you won't need to purchase a ready-made package, but if not a **template portfolio site** is a great way of getting all the features you need in a website without having to build your own. Here we've listed the points to consider when choosing a site, before detailing three of the most popular current offerings.

Choosing a template site

Many of the sites aimed at photographers are broadly similar, though their design varies, as do their prices and the level of support they offer. If you're thinking about signing up, it's worth asking your photo sharing contacts to see whether anyone has recommendations, as well as reading reviews of the sites you're considering. Browsing some of the websites' sample user sites will give you a feel for how you might customize your own site, and also how easy they are for a user to navigate. We've covered three of the most popular in depth, starting on p.192, but if these don't take your fancy, check out the further options listed on p.193. Whoever you choose to go with, these are the issues you'll want to consider before taking the plunge.

- **Image size** Since the main purpose is to show off your images, how large will the site allow you to display them?

- **Flash vs HTML** Lots of photo portfolio sites use Adobe's Flash platform, which makes possible creative transitions between images, but because Apple don't support it on the iPad or iPhone, your site might not be viewable on these devices. Another downside is that Flash isn't easily readable by search engines, with the result that a Flash-based site may not appear high up in search results. One way sites get around this is by providing a less fancy HTML mirror site – ask if this is part of the deal.

- **Tablet and mobile device mirror sites** Alongside the Flash issue, you need to consider how your site will appear on various mobile devices. It's a good idea to look at their sample sites on your smartphone or tablet as well as on your computer to see how they match up.

- **Intuitive navigation** The last thing you want is to put users off your site by making it hard to find what they're looking for. Is there a clear structure to your galleries and any text pages, such as your bio or contact page?

- **Speed** Look at real sites which use the template (most sites will have a gallery of current users). Are the pages slow to load? Anything that might make your viewer give up and click away is to be avoided.

- **Simple design** A cluttered interface will distract from your images, while a clean design will let them speak for themselves.

- **Customization** Are you able to customize the look to suit your needs, or are you shoehorned into a "one size fits all" format? Templates from some of the most popular sites are widely used and very recognizable, and you might prefer to go for a slightly more unique look.

- **Ease of updating** If there's a free trial for your preferred site, give it a go and see if it's straightforward to update your content, edit text pages, reorganize photos within galleries and so on. If it's easy to use you're more likely to keep your content up-to-date and fresh, which is in turn more likely to keep viewers coming back.

- **Web address** Will the site allow you to use your own URL, if you've registered a domain name (or register one for you as part of the package), or are you stuck with a [yourname].[sitename].com combination? It looks more professional and is better for branding purposes to be able to use your own domain name if possible.

- **Hosting** Does the site provide hosting for your content, as well as templating your site? Unless you actively want to host it yourself, it's worth considering a package which includes hosting, not least because you'll automatically be included in any rollout of bug fixes and new feature updates, without having to download upgrades.

- **E-commerce** If you want to be able to sell images and products, is there a shopping cart facility or can you link to another store elsewhere if not? Does the site link automatically to print services?

- **Blog** Does the site allow you to build to a blog, or link to an external blog if you have one elsewhere?

LiveBooks

www.livebooks.com ($39 per month, $399 per year)

One of the most popular of the portfolio sites, providing a mix of ready-made templates or custom-designed sites which they host for you, linked to your own URL. Their sites are fairly recognizable as liveBooks templates, in part because they have such a wide take-up. The basic templates allow you to create an unlimited number of portfolios and as many information pages as you like, for contact details or news and so on. You can link a blog to the site, plus there's a shopping cart and access to Google Analytics to track your usage stats. The user interface is straightforward, based on "drag and drop" content management, and sites are built in Flash, with an HTML mirror which the search engines can crawl and built-in sites designed for iPad and iPhone (which don't support Flash). After a free fourteen-day trial your site can go live if you decide to subscribe.

Clickbooq

www.clickbooq.com ($79 per month, $588 per year)

Instead of pre-designed templates, with clickbooq you get to pick and choose from a range of elements: background colour, font, whether you want your window to have rounded corners or a drop shadow, and so on. Or you can use the Custom Backdrop feature to upload a page incorporating your logo or a background design, or neatly frame the central area with a complementary colour. You can end up with something more original than with liveBooks templates, but the layout of images and portfolio buttons still has a recognizable look and feel. Clickbooq hosts your site, which is Flash-based with an HTML mirror site, but you can use your own URL and link the site to your blog; again there's a shopping cart and access to your stats through Google Analytics. You're limited to five portfolios but can buy up to another five for a one-off fee of $50 apiece. A

useful lightbox feature allows you to create private mini-galleries with their own URLs you can share with others, and portfolios are organized by straightforward dragging and dropping of photos. After the fourteen-day free trial, you can convert to a live site if you want to go ahead.

Photoshelter

www.photoshelter.com (Basic plan $9.99 per month, $109 per year; Standard $29.99/$329 and Pro $49.99/$549.99)

Providing an alternative to the Flash-based template websites, Photoshelter uses HTML to improve discoverability and ensure that its sites can be viewed as intended on devices such as the iPad and iPhone. You either adopt a ready-made template or manually

customize your own site. You can trial the site for fourteen days for $1. The package includes an unlimited number of galleries, linking a blog to your site and using your own URL, and Photoshelter also has in-built social networking tools, making it easy to export a gallery to Facebook, or post a link to Twitter. As usual, Google Analytics tracks usage and the site offers a shopping cart, plus links with print labs worldwide. Photoshelter takes an e-commerce commission of 8–10% on any sales. You also have the option of selling downloads, whether for licensing purposes or for personal use, and the site supports a wide range of file types (including RAW or PSD files). The help and support tools include video tutorials and webinars, alongside some good articles on sharing and marketing your photos.

If none of the above appeals, try one of the following alternatives:

Big Folio www.bigfolio.com
Blu Domain
www.bludomain.com
FolioLink www.foliolink.com
Foliopic www.foliopic.com
Zenfolio www.zenfolio.com

Photo blogging

There are plenty of reasons to start your own photo blog: perhaps you'd like to be more selective than you can be on your sharing site, or want the freedom to interleave your images with text and audio or video posts, or just to explore at greater length your photography-related interests. Whatever your aims, the following guidelines will help you create a blog that's worth visiting.

- **Your photos** Use the blog as a reason to push yourself to try new things, and don't post everything you shoot, just the highlights. A picture post is usually enhanced by some kind of text, so you might want to explain what led you to capture a particular image, what was happening that day, why you like the picture and even how you took it. You may prefer to let the picture speak for itself. But make sure you include an image with every post: it's a photo blog after all, and pictures help break up the text and make your blog more readable.

http://streetphotographyjeffslade.blogspot.com

- **Blog often** No one wants to keep checking into a blog to find it hasn't been updated, and frequent blog posts will help encourage search engine traffic, which will improve your position in search engine results. Even if you only have time to blog a single image, and not to write about it, try to post something up there every few days, or at least once a week.

- **Keep it varied** You might want to re-blog other images that grab you, or to mix your own writing with inspiring quotes from other photographers, or practical tips you've found useful, even reviews of kit or photography books you like. Some blogs also make a feature of interviewing other photographers, to throw some new ideas into the mix.

- **Develop a voice** People tend to follow a blog that they know will deliver what they want, not only in terms of pure content but also in engaging and consistent writing and image style. Avoid being over-formal or too technical, but don't shy away from voicing an opinion: it might engender a debate in the comments, which can make your blog a more interesting site to return to. And remember your readers: it isn't all about you, so tailor your content accordingly. Interact with them by responding to their comments, asking for feedback, or using polls and surveys to get their views.

- **Make it look good** Keep the layout simple and the navigation clear; don't have too many fancy features detracting from your images. And make it easy for people to find out how to follow your blog or subscribe to the RSS feed.

- **Browse other blogs** If you're struggling for ideas, look at some other blogs that appeal to you for a spark of inspiration: see how they tailor their approach, what kind of pieces they write, how they use text to tie their images together, and so on.

- **Step outside the blogosphere** Engage with other things that are going on in the photography world and report back on them, taking books, newspapers, exhibitions, films, and indeed anything you like for inspiration.

- **Make it discoverable** Link to other blogs you like, and which take a similar tack, and encourage them to link back to you. Tweet about your blog posts or mention them on Flickr, Facebook, or any other social networking sites you're using, to encourage traffic. If your blog service lets you see Google stats, check to see which are your most popular posts, and plan to post more along the same lines.

http://alpower.com

For a look at what's out there already ▶▶ see pp.184–185

Blog features to look out for

- Easy to navigate
- Intuitive uploading tools
- Choice of themes to suit your content
- Customizable domain name
- Tools for sharing blog posts on Twitter, Facebook and elsewhere
- Ability to interact with fellow bloggers
- Searchable archives
- Ability to allow/disable comments from readers
- Ease of reblogging other people's posts

Blogger www.blogger.com

Fotolog www.fotolog.com

Posterous www.posterous.com

Tumblr www.tumblr.com

TypePad www.typepad.com

WordPress http://wordpress.org

Blogging tools

Some of the portfolio sites (see pp.192–193) come with a blog feature, which ties into your main site. If not, it's easy to set up your own, using one of several blogging services. These are usually free, though you might opt to pay for a particular theme or template to customize the look of your blog or for a subscription that removes adverts from the page.

WordPress, **TypePad** and **Blogger** were designed for text-based blogs in the first instance, but offer intuitive photo uploading tools and a range of photo-oriented templates for bloggers wanting to make images the main focus. Micro-blogging sites **Tumblr** and **Posterous** emphasize ease of use, offering clean design and easy customization through themes, and the flexibility to mix up photo and descriptive posts with videos or audio files. **Fotolog** is a dedicated photo-blogging service, though with slightly cluttered navigation, and you have to pay to get rid of the ads and to upload more than a single image each day.

If you have friends that use a particular blog service, it may be worth signing up to the same one to make it easier to leave comments and notes on each other's pages. Otherwise, look at the blogs you like or just browse some of the themes available at the links in the box to get a feel for the kind of layout you're after and the features that will enable you to do what you want with your content.

Stock photography

The internet has made it ever easier for those who need pictures for their websites and publications to track down image providers, and if pushing your photographs in that direction interests you, the obvious next step is to look into **licensing** your photos for stock use. If you look for attributions for the photos used in newspapers, books and websites, you'll often see they're credited to an agency rather than an individual photographer. There are many more examples where you won't even see a credit, in advertising materials and company brochures, or even junk mail. These are all usually stock photos, existing images licensed by an agency rather than shot specifically for the purpose, which works out much cheaper for many businesses.

The professional photographers who make a living primarily from shooting for stock will probably have many thousands of images available for licensing, but the web has massively increased the demand for images, just as it has made it easier for photographers to get their pictures seen, and these two factors between them are transforming the stock industry.

>> QUICK TIP

Agencies will often send out "want lists" to the photographers on their books, detailing popular subjects for which they want more content.

Shooting for stock

If you want to try your hand at shooting stock, a good start, especially if you're already using Flickr, is to explore their partnership with Getty (see below); at the time of writing, there's a similar collaboration between DeviantART and microstock agency Fotolia being planned. Otherwise, you could simply submit a portfolio to one of the other main agencies, all of which have guidelines on their websites outlining the kind of images they are looking for.

Getty Images, **Corbis** and **Alamy** are the largest and best-known general agencies; there's also an increasing number of agencies dedicated to what's known as **microstock licensing** – selling images for very low prices (often just $1 for a single image) but at very high volume and often in batches – such as iStockphoto, Fotolia, Shutterstock and Dreamstime. What they all have in common is that they'll handle the administrative load of selling your images, market them widely, and protect the images on their books against illegal use. On the downside, they'll take a large commission on any sale – rarely less than 50% and often significantly higher – and may demand exclusivity, in other words that any image on their books can't be licensed through any other agency or even sold direct by you. To maximize your chances of making a sale, bear the following in mind when shooting.

Getty Images www.gettyimages.com
Corbis www.corbisimages.com
Alamy www.alamy.com
iStockphoto www.istockphoto.com
Fotolia www.fotolia.com
Shutterstock www.shutterstock.com
Dreamstime www.dreamstime.com

- Images need to be high quality and **well exposed**.

- Supply **high-resolution** images, so that they can be used for a variety of purposes.

- Choose **saleable** topics.

- Plan **ahead**: Christmassy photos are more likely to find interest in late summer than in December.

- Take the same image in both **portrait** and **landscape** versions where possible, to increase the number of ways in which it might be used.

- Where appropriate **leave some space** in the image rather than packing every corner with detail: image buyers often want something as a backdrop for their text.

- **Tag** extensively for anything you think your image might be used for, particularly if you're using Flickr – don't just leave it to chance.

- Avoid **trademarks**; similarly, don't shoot anything that's recognizable as a particular brand, such as the curve of a Coke bottle.

The Getty/Flickr partnership

If you use Flickr, it's not uncommon to receive a request to buy or use your work, particularly if you've tagged your images effectively, though as the community guidelines make very clear the site itself is strictly not for commercial use. Since 2009, however, Flickr have partnered with Getty, and Flickr photographers can

submit a portfolio of twelve images to a group pool for consideration and have the option of enabling a "Request to license by Getty images" link on their photostream as a whole. This means that if someone wanted to use any of your public photos they would approach Getty rather than coming to you direct, and if they chose to use it and you were happy to license it, Getty would broker the deal, handling the terms and the pricing, and taking a 70% (for RM) or 80% (for RF) cut in return (see box).

While there's some controversy about the fact that users are prohibited from adding their own commercial links to their work, set against that is the vast promotional reach of Getty Images. If you're interested in experimenting with selling images as stock, it may be a no-hassle next step. For more info, check out www.flickr.com/groups/callforartists.

Selling stuff online

If you're keen to sell your photos and other products adorned with your images, there are plenty of websites designed to help you do it, in addition to the photo-sharing sites covered in Chapter 7, and of course auction sites such as eBay. These will allow you to create an online store without worrying about your own website design or shopping carts and e-commerce functionality.

Some sites, such as **Etsy** and **Folksy**, require you to create your products yourself and mail them off to meet customer orders, paying a listing fee and sales percentage to the site. Both of these have a craftsy, homemade feel. Alternatively, sites like the art-oriented **DeviantART** and slick **RedBubble** do the heavy lifting for you – customers order from and are supplied by the company itself – and you receive a percentage of the sale value, after the cost charged for making and dispatching the products, and often choosing your own mark-up. As well as choosing the site that you like the look and feel of, the model which suits you better will depend on whether you have the time and discipline to regularly order prints, do your own packaging and queue in the post office, versus how important it is to you to approve the final quality of your products...

Stock licences

The main two types of stock licence are **rights managed** (RM) and **royalty-free** (RF).

RM licences grant rights to the user with a number of restrictions, such as the size at which the image may be reproduced, for how long, and in which territories. The price is dictated by usage, and a customer might sometimes choose to pay more for exclusivity, for instance to avoid a competitor using the same image.

RF licences give the user the flexibility of reproducing the image an unlimited number of times in unspecified ways, so long as it's not defamatory or illegal, and the user can't secure exclusivity. The price is set according to the file size.

Etsy www.etsy.com
Folksy www.folksy.com
DeviantART www.deviantart.com
RedBubble www.redbubble.com

>> QUICK TIP
Just as when you're putting together a portfolio, edit your work down to your best images when deciding what to display.

>> QUICK TIP
Make sure you upload images in the required format and resolution to make prints and products at the sizes you want to offer.

and, of course, how much money you're hoping to make. You obviously have more control over your mark-up and product costs, as well as over the range you can offer, if you do it yourself. Most sites have good community elements, with articles on how to get the best from the store and so on.

Photo books

Photo albums might seem a bit old hat, but making your own professional-looking **photo books** is becoming increasingly popular, using self-publishing websites like **Blurb**, **Lulu** or **MyPublisher**. You might want to create a book to record a particular holiday, gather family photos for a trip down memory lane, collect your photos into a book on a particular theme, or even create a photo magazine through a site such as **MagCloud**.

These self-publishing sites tend to work in two ways: either you upload your photos to the site and work on the book there, or download software onto your computer, then upload the book to their site once you've put it together. If you prefer working in your own design software, some sites allow you to do this and then upload your book as a PDF. Whichever route you take to get your content online, the steps are easy to follow, and the tools deliberately simple, often a case of just dragging and dropping your photos into a template. You can buy a single copy of the resulting book if that's all you want, but in many cases you can also add your book to the site's online store. There you can set the price to add a mark-up – so you can make some money from any sales if you want to, less a processing fee or commission – and let friends and family (or even complete strangers) buy their own copies. Blurb and Lulu both have tools to help you tell the world about your book on Facebook or Twitter, or on your blog.

Blurb www.blurb.com
Lulu www.lulu.com
MagCloud www.magcloud.com
MyPublisher
www.mypublisher.com

A Blurb book in progress, using their BookSmart sofware.

When you're **planning your book**, think about whether you want to mix up the photo sizes, grouping some smaller images that work together on one page while giving your best images a full page to themselves for maximum impact, or whether you'd rather reproduce every image at the same size throughout, for consistency. And, just as you would do when putting a slideshow together, think about the flow of the images you're using, grouping them by colour or subject or some other unifying aspect, so that you move naturally from one page to the next. Don't just think about the facing pages in a spread, but the preceding and following spreads too, to make sure that the book hangs together as a whole.

>> QUICK TIP

Wherever you're selling, remember you need to update your page regularly to keep friends and customers coming back to see if you've uploaded new work.

>> QUICK TIP

Some of the photo-sharing sites detailed in Chapter 7 offer book-printing services; and some software packages allow you to design books and perhaps get them printed too – see Chapter 6.

Other cool things to do with your photos

As well as creating prints, canvases and books, you can use your pictures to make badges, personalized CD covers, jigsaws, calendars, T-shirts, stickers, postcards, greetings cards, mouse mats, mugs and more or less anything you can think of. And there are lots of websites out there to help you do just that.

- **BigHugeLabs** http://bighugelabs.com Fantastic range of products and print templates, from photobooth strips to tailor-made ID cards.

- **The CoffeeShop Blog** www.thecoffeeshopblog.com Blog offering free downloadable storyboards, frame templates and more.

- **Moo** www.moo.com Create business cards or mini cards, which you can use as anything from gift tags to "save the date" notes or even a pocket-sized photo portfolio, using Moo's "printfinity" technology – which means you can use a different image on every single card.

- **PhotoMix** www.photomix.com Easy-to-use templates for making scrapbooks, calendars and collages.

www.etsy.com/shop/claireyhairey

Competitions

Whether you join your local photographic society and submit to regular contests for members or throw your hat into the ring for one of the major Photographer of the Year prizes, competitions are great way of not only challenging yourself but also finding out what other people think of your work. Several of the online competitions now invite entrants to give feedback on each others' work, awarding a place to the popular winner as well as the formally judged prizes. Having to shoot to a particular theme can be a great way to drag yourself out of your comfort zone.

Before you enter, look at previous winners to get a feel for the standard required and the type of images that tend to do well. Check the terms and conditions, too. Some less scrupulous organizations use competitions as a way of building an image library or with future publications in mind, requiring that photographers waive their copyright and moral rights and sign all usage over to them in perpetuity as a condition of entering the competition. Of course it is legitimate for the organizers of a competition to require that they should be able to use submitted photographs freely to promote the competition, the photographer and the image itself, along with certain other defined uses (an exhibition or book based on the competition for example), usually for a limited period. The Artists Bill of Rights for competitions outlines acceptable standards, and you'll find that the major awards have usually signed up to it (www.pro-imaging.org/content/view/177/156). Listed below are some of the main regular competitions; otherwise, it's a case of checking papers, magazines and online, and keeping your eyes open.

Astronomy Photographer of the Year
www.nmm.ac.uk/visit/exhibitions/astronomy-photographer-of-the-year

British Wildlife Photography Awards www.bwpawards.org

Digital Camera Photographer of the Year www.photoradar.com/photographer-of-the-year

Environmental Photographer of the Year
www.ciwem.org/competition-and-awards/environmental-photographer.aspx

International Garden Photographer of the Year www.igpoty.com

Landscape Photographer of the Year www.take-a-view.co.uk

National Geographic Photography Contest
www.ngm.nationalgeographic.com/ngm/photo-contest

Sony World Photography Awards www.worldphoto.org

Taylor Wessing Photographic Portrait Prize
www.npg.org.uk:8080/photoprize/site10/index.php

Travel Photographer of the Year www.tpoty.com

Veolia Environnement Wildlife Photographer of the Year
www.nhm.ac.uk/visit-us/whats-on/temporary-exhibitions/wpy

Wanderlust Travel Photo of the Year
www.wanderlust.co.uk/magazine/awards/photo-of-the-year

Marketing your work

Marketing your work, especially if your pictures are hosted on a non-commercial site like Flickr, can be tricky without breaking the rules. Flickr's community guidelines permit a single link on your profile page to your own website or store, but repeated promotion of the information with each new photo upload is likely to get your account deleted. But there are other ways to promote your store, including the creation of a **Facebook Page** where you can publish new work and write posts about your photography accompanied by links to your store.

Most of the online stores provide **marketing tools** – widgets, website banners and buttons for your Facebook page or Flickr profile. If you have a separate photography (or other) website, you can use one of these stores as your selling mechanism, and link to it from your main site, and you can tweet or blog about it, as well as actually telling people in the real world. If you don't have a photography website, RedBubble or DeviantART will also allow you to create separate portfolio pages without the clutter of your selling or profile information.

You can easily make yourself a Fan page on Facebook (left) which will allow you to connect with those who choose to "Like" you and, thereby, sign up to your updates. You can also copy a piece of code to your own website (above) which will allow users to click "Like" and will take them to your Facebook Page. The Page feature is separate to your own Facebook Profile so you won't be giving away any personal information that you don't wish to share with fans.

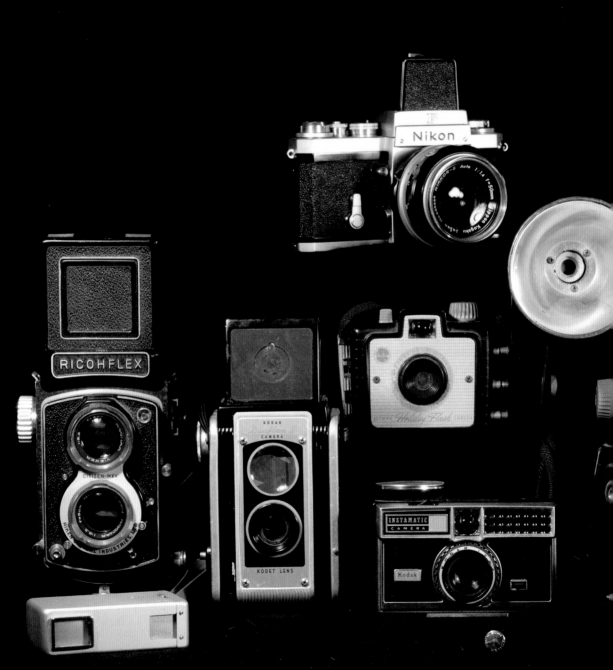

9

THE RESURGENCE OF FILM

Analogue photography in the digital age

The rise of digital photography has brought with it a new generation of photography fans keen to dabble in film, and demonstrating an obsessive affection akin to that of the vinyl record aficionado. Old film cameras are being dug out and dusted off, and cheap plastic "toy" or "lo-fi" cameras abound – there are dozens of models available and dedicated groups of followers hooked on the dreamy, nostalgia-infused images they create. Perhaps ironically, it's the online photo communities helping drive this analogue obsession.

Experimenting with film

Getting back into film, or experimenting with it for the first time, inevitably means you start to think more before pressing the shutter, as each exposure becomes that little bit more precious, and with no LCD viewer you get a genuine sense of anticipation as you wait to see how your prints turn out.

It's quite easy to get your hands on a working **film camera** without spending too much money. Friends and family may have something lying around, and car boot or yard sales, charity/goodwill shops and eBay are all good places to turn up a cheap, basic camera. The main thing is to check that the film it takes is still available: 35mm and 120 film are still widely sold, though many other **formats** have been discontinued. If you're still getting to grips with the settings on your digital camera, try and find a film camera with auto exposure and perhaps even autofocus. Some wind on automatically too, which will save you inadvertently taking multiple exposures on the same piece of film: it's easy to forget to move the film on when you're used to working with digital.

>> QUICK TIP

If you're just after the look of old-school film and not the real thing, then check out the effects available for smartphones (pp.136–137) and in various editing programs (pp.138 and 164).

>> QUICK TIP

For those used to the viewfinder on a digital camera showing you what can actually be seen through the lens, it's easy to forget to remove the lens cap when shooting with your film camera, where all the viewfinder does is point in the same direction as the lens. If you do forget, and fire off a shot, there's no need to wind on to the next exposure, as you haven't actually exposed that frame to light.

For info on choosing a printer
▶▶ see pp.40–42

Multiple-exposure image, shot with a Holga.

Shooting with film

Working with negative film requires a different approach, demanding that you think your composition through in advance. You won't want to waste film by shooting multiple versions of each subject, making incremental adjustments to framing and settings until you have the image you were after. Nor will you have the luxury of going back through the EXIF data to learn more about what worked and what didn't. Some film photographers make a point of jotting down their **settings**, so they have them for reference.

Different **brands of film** often have different looks or characters. For example, Fuji Velvia is renowned for great colour reproduction, with rich saturated colours, while Ilford HP5 Plus and Kodak Tri-X are both fine-grained films that cope well in lower-light situations (both ISO 400).

Scanning film to share online

It's easy enough to scan the prints you've got back from the lab, or you might be able to pay more and get a CD containing the digital files. But if you want your images to include the sprocket holes or the film border – which can give a striking effect – you'll need to work from **scanned negatives**, which you can then convert to positive images

using your editing software. If you have a flat-bed **scanner** with built-in negative or slide attachment, perhaps as part of your all-in-one printer, you're almost ready to go. If not, you'll get better results if you invest in a separate transparency adaptor, or you can buy dedicated negative scanners for anything from £40/$65 upwards.

Scanned files can be huge, but if you're likely to create prints at some stage in the future, or you want to edit or tidy up the files, it's worth scanning at the highest available resolution – not least because if you want an image that's larger than the negative, you don't want to lose detail if you blow it up. It's hard to judge the quality of an image from its negative (though slide film can be a little easier to assess, by just holding it up to the light), so it's best to scan everything and then delete any images that don't make the grade once you've viewed them on your computer.

Clean the glass with a lint-free cloth before you start and then select the scanner setting you want to use, such as dust or scratch removal, as well as the resolution. Most scanners want you to load the negatives emulsion or duller side down (the shiny side is the backing side), but some vary, so check the manual. Scanning the film the wrong way round may make your images less sharp, and you'll also need to flip them in the edit, unless you like the reversed version better.

Storing slides, negatives and prints

Slides and negatives will fade over time, just as prints will. Strong light, humidity and extremes of temperature will all accelerate this process, and pollutants and airborne particles can also damage prints and negatives, so try and keep them away from direct light and in a cool, dry, clean and well-ventilated area.

The best way to store prints is to lie them flat, interleaved with sheets of acid-free tissue paper, in an archival quality box or a steel cabinet. Negatives and slides can be safely stored in archival pages, usually made from polypropylene or polyethylene (avoid vinyl pages as they can leak softening agents, which will stick the film to the page), and slides can also be stored in acid-free boxes. You can get all these items relatively cheaply from photographic stores and art suppliers, or use the packaging for negatives and slides that comes back from the photo lab – though check what materials your lab uses. Don't forget to label or file negatives and slides to make it easier to find what you're looking for at a later date.

>> QUICK TIP

If you're still getting used to working with film, and don't feel quite confident about exposure and other settings, try taking a quick shot with your digital camera first to see what settings you might need, though remember that you can't adjust the ISO with your film camera.

>> QUICK TIP

Handle your negatives as little as possible, to avoid scratching them or covering them in fingerprints, and keep the strips in the sleeves in which they came back from the lab (except when you're actually scanning them), so they gather as little dust as possible. Dirt and marks that may not be visible to the naked eye will show up prominently in a high-res scan, and cloning them out can be a very laborious task.

Playing with toy cameras

The rise of candy-coloured, plastic toy cameras continues apace, with new models being introduced all the time, alongside the classics of the genre, from the **Lomo LC-A+**, **Holga** and **Diana** to the **Blackbird, Fly**, produced by Japanese cult design house Superheadz. The very characteristics that would be considered a problem in a conventional camera are celebrated by the toy camera's fanbase: erratic focus, vignetting and light leaks, all of which require a degree of thought to handle, make for a much more idiosyncratic outcome than shooting digital. Increasingly, too, these cameras are moving into the mainstream, with fine art photographers experimenting with Holgas and other toy cameras, and New York's Soho Photo Gallery running an annual Krappy Kamera competition, alongside the world's largest exhibition of toy camera photographs.

A typically brightly coloured plastic Holga, shot with an iPhone.

The Holga

Lightweight and cheap, the popular Holga (and its close relative, the **Diana**) are where a lot of toy camera photographers start. They're easy to use, with the most basic models lacking meters, adjustable shutter speeds or f/stops and autofocus, and only featuring rough controls for bright, cloudy or dull conditions and approximate distance from the subject. Their manual film winding mechanisms are often clunky, and their low-quality, plastic lenses give images a trademark soft focus feel, framed with a blurry or dark vignette. Both are renowned for light leaks and haphazard focus, and readily lend themselves to customization. They take medium-format 120 film, which is still widely available, though a 35mm version of each is also available. Different models come with a flash, a glass lens or even a fisheye, and both come in a range of different colours.

Lots of people customize their Holgas, partly because they're relatively cheap to replace, and partly because the Holga movement is all about idiosyncrasy and quirkiness. Common changes range from the cosmetic – people often paint them or stick stuff to them – to more technical tweaks and modifications, some of which are listed below; check out some of the websites listed on pp.216–217 for walkthroughs of the more elaborate customizations.

- **Flocking** Spray the inside with black matte paint to minimize interior reflections from light leaks.

- **PinHolga** Replace the lens with a pinhole. Use an old Holga or one with a broken lens, as while this process is technically reversible, it would be fiddly to do. Carefully cut a square piece of metal from a drink can or foil food tray, draw a cross in the centre and slowly drill a hole in it by twisting a needle until it breaks through (don't simply push it straight through, or it will bend the metal and distort the hole). Next, remove the Holga back and the film mask, then unscrew and remove the lens/shutter mechanism. If your Holga has a flash, simply cut the yellow wire close to the camera body, as you won't need it when using the pinhole. Tape the pinhole to the front of the camera, using the cross you drew on the reverse to centre it precisely, and taping the whole way around it to prevent light leaks. Replace the film mask, using the lens cap or a piece of duct tape to cover the pinhole when not making an exposure, and your PinHolga is good to go.

- **Going instant** Turn your Holga into a "Holgaroid" by replacing its back with a Polaroid back, which you can buy separately, allowing you to use Polaroid instant film with the camera.

>> QUICK TIP

If you want to experiment with pinhole photography, but don't want to mess around with developing film yourself, try the PinHolga tip here, or buy a "no dust" pinhole body cap for your SLR and experiment that way, removing the lens and putting the cap on the camera body, then setting to manual with a low ISO and playing with different slow shutter speeds.

Exposing the whole surface of the film, including the sprocket holes, and then scanning the negatives, can create a striking effect.

Like them or loathe them, light leaks create some interesting effects.

- **Filters** Make your own coloured filters, using any coloured transparent material you can find, from sweet papers to cellophane gift wrap, and simply tape over the lens to add the effect to your images. You may need to use a higher ISO film, or to make sure you're shooting in bright conditions, as the filters will reduce the light entering the camera.

- **Light leaks** Block the red window on the back and tape up the sides to minimize light leaks and ensure the back doesn't fly off (a not uncommon problem); or use tape in just a few places and leave as much of it open to potential light leaks as possible. Every model is different, so shoot a film first and get a feel for how much light your camera lets in, and the kind of look that pleases you most.

- **Shooting 35mm** Tape 35mm film into the spool, instead of 120 film. This enables you to shoot pictures that expose the entire surface of the film including the sprocket holes, which gives a great, quirky look. Pad the cartridge on the left-hand side with foam then pull enough film across to reach the take-up spool and tape the very end onto the reel, to keep it in place and ensure the film runs straight across the camera. You'll need to load and unload the film in the dark (or in a dark bag) and tape the camera up carefully to avoid light leaks, because 35mm doesn't have paper backing (unlike 120 film). This also means taping up the red window on the back, which means you won't be able to see the film counter, but simply turn the winder 1.5 times between exposures to wind the film on by more or less the correct amount.

Heavily vignetted image, typical of a toy camera.

- **Frames and silhouettes** Create a quirky frame for your images by cutting a square of card the same size as the film mask, then cutting a hole out of its centre with jagged or curvy edges, and taping it into the camera between the lens and the film in place of the mask. Alternatively, add some text or a design to a sheet of transparent plastic and tape that into the camera, without cutting a hole. Just remember that the image falls upside-down on to the film, so if your frame or screen has a right way up, you'll need to insert it into the camera upside-down. You'll also need to tape the batteries, which are usually held in position by the mask, into place.

Multiple exposures

One of the things you can do with film which you can't do with digital, in-camera at least, is deliberately take multiple exposures, shooting one picture on top of another to create beautiful and otherworldly (or disastrous and barely visible) results. You can use the technique to take multiple shots of a **moving subject**, such as someone running on the street, to end up with strange special effects. Or you might keep the camera still and simply **shift the focus** between shots, so you merge blurry and crisp versions of the same subject; turn the camera **upside down** for the second shot, so that your scene is the right and wrong way up within a single image, or **zoom in or out** for the second shot, so that your image combines close-up and distance shots of the same scene.

Because you're exposing the same frame more than once, the most successful multiple exposures will combine slightly under-exposed shots, as the image will become progressively lighter with each exposure. The detail of one image will also be most visible in darker areas of the other, so bear this in mind when planning how elements of the different shots will work together.

Multiple exposures, where the camera has been rotated or moved between shots.

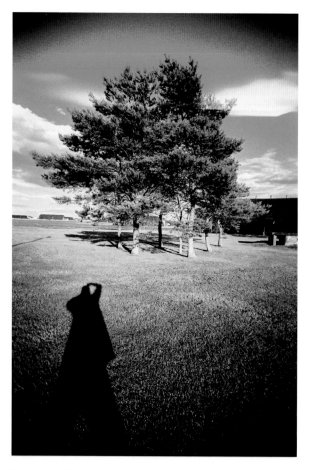

Cross-processed film has a distinctive look, with vivid saturation and strong contrast.

Cross processing

If the look you're after for your prints is a retro one, ask your lab to **cross process** your film. This practice, also known as X-Pro, involves deliberately processing film in the wrong chemicals, using slide chemicals for film and vice versa. Several labs offer this as a service, though you may need to send your film away for processing rather than taking it into your local store. But it's well worth trying out, as it can transform your images from something everyday and mundane to something extraordinary.

The results will vary from film to film, and even from lab to lab, and their unpredictability is part of the appeal, but you're likely to end up with images which have a very distinctive look, with unusual colour shifts, striking contrast and vivid, saturated colours. Film that's passed its **expiry date** often produces the most quirky results, because of its chemical breakdown, so if you come across an old roll of film, don't throw it away – run it through your camera and see what you come up with. Otherwise there's always plenty of expired film for sale on eBay.

Film communities online

Film photography continues to flourish online, with new resources, retailers and galleries springing up all the time. Flickr has a large number of groups devoted to film photography, plus millions of digitized film images.

Film on Flickr

The "Explore Analog" dropdown from the main Explore menu gives you a quick route into some of Flickr's film resources, highlighting a bunch of recent film uploads and some of the popular groups about film on the site. There's a group for pretty much any model of **film camera** you can think of, from the classic Polaroid SX-70 to the Rolleiflex; as well as camera **types** such as the Twin Lens Reflex (TLR) or **toy cameras** such as the Holga; groups devoted to **film types** such as Kodachrome or Fuji Velvia; or to **techniques** such as cross processing or double exposure; and broader generic groups such as "I Shoot Film", "Analog Photography", "Film is not dead!", "Film cameras only!", "Black and white film" and many others.

As the frequent exclamation marks in group titles suggest, the film community on Flickr (and elsewhere) can be vociferous, and sometimes dismissive of digital for the many shortcuts they think it represents. But it's also a community which is always ready to share information, tips and tricks, with the hundreds of useful discussion threads on Flickr a good starting point to find out more about shooting film.

From the Impossible Project: shot by Rommel Pecson on PX 600 Silver Shade UV+ (above); PX 600 Silver Shade (below).

> "Don't undertake a project unless it is manifestly important and nearly impossible."
> **Edwin Land (1909–91),** founder of the Polaroid Corporation

The Impossible Project

http://the-impossible-project.com

Digital photography, with its immediate results, dealt a body-blow to instant film: the Polaroid Corporation stopped making instant cameras in 2007 and then closed down its production of film in 2008, with the last batches expiring in November 2009. But in early 2010, after a few technical hitches, a company called the Impossible Project launched their first two new instant films for classic Polaroid cameras. Run by a group of former Polaroid employees keen to save analogue instant photography from obsolescence, the Project rescued the last Polaroid production plant in the Netherlands. Their first films were **Silver Shade**, which hovers somewhere between sepia and silver, with a kind of milky opacity, and **Color Shade**, which gives the gorgeous retro haze of a faded print.

In repositioning mass market instant film as an artistic niche product the Impossible Project has found new advocates among the digital generation, and their plans are generating a real buzz, with press coverage, exhibitions and collaborations with musicians. They have expanded into supplying refurbished Polaroid **cameras** and a range of **accessories** from sleek camera cases to branded boxes to protect your Polaroids, "coldclips" which will tell you whether the picture you've just taken is too warm or cold to develop properly, and more. All this has helped build their brand identity and customer loyalty, and made a thriving business a reality. They're also talking about developing a new instant camera, and have founded the **Impossible Collection**, an archive of photography and artworks created with their films.

This buzz seems to be rubbing off on the Polaroid Corporation itself (www.polaroid.com), who have signed up Lady Gaga as Creative Director and started 2011 by unveiling new camera products, including a pair of camera glasses which will capture still and video images and display them to those around you.

Lomography

www.lomography.com

In the early 1990s, two Austrian students on a trip to Prague came across the mass-produced Soviet camera, the **Lomo Kompakt Automat** (also known as the Lomo LC-A), and started snapping away, creating the characteristically highly saturated, grainy, vignette-framed shots now considered typical of this piece of kit. Spreading by word of mouth through the underground scene in Vienna, the Lomo craze took off rapidly, and the camera was soon being widely distributed by Austrian company Lomographische AG, under the Lomography trademark.

Since then, Lomography has secured an international following, not just as a brand but also as shorthand for a distinctive artistic style of photography: snapping pictures widely and in unusual situations, often shooting from the hip rather than carefully composing

It began with a fateful encounter in the early 1990s, when two students in Vienna, Austria, stumbled upon the Lomo Kompakt Automat – a small, enigmatic Russian camera. Mindlessly taking shots from the hip, and

images through the viewfinder, using cross processing to create an alternative look (see p.212) and actively playing up the camera's idiosyncrasies – its light leaks, unpredictable focus and garish colours. As the embodiment of an idea, lomography is about not overthinking what you're doing, but having some fun with it, and Lomography.com has become something of a cult global online community for all things toy-camera related, with their "Don't think, just shoot" motto, contribution to countless exhibitions worldwide, and ongoing collation of the **LomoWorldArchive**.

The website doesn't just peddle new gear – though it has a savvy approach to product discovery and launch, now producing a whole range of cheap lo-fi cameras with plastic lenses – but also has community features such as collaborative projects, contests, articles and tips, and a place to share your photos. There are also a whole host of dedicated groups on Flickr, if you search on "lomo".

More film sites

- **Feeling Negative?** www.feelingnegative.com A really useful space for anyone starting to investigate the world of film photography, featuring articles on old cameras and lenses, different types of film, processing and negative scanning, even how to build your own darkroom alongside shooting tips and photos and feedback from the site's community of readers.

- **Film Wasters** www.filmwasters.com A site dedicated to showcasing the creative side of film photography, with a useful forum and blog, plus interesting galleries of film images.

- **Four Corners Dark** www.fourcornersdark.com A great blog about all things toy camera-related, with news, product reviews, and plenty of techniques and tips. Run by photographer Nic Nicholls, the blog regularly features different photographers and images to inspire you, while the Four Corner Store (www.fourcornerstore.com) is a great place to browse for cameras and accessories.

- **Holga Inspire** www.holgainspire.com Launched by the company who created and continue to produce the Holga, it hosts a fantastic gallery of images, alongside news of competitions and events and information about the different types of Holga available.

- **Holgablog** www.holgablog.com An online magazine from a group of Holga-obsessives, offering a great selection of news, reviews, tutorials and processes, competitions and a useful buyer's guide.

- **GoHolga.com** www.goholga.com and **Squarefrog** www.squarefrog.co.uk Two Holga-focused blogs, with "how to" guides on popular hacks and modifications, plus tips and ideas for your own photography.

- **Light Leaks magazine** www.lightleaks.org Website accompanying a print magazine about lo-fi analogue cameras, with articles, interviews, resources and lots of shooting tips.

10 RESOURCES

Digital photography and the online environment are becoming increasingly interconnected, and we've included links and reviews for specific websites, blogs and online services in the relevant chapters. Photography is a vast subject, however, so we've gathered here a selection of more general resources – both online and off – to help you explore further. These range from camera review websites to photographic societies, by way of reference books, online courses, and even a handful of museums dedicated to the photographic arts.

Cameras and kit

Product and kit review sites

With so much equipment on the market and new, seemingly indistinguishable models being released all the time, actual user feedback is invaluable in helping you decide what to buy. Following are some of the best camera and kit review websites, offering a mixture of product reviews, buyers' guides, forum discussions and price comparison pages. Several of them also have tools which allow you to compare different models or search for particular features. And since you're sometimes looking at spending a fair amount, a bit of online research can really pay off.

- **Digital Photography Review** www.dpreview.com An independent site, with free registration, providing a massive database of digital camera information and extensive and detailed product reviews. The site includes buying guides and a great

Further review sites you may
want to check out:

Digital Camera Resource
www.dcresource.com

Imaging Resource
www.imaging-resource.com

Digital Camera Review
www.digitalcamerareview.com

BobAtkins.com
www.bobatkins.com/
photography

DigiCamReview
www.digicamreview.com

Photography Blog
www.photographyblog.com

side-by-side comparison model, allowing you to compare the specifications of up to ten cameras at once, as well as user galleries and a "Learn" section with articles on key areas of technique and composition.

- **Photo.net** www.photo.net/equipment As well as being a great learning environment (see p.223), photo.net has a good range of user-friendly reviews, accompanied by comparison photos. The full reviews are followed by reader feedback, which can also be useful, and you can often find more discussion of a particular model in the equipment forum – or sign up and post a question of your own.

- **Fredmiranda** www.fredmiranda.com A more community-based approach to reviews, though with good coverage of SLRs and lenses, and user reviews both available to read in full and collated into a summary box which indicates average rating and price paid. A useful back-up to the more thorough product testing sites, if you want some hands-on feedback from users, which can be very revealing about what does and doesn't work and just how popular a particular camera or lens is.

- **Steve's Digicams** www.steves-digicams.com Navigate your way through the ads, and you'll find a series of thorough and easily comprehensible reviews that analyse the technical specifications, features and the look and feel of hundreds of cameras and the occasional lens. The site also features an active discussion forum alongside a few useful "how to" articles, and pieces which recommend cameras for particular purposes (such as good cameras for teenagers or new parents), which can be a useful way to start making sense of the models available.

Buying secondhand

There are several stores in the UK, such as the London Camera Exchange and Jacobs Digital Photo and Video, which have branches around the country and a good turnover of secondhand stock. Many online retailers, such as Warehouse Express, also have a section selling secondhand and mail order returns, with clear quality grading and a retailer's warranty. In the US, photo stores B&H Photo Video, Calumet and Adorama all have departments selling used and reconditioned equipment, also available in their

online stores, which in most cases comes with a shop warranty. Finally, if you're lucky enough to have a local independent photography shop, they may also trade in used items or be able to recommend somewhere nearby.

London Camera Exchange www.lcegroup.co.uk
Jacobs Digital Photo and Video www.jacobsdigital.co.uk
Warehouse Express www.warehouseexpress.com
B&H Photo Video www.bhphotovideo.com
Calumet www.calumetphoto.com
Adorama www.adorama.com

For an up-to-date list of secondhand dealers in the UK, visit
▶▶ *www.amateurphotographer.co.uk/shop/Second_Hand_Dealers_4719.html*

For tips on buying secondhand gear
▶▶ *p.7*

Equipment rental

Renting camera equipment is a good way to see whether something is right for you before you invest in it. The companies below all have a good range of items on their rental lists, and you can look online for companies local to you. Check online reviews of the service before giving them your credit card details though, as you normally have to lay down a fairly hefty deposit for camera equipment, and there are several disreputable firms in this sector, as there are everywhere else.

In the UK:
Fixation www.fixationuk.com
Hire a Camera www.hireacamera.com
Lenses for Hire www.lensesforhire.co.uk

In the US:
BorrowLenses.com www.borrowlenses.com
LensRentals.com www.lensrentals.com

Courses, workshops and online learning

For websites offering tips and tutorials on specific subjects, turn to the relevant section of the book:

lighting ▶▶ p.64 & p.186–187
software tutorials ▶▶ p.131
shooting video ▶▶ p.16
sensor cleaning ▶▶ p.28

For reviews of our pick of photography blogs and sites, some of which offer tips and tutorials ▶▶ see Ch7; for sites offering inspiration and tips on different genres and styles of photography ▶▶ see Ch5.

Wherever you are, there are likely to be photography courses available in some shape or form, from evening classes to full degrees, plus courses offering hands-on experience of different genres. Look up your local college or university online to see what they offer, or check out some of the resources listed below. The major camera manufacturers also often offer courses and seminars, to help you get the best out of their gear, as do some of the main photography stores. Of course, there's a growing number of web-based learning resources and the benefits of the online environment are that you can work at your own pace, drilling down into exactly whatever it is that has you stumped. As well as online courses, there are countless sites offering tutorials, top tips, quick solutions to particular problems or how-to video guidance.

General distance and online courses

- **Cambridge in Colour** www.cambridgeincolour.com A free online learning environment with a great range of articles on technique and tutorials, from getting to grips with your camera to composition and post processing, and an active forum hosting competitions and general photography discussions.

- **Digital Photography School** www.digital-photography-school.com With an astonishingly broad range of learning tools aimed at everyone from newbies to the semi-experienced, Digital Photography School's easy-to-follow articles and tutorials cover composition, technique, different genres, and reviews of popular cameras and lenses. There's an active forum where members share their photos, discuss tips and seek feedback, which also hosts weekly assignments to inspire you and help improve your photography.

- **Geoff Lawrence** www.geofflawrence.com The many tutorials here are helpfully graded by level, and the site offers great coverage of technique, composition, post processing and photographic genres, plus ways to try and make money from your images. In addition, there's a small but developing forum and members' gallery.

- **Luminous landscape** www.luminous-landscape.com Another online learning resource, devoted to landscape, nature and documentary photography, but with articles and tutorials on a wide range of topics, as well as product reviews and an active forum discussing all manner of photography-related topics.

- **New York Institute of Photography** www.nyip.com The world's largest and oldest photography school, the NYIP offers three distance learning courses available wherever you are in the world: a basic short course, one primarily focusing on Adobe Photoshop, and a complete course for those really serious about taking their photography further, all including DVDs and audio guides.

- **The Open University** http://www3.open.ac.uk/study/undergraduate/course/t189.htm A ten-week online introductory course, providing comprehensive coverage of the basics, and active forums in which students discuss their weekly assignments and help each other with issues. You aren't assigned an individual tutor, but there are moderators on hand to answer questions if necessary.

- **Photo.net** www.photo.net/learn A great community space, Photo.net not only offers comprehensive product reviews (see p.220), but also some extremely clear and helpful learning tools, from introductory articles on technique to interviews with professional photographers, and everything in between. The site has a huge community, with hundreds of thousands of members, and a bustling discussion forum.

- **Phototuts+** www.photo.tutsplus.com Also providing online tutorials, articles and tips, on subjects from composition to working with film, Phototuts+ is a regularly updated and popular site, clearly written and easy to understand, and with plenty of illustration. You'll need to pay to access the premium content, but there is plenty of free material available on the basics.

Other sites you may want to check out for photography holidays include:

Exodus www.exodus.com

Imaginative Traveller www.imaginative-traveller.com

Mountain Paradise Ltd www.mountainparadise.co.uk

Responsible Travel www.responsibletravel.com

There are plenty of courses and workshops for portrait and wedding photography out there, too. Search online to find something local to you, or – in the UK – check out the following sites:

Annabel Williams www.annabelwilliams.com

Aspire Photography Training www.aspirephotographytraining.co.uk

Brett Harkness www2.brettharknessphotography.com/Brett-Harkness-Photography-Training-workshops.aspx

Society of Wedding and Portrait Photographers www.swpp.co.uk/seminar_files/members_training_days.htm

Travel and landscape courses

Some travel companies now offer a few dedicated photography holidays, where a trip to a popular location such as Antarctica or the Kenyan game reserves is led by a professional photographer and tailored accordingly, with more time spent in a location to capture images than is possible on the usual whistle-stop tours. There is also a handful of companies that specialize in photography tours.

- **Light & Land** www.lightandland.co.uk One of the first companies to offer photography tours, Light & Land (founded by eminent landscape photographer Charlie Waite, see p.108) has a great range of trips and workshops, from an introduction to digital photography or a day visit to photograph snowdrops in the grounds of a National Trust estate, to trips to far-flung destinations such as Namibia or Cuba. The tours are led by some of the UK's finest photographers.

- **Travellers' Tales** www.travellerstales.org With a range of travel writing and photography courses in the UK and overseas, Travellers' Tales works with a number of professional photographers and travel writers or journalists to offer courses tailored to both honing your skills and learning how to get your photographs or articles published.

Books

History of photography

- **Gerry Badger** *The Genius of Photography* (Quadrille Publishing Ltd, 2007). The accompaniment to a major television series, this book explores the development of the medium through a series of key events, personalities and images, giving a carefully plotted history of photography from its origins through to the move towards digital.

- **Ian Jeffrey** *The Photo Book* (Phaidon Press Ltd, 2005). Presents 500 photographers alphabetically over 500 pages, with a single photo apiece, explaining the key themes and works of each photographer in a fact-filled extended photo caption. A great way to get a quick feel for a lot of different styles, which you might then explore further.

- **Mary Warner Marien** *Photography: A Cultural History* 3rd edn (Laurence King, 2010). A major survey of the international history of photography and its changing social uses, by amateurs as well as professionals, encompassing topics such as the effect of the mass media on morality, alongside good coverage of non-Western photography.

- **Naomi Rosenblum** *A World History of Photography* 4th edn (Abbeville Press, 2008). A comprehensive overview of the history of photography from the 1830s, looking at different genres, the work of a number of photographers and the impact of key technical advances.

Reference

- **Anne H. Hoy** *The Book of Photography: The History, The Technique, The Art, The Future* (National Geographic Books, 2005). A comprehensive volume looking at every aspect of photography, illustrated with photos from around the world.

- **Peres (ed.)** *The Focal Encyclopedia of Photography* 4th edn (Focal Press, 2007). A great source of information about all aspects of photography, from the technical to the artistic, historical processes and contemporary applications, evolving digital technologies, and different genres and photographers.

Classics

- **Ansel Adams** *The Camera* 2nd edn; *The Negative* 2nd edn; *The Print* 2nd edn (all Little, Brown, 1995). Trilogy on how to harness the full artistic potential of the process

from camera through to final print. While *The Negative*, in particular, explores film and darkroom techniques, the overall concept – the visualization of the finished photograph – has relevance for anyone interested in photography.

- **John Berger** *Ways of Seeing* (Penguin Classics, 2008). Influential art book first published in 1972, looking at the relationship between what we see and what we know, and juxtaposing words and text to explore the ways in which the two influence each other.

- **Susan Sontag** *On Photography* (Penguin Classics, 2008). Sontag's 1977 collection of six essays on the history of photography, its role in 1970s capitalist society, and on how photographs can shock or idealize, create a sense of nostalgia or serve as a memorial – and how we come to rely on them to define our view of the world.

Inspiration and ideas

- **Leah Bendavid-Val** *National Geographic: The Photographs* (National Geographic Society, 2008). Packed with awe-inspiring images of nature, wildlife and people from around the world, alongside commentary on how they were achieved from an artistic, technical and compositional point of view.

- **Amit Gupta with Kelly Jensen** *Photojojo! Insanely Great Photo Projects and DIY Ideas* (Potter Craft, 2009). Quirky things to do with your favourite photographs, plus photography tips, tricks and DIY fixes.

- **Brigitte Lardinois** *Magnum Magnum* (Thames & Hudson, 2009). A stunning collection of images from Magnum agency members from the 1940s on, along with brief photographer bios.

- **Kevin Meredith (ed.)** *52 Photographic Projects: Creative Workshops for the Adventurous Image-Maker* (Rotovision, 2010). A collection of ideas for projects, one for every week of the year, from jump shots to people montages, camera tossing to

light painting, accompanied by lots of colourful pictures and practical, jargon-free tips on how to put the ideas into practice.

- **Reuters** *Our World Now* 4th edn (Thames & Hudson, 2011). Classic images from Reuters photojournalists documenting the year 2010, from the most memorable news stories and events to the less familiar and more surprising.

Technique

- **Tom Ang** *How to Photograph Absolutely Everything: Successful Pictures from your Digital Camera* (Dorling Kindersley, 2009). Covers some basic techniques, and then jumps straight into how these apply to particular types of photography, whether people or architecture, or using your photography for the purpose of artistic expression. The book talks you through the equipment and set-up you'll need to deliver great shots, no matter what you're trying to capture.

- **Michael Freeman** *Perfect Exposure: The Professional Guide to Capturing Perfect Digital Photographs* (ILEX, 2009) and *The Complete Guide to Light and Lighting in Digital Photography* (ILEX, 2006). These two guides get right to the heart of how exposure and lighting work, from composition through to post production, laying out the decisions you need to make with real clarity, and accompanied by plenty of helpful illustrations.

- **Fil Hunter, et al**. *Light – Science and Magic: An Introduction to Photographic Lighting* 4th edn (Focal Press, 2011). A comprehensive reference guide that takes you through the theory and practice of lighting in clear and easy-to-follow steps, looking at how light works and how to control it, covering equipment and location lighting and how to light pretty much any subject.

- **Joe McNally** *The Moment it Clicks: Photography Secrets from One of the World's Top Shooters* (New Riders, 2008) and *The Hot Shoe Diaries: Big Light from Small Flashes* (New Riders, 2009). The first book offers a great mix of stunning images and practi-

cal, jargon-free advice on how they were taken, particularly good if you're interested in photojournalism, but with enough tips and tricks to be useful to anyone. In *The Hot Shoe Diaries* McNally shows you how to shape, control and direct light by demonstrating how a series of images were lit, in his perennially approachable style.

- **Bryan Peterson** *Understanding Exposure: How to Shoot Great Photographs with Any Camera* 3rd edn (Amphoto Books, 2010). A really straightforward introduction to exposure, with practical tips on how to get it right when taking pictures yourself, sections on how exposure is affected by elements such as flash and filters, and plenty of illustrations.

Film photography

- **Michelle Bates** *Plastic Cameras: Toying with Creativity* 2nd edn (Focal Press, 2010). A brief history of the plastic camera and its popularity, followed by a look at some of the main models, galleries from plastic camera devotees, advanced tips and tricks for shooting with your toy camera, and advice on working with film. A nice overview, with some useful practical applications if you're interested in experimenting.

- **Barbara Hitchcock** *The Polaroid Book: Selections from the Polaroid Collections of Photography* (Taschen, 2008). A great selection of 400 images from the Polaroid Collection, started by Polaroid founder Edwin Land and Ansel Adams and including images taken by photographers such as David Hockney and Helmut Newton. Includes an interesting essay on the history underpinning this classic of instant film. Perfect if you've got hold of a Polaroid and are looking for inspiration.

- **Kevin Meredith** *Toy Cameras, Creative Photos: High-end Results from 40 Plastic Cameras* (Rotovision, 2011). A great visual guide to the quirky style of a range of different toy camera models, looking at their different characteristics, how they differ from digital cameras, tips and tricks to get the most out of them, and the potential for experimentation that toy camera aficionados love.

Taking things further

- **Rohn Engh** *Sell and Re-sell Your Photos* 5th edn (Writer's Digest Books, 2003). Lots of information on how to sell your work, with advice on what's marketable, stock photography, promotional techniques to get your pictures noticed, and so on.

- **Douglas Freer** *Microstock Photography: How to Make Money from Your Digital Images* (Focal Press, 2008). A comprehensive and useful guide to microstock photography, looking at the kind of images that sell alongside an explanation of the stock market and how to shoot good stock images, and offering practical advice on subjects such as release forms, copyright, privacy and trademarks.

- **Ed Greenberg and Jack Reznicki** *Photographer's Survival Manual* (Lark, 2010). Written by the president of the Professional Photographers of America association and a leading New York copyright attorney, this book is a good source of basic legal advice for photographers, covering contracts, releases, copyright law, how to protect work from infringement, and more.

- **Photopreneur** *99 Ways to Make Money from Your Photographs* (New Media Entertainment Ltd, 2009). Packed with strategies for making money from your images, including selling stock photos, creating and marketing photo products and getting into event photography. The book includes insider tips on the kind of things to shoot, practical advice on breaking into a particular field or market, and illustrative case studies.

Societies and organizations

Joining a club or organization is a great way of sharing your interest with others, and many groups hold photo walks, organize talks and member exhibitions, and run regular competitions. It's also a good way to learn more, on an informal basis, from people who may take a different approach to photography, or even just to check out different bits of kit in real life.

Many local areas have their own camera club or photographic society, or there may be an active Flickr group in your region. If you're interested in finding a group that shares your interest, this is a good place to start. There's a good list of UK camera clubs at http://ukcameraclubs.com, or you can simply search the internet for clubs in your area.

- **Association of Photographers** www.the-aop.org A body formed for professional photographers, the AOP runs workshops and seminars, hosts exhibitions, and lobbies for photographers' rights.

- **British Copyright Council** www.britishcopyright.org A forum for the discussion of copyright issues, and a pressure group for change in copyright law at UK, European and international levels.

- **Bureau of Freelance Photographers** www.thebfp.com A society offering useful resources for freelance photographers looking to make money from their photography. They run courses and publish books, as well as a newsletter featuring photography opportunities.

- **Photographic Alliance of Great Britain** www.pagb-photography-uk.co.uk Coordinates activities for camera clubs in the UK, from inter-club competitions to lectures. Membership is only possible through an affiliated camera club.

- **Photographic Society of America** www.psa-photo.org An American not-for-

profit which publishes a journal and holds an annual conference, as well as running various challenges and competitions. It also provides a list of camera clubs in the US and Canada on its Resources page.

- **Royal Photographic Society** www.rps.org A charity promoting the art and science of photography, the Royal Society hosts lectures and workshops, and features an online learning zone. You can also apply to have your work evaluated for Licentiateship, Associateship or Fellowship of the Society.

- **Stock Artists Alliance** www.stockartistsalliance.org A trade association for stock photographers, with useful information on industry issues. The site also features some free resources, for which you have to register, including information about model and property release forms (www.stockartistsalliance.org/stock-releases).

Museums, galleries and foundations

- **Aperture Foundation** www.aperture.org New York-based nonprofit organization founded in 1952 by a group of photographers including Ansel Adams and Dorothea Lange to promote photography. Starting with a quarterly periodical, *Aperture*, the foundation developed a book publishing programme in the 60s, and now also has a gallery space in the Chelsea Art District which hosts a range of eclectic and critically acclaimed exhibitions. It also runs lectures and panel discussions.

- **International Center of Photography** www.icp.org The ICP, also in New York, is a museum and school dedicated to the understanding and appreciation of photography. The museum hosts exhibitions of both historical and contemporary work, and the school offers a range of courses from seminars and lectures to Master's degree programmes. The research centre also features photographic collections and an extensive library.

- **National Media Museum** www.nationalmediamuseum.org.uk Host to the National Photography Collection, the National Media Museum, in Bradford in the UK, features a great mix of photography archives, including the Daily Herald Archive, the Royal Photographic Society collection and the Photographic Technology collection, representing all major genres, technological applications and photographic movements.

- **The Photographers' Gallery** www.photonet.org.uk The UK's largest public gallery dedicated to photography, the Photographers' Gallery in London holds exhibitions, talks, print sales and portfolio reviews, and runs a number of offsite community and schools projects. It also has a fantastically well-stocked photography bookshop, with an interesting sideline in toy, and other film, cameras.

- **Viewfinder Photography Gallery** www.viewfinder.org.uk Based in London, the Viewfinder Photography Gallery holds exhibitions, workshops and events showcasing the work of emerging and established photographers.

INDEX

R

S

IMAGE CREDITS

Front cover: The London Eye and Houses of Parliament from the Golden Jubilee Bridge © Diana Jarvis, www.dianajarvisphotphotography.com **Inside front cover:** Lighting setup © Mike Stimpson, www.mikestimpson.com
Back cover: Efterklang performing at Field Day, Victoria Park, London 2008 © Diana Jarvis; Gerbera flowers © Sophie Goldsworthy; Model Ivory Flame (www.ivoryflame.co.uk) © Sophie Goldsworthy; Broadway Tower, Worcestershire © Diana Jarvis; Hong Kong street scene (taken with iPhone4) © Brad Haynes, www.flickr.com/photos/londonbrad

Introduction: p.iv Bicycle by Jesus College, Oxford © Sophie Goldsworthy; p.vi Model: Mihaela Stancu (www.facebook.com/pages/MichelleSt-Model/189555284424404) © Sophie Goldsworthy; p.vii Gateway to All Souls College, Oxford © Sophie Goldsworthy; p.ix Sneezeweed flowers © Sophie Goldsworthy; p.xi Self-portrait with coffee, Blue flower with textures added, Purple allium haze, all © Sophie Goldsworthy

CHAPTER 1: **YOUR CAMERA**

CHAPTER 2: **THE REST OF THE KIT**

CHAPTER 3: **GETTING TECHNICAL**

CHAPTER 4: **COMPOSITION**

CHAPTER 5: **GENRES AND STYLES**

CHAPTER 6: **DIGITAL DARKROOM**

CHAPTER 7: **PHOTOGRAPHY ONLINE**

CHAPTER 9: **THE RESURGENCE OF FILM**